The American Impressionists

The American Impressionists

BY DONELSON F. HOOPES

WATSON-GUPTILL PUBLICATIONS, NEW YORK

First published 1972 in New York by Watson-Guptill Publications,
a division of Billboard Publications, Inc.,
1515 Broadway, New York, N.Y. 10036

Library of Congress Cataloging in Publication Data
Hoopes, Donelson F.
 The American impressionists.
 Bibliography: p.
 1. Impressionism (Art)—United States. 2. Painting,
Modern—19th century—United States. I. Title
ND210.5.I4H6 759.13 72-190522
ISBN 0-8230-0212-8

Manufactured in Japan

First Printing, 1972
Second Printing, 1977
Third Printing, 1978

Impressionism is generally considered to be a derivative form of expression in American art, a form that slipped comfortably into American culture around the turn of the century, and it remains suspect because of its wide popular acceptance. Only those three famous "expatriates," Whistler, Cassatt, and Sargent, with their authentic European credentials, have been treated to any thorough study by art historians. Impressionism is also a term whose applications to American art are rather imprecise, for even that august group who formed the official academy of the American branch of impressionism—the "Ten"—worked in styles ranging from plein-air to a modified realism. Many artists are included in this volume whose qualifications to be called impressionists might seem insufficient to those less willing to stretch the term to accommodate them than I am. But my working thesis is simple: I acknowledge as impressionists those important talents in American art of the late 19th and early 20th centuries who used color rather than the traditional American approach through line. On this assumption this volume embraces such diverse artists as George Inness and Maurice Prendergast. A number of now-forgotten talents are included here, too, along with the expected names. However, the present volume, with its limited space, does not pretend to include all who might represent, with equal distinction, the American artist's adaptation and transformation of that powerful movement that reshaped Western art.

In this endeavor, I was encouraged and sustained by Donald Holden, Editorial Director of Watson-Guptill, and by his very able Associate Editor, Adelia Rabine. Mrs. Rabine, in addition to guiding this manuscript through to its final form, undertook to round up all of the illustrations with which this book is so magnificently adorned. Considering the number of collections represented, her task was heroic; and I owe her an enormous debt of gratitude. For his felicitous achievement in this book's design, my admiration and appreciation to James Craig is here recorded.

Others outside the precincts of Watson-Guptill aided me in many ways. I am particularly indebted to Richard J. Boyle, Curator of Painting, Cincinnati Art Museum, who shared with me his insights and portions of his soon-to-be published manuscript on American impressionism and who responded with his accustomed alacrity to my many questions and requests for now-scarce exhibitions catalogs. Others aided me in like manner: John K. Howat, Curator, American Paintings and Sculpture, The Metropolitan Museum of Art; Miss Cecily Langdale, Hirschl and Adler Galleries; and Mrs. Elizabeth Bailey, the Pennsylvania Academy of the Fine Arts. Ira Spanierman and Charles Slatkin Galleries of New York and Fred Maxwell of San Francisco were especially helpful. Also, I am indebted to Geoffrey Clements and the other photographers for their excellent work with the paintings represented in this book. To all, I offer my sincerest thanks.

D.F.H.

LIST OF COLOR PLATES

Plate 1 George Inness, *Gray Day, Goochland*, The Phillips Collection, 21

Plate 2 James McNeill Whistler, *The White Girl, Symphony in White No. 1*, The National Gallery of Art, Harris Whittemore Collection, 23

Plate 3 James McNeill Whistler, *Nocturne in Black and Gold: The Falling Rocket*, Detroit Institute of Arts, The Dexter M. Ferry, Jr. Fund, 25

Plate 4 James McNeill Whistler, *Note in Blue and Opal: The Sun Cloud*, Freer Gallery of Art, Smithsonian Institution, 27

Plate 5 Homer Dodge Martin, *Harp of the Winds: View of the Seine*, The Metropolitan Museum of Art, 29

Plate 6 Mary Stevenson Cassatt, *Young Woman Reading*, Museum of Fine Arts, Boston, Bequest of John T. Spaulding, 31

Plate 7 Mary Stevenson Cassatt, *Lydia Working at a Tapestry Frame*, Flint Institute of Arts, 33

Plate 8 Mary Stevenson Cassatt, *Lady at the Tea Table*, The Metropolitan Museum of Art, Gift of Miss Mary Cassatt, 35

Plate 9 Mary Stevenson Cassatt, *The Bath*, The Art Institute of Chicago, 37

Plate 10 William Merritt Chase, *Sunlight and Shadow*, Joslyn Art Museum, 39

Plate 11 William Merritt Chase, *Hide and Seek*, The Phillips Collection, 41

Plate 12 William Merritt Chase, *A Friendly Call*, The National Gallery of Art, Chester Dale Collection, 43

Plate 13 William Merritt Chase, *Near the Beach, Shinnecock*, Toledo Museum of Art, Gift of Arthur J. Secor, 45

Plate 14 William Merritt Chase, *Interior: Young Woman at a Table*, The Joseph H. Hirshhorn Collection, 47

Plate 15 Theodore Robinson, *The Vale of Arconville*, The Art Institute of Chicago, The Friends of American Art Collection, 49

Plate 16 Theodore Robinson, *Bird's Eye View: Giverny, France*, The Metropolitan Museum of Art, Gift of George A. Hearn, 51

Plate 17 Theodore Robinson, *The Watering Pots*, The Brooklyn Museum, 53

Plate 18 Theodore Robinson, *Willows (En Picardie)*, The Brooklyn Museum, Gift of George D. Pratt, 55

Plate 19 Dwight William Tryon, *Early Morning, September*, Museum of Fine Arts, Boston, Ernest Wadsworth Longfellow Fund, 57

Plate 20 John Singer Sargent, *Home Fields*, The Detroit Institute of Arts, 59

Plate 21 John Singer Sargent, *Claude Monet Sketching at the Edge of a Wood*, The Tate Gallery, London, 61

Plate 22 John Singer Sargent, *Paul Helleu Sketching, and His Wife*, The Brooklyn Museum, 63

Plate 23 John Singer Sargent, *Stream in the Val d'Aosta*, The Brooklyn Museum, A.A. Healy Fund, 65

Plate 24 Frederick Childe Hassam, *Grand Prix Day*, Museum of Fine Arts, Boston, Ernest Wadsworth, Longfellow Fund, 67

Plate 25 Frederick Childe Hassam, *Flower Garden*, Worcester Art Museum, Theodore T. and Mary G. Ellis Collection, 69

Plate 26 Frederick Childe Hassam, *Washington Arch in Spring*, The Phillips Collection, Washington, D.C., 71

Plate 27 Frederick Childe Hassam, *Late Afternoon, Winter, New York*, The Brooklyn Museum, Dick S. Ramsay Fund, 73

Plate 28 Frederick Childe Hassam, *Southwest Wind*, Worcester Art Museum, Theodore T. and Mary G. Ellis Collection, 75

Plate 29 Frederick Childe Hassam, *Union Jack, New York, April Morn*, The Joseph H. Hirshhorn Collection, 77

Plate 30 Thomas Wilmer Dewing, *Lady in Gold*, The Brooklyn Museum, 79

Plate 31 Thomas Wilmer Dewing, *The Spinet*, National Collection of Fine Arts, Smithsonian Institution, 81

Plate 32 Julian Alden Weir, *Upland Pasture*, National Collection of Fine Arts, Smithsonian Institution, 83

Plate 33 Julian Alden Weir, *The Red Bridge*, The Metropolitan Museum of Art, 85

Plate 34 John Henry Twachtman, *Arques-la-Bataille*, The Metropolitan Museum of Art, 87

Plate 35 John Henry Twachtman, *Snowbound*, The Art Institute of Chicago, Friends of American Art Collection, 89

Plate 36 John Henry Twachtman, *Summer*, The Phillips Collection, Washington, D.C., 91

Plate 37 John Henry Twachtman, *Reflections*, The Brooklyn Museum, Dick S. Ramsay Fund, 93

Plate 38 John Henry Twachtman, *Sailing in the Mist*, Pennsylvania Academy of the Fine Arts, Temple Fund, 95

Plate 39 Joseph Rodefer De Camp, *The Guitar Player*, Museum of Fine Arts, Boston, Charles Henry Hayden Fund, 97

Plate 40 Joseph Rodefer De Camp, *The Little Hotel*, Pennsylvania Academy of the Fine Arts, 99

Plate 41 Frank Weston Benson, *Rainy Day*, The Art Institute of Chicago, Friends of American Art Collection, 101

Plate 42 Edmund Charles Tarbell, *In the Orchard*, National Collection of Fine Arts, Smithsonian Institution, 103

Plate 43 Willard Leroy Metcalf, *Early Spring Afternoon, Central Park*, The Brooklyn Museum, Frank L. Babbott Fund, 105

Plate 44 Robert Reid, *Fleur-de-Lys*, The Metropolitan Museum of Art, George A. Hearn Fund, 107

Plate 45 Charles Harold Davis, *North West Wind*, The Art Institute of Chicago, The Walter H. Schulze Memorial Collection, 109

Plate 46 Sören Emil Carlsen, *Connecticut Hillside*, The Art Institute of Chicago, The Walter H. Schulze Memorial Collection, 111

Plate 47 Abbott Handerson Thayer, *Mount Monadnock*, The Corcoran Gallery of Art, 113

Plate 48 Henry Ward Ranger, *An East River Idyll*, Museum of Art, Carnegie Institute, 115

Plate 49 Theodore Earl Butler, *Gisors Train in the Flood*, Private Collection, 117

Plate 50 Edward Henry Potthast, *A Holiday*, The Art Institute of Chicago, Friends of American Art Collection, 119

Plate 51 Walter Parsons Shaw Griffin, *Springtime*, Memorial Art Gallery, University of Rochester, 121

Plate 52 Frederick Carl Frieseke, *Summer*, The Metropolitan Museum of Art, 123

Plate 53 John Sloan, *Wake of the Ferry*, The Phillips Collection, Washington, D.C., 125

Plate 54 George Wesley Bellows, *Pennsylvania Station Excavation*, The Brooklyn Musuem, A. Augustus Healy Fund, 127

Plate 55 William James Glackens, *Chez Mouquin*, The Art Insitute of Chicago, Friends of American Art Collection, 129

Plate 56 William James Glackens, *Nude with Apple*, The Brooklyn Museum, Dick S. Ramsay Fund, 131

Plate 57 Ernest Lawson, *Spring Night, Harlem River*, The Phillips Collection, Washington, D.C., 133

Plate 58 Maurice Brazil Prendergast, *The East River*, The Museum of Modern Art, Gift of Abby Aldrich Rockefeller, 135

Plate 59 Maurice Brazil Prendergast, *Eight Bathers*, Museum of Fine Arts, Boston, Abraham Shuman Fund, 137

Plate 60 Walter Elmer Schofield, *Building the Coffer Dam*, The Art Institute of Chicago, Friend of American Art, 139

Plate 61 Guy Carleton Wiggins, *Lightly Falling Snow*, The Art Institute of Chicago, The Walter H. Schulze Memorial Collection, 141

Plate 62 Edward Willis Redfield, *The Mountain Stream*, Museum of Fine Arts, Boston, The John Pickering Lyman Collection, 143

Plate 63 Daniel Garber, *The Quarry*, Pennsylvania Academy of the Fine Arts, 145

Plate 64 Robert Spencer, *White Tenements*, The Brooklyn Museum, J.B. Woodward Fund, 147

The influence of impressionism upon American art has been, in very large measure, an imported taste. The battle of styles, which so characterized French painting in the early 19th century, never saw its equivalent in the United States. The contest for supremacy in French painting in the first half of the 19th century was between the establishment represented by Ingres, who asserted that line was the triumphant element of art, and Delacroix, who believed that color was the most significant element in art. This was a struggle between classicism on the one hand and realism on the other, but the battle of styles in Paris never for a moment questioned the supremacy of the official academies.

For the better part of the 19th century, French artists continued to accept the idea that prizes and medals awarded by the Academy were the only means to success. By contrast, the American artists of the 19th century rarely relied upon such conventional means.

Academies of painting had been established in New York and Philadelphia in the early 19th century; they offered young artists, aspiring to become known, a place in which they could gain technical proficiency in the craft of painting. Dissent existed there too, as in Paris, but for reasons which were entirely different. In Europe, where royal patronage had established official national academies in the late 18th century, recognition by those academies constituted the supreme fact of life in European art.

No such hegemony existed among the establishments in America, where the traditions of individualism and independence operated even at the level of art. The collapse of the American Academy of Art in 1825 and the birth of the National Academy of Design in 1826 came about not because of a struggle between conflicting theories of art, but because of a conflict between personalities.

The strongest American artists of the 19th century exhibited an innate individualism, leading them away from the safety and approval of academic institutions. This strain of individualism in American art carried with it, however, a negative aspect. Many of the most prominent French artists of the 19th century operated their own studios where pupils might study, but no major American artist of this period (with the notable exception of Thomas Eakins) encouraged a teacher-disciple relationship.

One can speculate upon what might have happened to the field of landscape painting in the early 19th century, for instance, had Thomas Cole admitted to his studio more than the solitary talent of Frederick Church. And what of the tradition of marine painting had Winslow Homer been a personality less isolated, both physically and emotionally, from his contemporaries?

The history of this period shows that American artists continued to look toward Europe for instruction. And it was to the various centers of European culture—first London, then Rome, Munich, and finally, Paris—that they went. Throughout the century, each of these cultural centers had an effect upon American art. Through these centers also may be traced the development of an international style from classicism to romanticism to realism and finally to impressionism.

American impressionism, so far as it may be defined, has no real center. Unlike his French counterpart, the American impressionist painter rarely associated with groups; the "Ten American Painters," formed in 1898 in New York, were only loosely impressionists. Among their members were men whose pictorial styles embraced solidly academic realism, touched only passingly by the manners of impressionism. While impressionism undoubtedly added another facet to American art, at no time did it ever threaten to eclipse the central motive force of American art, namely, realism. Indeed, American art has always been at its best when grappling with the problems of realism.

While the tonal poetry of light and color might be the only subject matter needed by a Monet, an American like Childe Hassam—an artist whose style is much like that of his French contemporary—betrays a constant need in his art to return time and time again to specific subject matter. Thus, Hassam's many paintings of flags displayed on Fifth Avenue (around the time of the First World War) exhibit a dual interest in painting and a form of illustration. Only in the hands of James Whistler, whose nocturnes partake of the essentially abstract tonal poetry of French impressionism, can an American artist be truly said to have approached the French spirit in painting. While a great many of the American painters who called themselves impressionists—and who are represented in this volume—indeed thought of themselves as inheritors of a tradition of painting, one may observe that they were perhaps more enchanted with the technique than with the substance of impressionism. For in French hands, impressionism was always a consideration of light and color, and subject matter only secondarily. No American artist ever went so far as Monet, for example, in dissolving form and subject matter into pearly color.

Early in the 19th century, both France and America possessed strong landscape painting traditions. And both traditions were essentially motivated by a strong romantic realist persuasion. American landscape painting, under the Hudson River School artists, developed a distinguishing penchant for luminist color. In American painting, luminism sought to intensify the experience of reality by a heightened rendering of light and color, combined with

linear precision and extreme clarity of detail. The development of romantic realist landscape in France, however, proceeded entirely along different paths. In the village of Barbizon, on the edge of the forest of Fontainebleau, some twenty miles southeast of Paris, French landscape painting began to evolve a form and substance all of its own. Led by artists like Corot, Diaz, and Theodore Rousseau, the Barbizon School of French landscape painting in the first half of the 19th century established a balance between romanticism and realism.

In the second half of the 19th century, the native American school, whose strongest champions were the landscape painters Thomas Cole and Asher Durand and the genre painters George Bingham and William Mount, had lost favor with the American public. There were signs even at mid-century that European tastes—particularly German and French—were beginning to have a substantial effect upon the American public, and not incidentally, upon the American artist.

As early as 1856, Corot had been introduced to a group of collectors in Boston by the young American artist William Morris Hunt. The Barbizon painters offered American artists a view of nature that was not always sympathetic with the native school tradition, however. Worthington Whittredge, who visited Barbizon, said of this school: "I liked the spirit of these young men but did not think much of their pictures." Likewise, a fellow luminist, Sanford Gifford, commented that he found the Barbizon School "slovenly." These were typical reactions expressed by Americans who were seeing a new kind of art for the first time. The tendency of the American school was for the artist to work towards the concealment of his own presence in the painting. That is, his subject—the great American landscape—was a phenomenon to be recorded as if it had been painted by the artist's mind rather than by his hand. Thus, clear drawing, pure color, and an absence of brushstrokes in these native school pictures worked toward the revelation of the subject and sublimated the artist himself within that subject.

French painting, on the other hand, made no such concessions to the subject matter. If anything, the personality of the artist, as evidenced by the surface manipulation of paint on canvas was always a very strong element in the creation of a painting. This concern for the sensuous quality of tactile values in paint may be traced back to the early 19th century and to the rediscovery of artists like Rembrandt and Velasquez. An English critic, George Moore, said of this: "In 1830 values came upon France like a religion. Rembrandt was the new Messiah, Holland was the Holy Land, and disciples were busy dispensing the propaganda in every studio." It was this reappraisal and rediscovery of the sensuous values of 17th century European painting that would provide the 19th century European artist with a powerful new tool—one that eventually revolutionized 19th century art.

No comparable development took place in America, where painting remained dedicated to the principles of luminism and realism through the third quarter of the century.

The term "impressionism" has a number of meanings. In the purely technical sense, impressionism is a technique in painting whereby the immediate sense impression of nature, as seen by the artist, is transferred to canvas or paper. The technique also favors the elimination of black as a pigment and relies upon the primary colors of red, yellow, and blue, together with their complements, orange, purple, and green. These colors, modified only by the mixture of white, are directly applied to the painting's surface. Seen from a distance, colors applied in this manner tend to fuse in the eye of the beholder, not only producing a great many more variations, but also representing the quality of light to a much more faithful degree than possible in more conventional forms of painting. Of course, most artists employed this manner of painting only partially. And, some who may be thought of as impressionists also, reverted to the use of black once more. A second definition of impressionism is thereby attained: impressionism may be a *manner* of painting rather than simply a technique. Impressionism, then, may be broadly seen as any style of painting that eliminates detail in favor of an overall, generalized treatment of subject matter.

Impressionism was an outgrowth of that strong tendency in 19th century art to abandon the ways of classicism in favor of a more painterly style. Its origins lie in the dispute between the classicist, Ingres, and the romanticist, Delacroix. And the road that eventually took Western art to impressionism and beyond can surely be traced through the forest at Barbizon, to the studios of the realist painters of Paris such as Gustave Courbet and Edouard Manet, culminating eventually in the sunlit fields of Giverny where Monet painted.

But the impact that impressionism had on Western art was born not out of theories about optics and color, but was a direct product of a continuing development of the school of realism. Impressionism was the inevitable outgrowth of striving for a realistic interpretation of the visible world. As Courbet and Manet endeavored in their time to break the hold on art that was maintained in the mid-19th century by the French Academy—with its insistence upon naturalistic, photographic exactitude about nature—so the impression-

ists, under the leadership of Pissarro and Monet, sought to advance realistic painting beyond description, per se, into a broader approach to nature. The English critic George Moore observed, "Impressionism penetrates all true painting and in its most modern sense, signifies the rapid noting of elusive appearance."

With the rediscovery of the 17th century Spanish painter Velasquez 19th century realist painters were given a powerful example from history. The realists noted, perhaps with a sense of triumph, that the Spanish master's paintings exhibited a certain impressionist point of view; that is, Velasquez (and, indeed, a great many 17th century masters) had painted in a manner which refuted the classicist tradition of the late 18th and early 19th century, a tradition upon which the French Academy of Fine Arts was securely founded.

Essentially, the classicists believed that the painter ought to reproduce as faithfully as possible all of the details of nature that his eye observed, one by one, and set down on paper or canvas. The realists, however, noted that this was not the way the eye actually saw. The dispute, then, between the classicist and the realist positions was a conceptual one: the classicist painter believed that he should paint what his *mind* knew to be, but the realist painted what his *eye* saw.

Impressionism's major break with tradition lay in its approach to painting; while for generations, artists had worked in their studios painting pictures from notes and color sketches made in preparation for the final product, the impressionist landscape painter often worked entirely outdoors. He aimed at achieving a spontaneous notation concerning the effects of light in a given situation at a specific time of day. For a time, impressionism was preoccupied with, as George Moore termed it, the "elusive appearance" of nature. It was this enchantment with the evanescent appearances of nature that led Monet to paint his *Impression—Sunrise* for the first group exhibition of 1874. It was from the title of Monet's painting that the Paris critic, Louis Leroy, first coined the title "impressionists" for the group of artists which included—besides Monet—Degas, Pissarro, Cézanne, Renoir, Sisley, and Morisot.

The growth of the movement in art called realism, and the subsequent developments of impressionism and later stylistic developments in the 19th century, were undoubtedly fostered by parallel developments in technology. The advent of photography as a serious medium of pictorial expression was first hinted at in 1839 when a realist painter named Louis Daguerre invented a mechanical way in which the appearances of the nature could be exactly reproduced on a two-dimensional surface. The Daguerreotype offered a mechanical aid to the artist in his note gathering; at the same time, it spelled the doom of other artists, principally those engaged in making portraits. Since the camera recorded all subjects with the utmost fidelity to accuracy and detail, its existence relieved the artist of his responsibility for naturalistic approaches to art. Thus the invention of the camera offered the artist a new avenue for his art. While the camera recorded everything in front of it unselectively and indiscriminately, the artist was at last free to embark upon an approach which was to be more and more a highly personal, idiosyncratic expression.

He was aided in that expression by the development in the 19th century of a great array of new colors. Whereas the artist had been restricted in previous centuries to colors based upon natrual earths (both organic materials and metals found abundantly in nature), advances in 19th century chemistry provided the artist with a great variety of low-cost artificial colors. For example, until 1826, an artist wishing to use a strong blue in his palette of colors was obliged to purchase a very expensive pigment made from ground-up lapis lazuli—a semiprecious mineral. In that year, 1826, a French chemist devised a means for manufacturing a substitute by combining a group of inexpensive, readily available elements. The result was a blue pigment of extraordinary intensity and beauty, which has come to be called French ultramarine. In like manner, 19th century chemistry produced new families of colors—reds and oranges with greater brilliance and intensity than had been available to artists before. Substitutes were also found for the dangerous toxic pigments, such as white lead and emerald green. All of these improvements, which so greatly benefited the artist, were products of the industrial development of the 19th century.

But none of these improvements in the quality of artists' pigments would have benefited the painter who preferred to work in the open landscape had it not been for the development of the collapsible metal tube. This seemingly simple, but essential invention was the product of an American painter named John G. Rand. Thus, the strong, new and cheap pigments contained within the collapsible tube enabled the artist to go out into the landscape; in a sense, impressionism owes as much to these developments as it does to the native genius of the artists who produced the movement.

French culture and fashion exerted a powerful hold upon America in the early 19th century; the manifestations of French art appear as frequent references in the writings of 19th century American journalists. The *American Monthly Magazine* noted in 1836 at least 1,385 artists in France, and innumerable art schools and museums. While many American writers took a superior tone, they were frequently

motivated by chauvinist pride, rather than by critical discernment. The same *American Monthly*, acknowledged in 1838 that, while the French nation "has a very few good painters and sculptors, the prospects for Art in France are not discouraging." But the real education of American taste in the 19th century—a taste for French art of the newer sort—came not from writers but from American artists.

One of the first important native talents to appreciate French art and to incorporate it into his own manner was William Morris Hunt. For a period of ten years, beginning in 1846, Hunt studied and worked in France. He studied in Paris under Thomas Couture and was a close friend of the then officially despised realist painter J. F. Millet. From time to time he sent paintings back to America for exhibition; his Barbizon painting manners proved to be too crude for mid-19th century America, however. Hunt believed in the necessity for realism in art: "You want a picture to seize you forcibly as if a man had seized you by the shoulder."

Indeed, the realist landscape and figure painters of Barbizon, in their advocacy of ordinary life as fit subject matter for painting, were shaking the foundations of official French art at mid-century. As Nieuwerkerke, the Imperial Director of Fine Arts of France, said, "This is the painting of democrats, of those who don't change their linen, who want to put themselves over on men of the world; this art displeases me and disgusts me." Returning to his native New England in 1856, William Hunt brought with him some examples of this despised "democratic painting." And so the Barbizon painters were to be seen in America for the first time; the seed was planted, though it was to lie dormant for some years to come. It would be some twenty years before American collectors began to abandon their taste for the hard, dry, meticulous naturalism of the leaders of the French Academy in favor of the realist painters of the Barbizon school and, eventually, of the impressionists.

At the very moment that Hunt was propagandizing for the Barbizon School in Boston, two young Americans were first discovering Paris. The older of the two, George Inness, had advanced his art through a succession of style changes that included his native American luminist tradition, through a solid grounding in the landscape tradition of Claude Lorraine and Poussin. But, after a brief trip to Paris and Barbizon in 1854, Inness abandoned all that he had known before, in favor of the romantic realism of the Barbizon School. Years later, he justified the many changes that his art had taken in a letter to a friend: "I have changed from the time I commenced because I have never completed my art and, as I do not care about being a cake, I shall remain dough subject to any impression which I am satisfied comes from the region of truth."

The paintings for which Inness was celebrated in his own time, and for which he has been given a permanent place in the history of American art, are true descendants of the Barbizon style. At the height of his fame, following his permanent move to Montclair, New Jersey, in 1878, he became the object of near adulation. The critic James Jackson Jarves, called him, "the Byron of our landscapists." And during his closing years, he was, to his contemporaries, the greatest landscape painter that America had ever produced. He was not kindly disposed to the painting of Monet and the other impressionists; he believed that they had given art over to purely physical response, that they had abandoned reason for feeling. In spite of this, the works from his later period reveal Inness to have been, ultimately, an impressionist painter. His quest for the elusive appearances of nature and his single-minded concern for light and atmosphere eliminate from his art the more sentimental aspects of the Barbizon School and place him among the impressionists.

James Whistler arrived in Paris in 1855, a year after Inness was there. Whistler, ten years younger than Inness, was attracted to the excitements of Paris rather than to the pastoral quiet of Barbizon which Inness preferred. As a child, Whistler had lived for a number of years abroad; his family had spent a few years in St. Petersburg, Russia, and he had also lived for a time in Paris and London. He had apparently attempted to follow his father's career in the Army, but a disastrous three years at West Point turned him toward another way of life. Given by nature a natural facility for drawing and possessed of an independent spirit, he found a career in art. He was drawn to Paris by reading a fictionalized account of artists' life in that city—Henri Murger's *Scenes of Bohemian Life*, serialized between 1845 and 1849.

Whistler arrived in Paris during the exhibition of the World's Fair of 1855. Paris was alive with the controversy raised by the exclusion of Courbet from the World's Fair exhibition. His art was, in Count Nieuwerkerke's phrase, "the painting of democrats." In defiance of official rejection, Courbet constructed his own exhibition hall just outside the fair grounds and called it the "Pavilion of Realism." Thus, Whistler found himself present at the birth of a revolution in art. The Barbizon painters had contented themselves with the peace and seclusion of Fontainebleau Forest. But the younger generation of realist painters, with Courbet and Manet at their head, took the struggle to the heart of the French art establishment in Paris.

In 1855, France was ruled by a dictatorship in the person of Napoleon III, the nephew of the first Napoleon. The Paris World's Fair of that year was created by Napoleon III to en-

hance the image of his empire; the officially approved styles of painting, which were generated by the Academy of Fine Arts, rigorously conformed to the tastes of the Emperor and his court. They favored subjects drawn from mythology and history, suffused with sentimentality—a style best described as "candy box."

This point of view and style in official French painting was maintained and furthered by a system of art education controlled by the government-sponsored Academy of Fine Arts. The Academy maintained a system of training, advancement, and rewards that was very much like a military system, as the historian John Rewald has noted. Under the aegis of the Academy, a number of the most prominent established artists maintained studios where they dispensed instruction.

Whistler selected the studio of Charles Gabriel Gleyre, probably because that painter offered the least interference with the work of his pupils. His distrust of color as an element in painting, and his preference for drawing made him an unlikely master for Whistler; he once remarked to a pupil, "Nature is all right as an element of study, but it offers no interest. Style, you see, is everything." Years later, in a letter to his friend, the French painter Fantin-Latour, Whistler expressed a great regret at having been so thoroughly seduced by realism and by color during his early years in Paris. He noted, "It is because that damned realism made an immediate appeal to my painter's vanity, sneering at old traditions, cried aloud to me with the assurance of ignorance: 'Long live nature!'"

Whistler regretted what he believed was a terrible deficiency in his ability to draw; yet, paradoxically, Whistler was one of the greatest etchers of all time. As early as the summer of 1858, he made a brilliant set of etchings, whose subjects were landscape scenes of northern France. Entitled the "French Set," these received the enthusiastic approval of such artists as Fantin-Latour and Carolus-Duran. After his first important painting, At the Piano, was rejected from the Paris Salon of 1859, Whistler moved to London where he would spend most of his professional life. There, he immediately set upon creating another series of etchings, called the "Thames Set." The delicacy of line and sophistication of the compositions of this set show that Whistler had become fully aware of the newly discovered art of the Japanese print, which was brought to his attention by his friend, the French painter Bracquemond.

Present also in his figure paintings of this period is the influence of the Pre-Raphaelite Brotherhood. This movement in English art, which originated some ten years before Whistler moved to London, stressed the flat, decorative elements of medieval art. Whistler was surely aware of the novelties of this revival movement and seems to have incorporated some of their ideas into his painting, The White Girl. About the time Whistler had completed this portrait, he formed a friendship with the leader of the Brotherhood, Dante Gabriel Rossetti.

But, as a portrait painter, Whistler owes more of a debt to Manet. Even when he painted a portrait of his friend Theodore Duret—who wrote The Impressionist Painters in 1878, the first book on the new movement—Whistler employed Manet's rather stark simplicity of composition and dark palette.

However, it is in his landscape paintings that Whistler makes his secure claim as an impressionist. For the most part, these landscapes are mood pictures, evoking the serenity of twilight and evening. Whistler often entitled these pictures "nocturnes," and they do create a poetic visual equivalent to the impressionist music of Debussy. The jewel-like color and the gentle poetry of his landscape paintings belie the essential character of Whistler; his flamboyant, eccentric personality and his outspoken opinions on all matters concerning art seem almost irreconcilable with the character of his painted creations.

Whistler was one of the most original and powerful artists of his time. He was not a teacher of artists, but through the example of his paintings, he left generations of disciples. Most young Americans who came in contact with him were profoundly affected. Homer D. Martin was one of the fortunate young American artists who came directly under Whistler's influence. Whistler's gentle, lyrical landscapes seemed to have inspired a new school of artists that E. P. Richardson has termed "painters of quietism." Among these, Dwight Tryon comes closest to the poetic charm of Whistler.

Tocqueville observed in the 19th century that no democracy ever produced great art. He was, of course, observing America and the genteel tradition that governed all matters concerning art and society. The native American luminist-realist tradition that grew out of the Hudson River School fostered an indigenous American art that was thoroughly conservative in its outlook. Whistler was but the first of a growing number of American artists who found the strictures of the native school too confining. In the era that followed the Civil War, when communications and travel were beginning to be opened up, the influences of Europe were imposing themselves upon the consciousness of the younger Americans.

It is doubtful, for example, if Mary Cassatt could have ever found room for expression and growth as an artist in her native Philadelphia. France, on the other hand, had a long history of permitting women to flourish as important

national artistic figures. Marie Vigée-Lebrun in the 18th century and Rosa Bonheur and Berthe Morisot in the 19th were all prominent in French painting. Mary Cassatt's own feelings about the propriety of women engaging as professionals may be judged by the fact that she exhibited at first under her middle name, Stevenson, concealing her true identity.

For several years after her return to Paris in 1883, Cassatt continued to follow the well-beaten path of conservative realism, dutifully submitting her pictures to the annual exhibitions of the Paris Salon. It can only be imagined with what temerity this well-bred young woman from a fashionable and conservative Philadelphia family threw herself into impressionism. She had come to admire the works of Edgar Degas. Although she was never at any time actually a student of Degas, her work most resembles that of the Frenchman. And it was through him that she was invited to exhibit with the third group exhibition of the impressionists, in 1877. Her best works are sensitive in color and strong in drawing, but an obsession with subject matter—mothers with their children—makes her late works seem repetitious.

Her influence upon the collecting tastes of certain influential Americans was an important part of her career. Following their meeting in Paris in 1873, Cassatt formed a lifelong friendship with Louisine Elder, who later became Mrs. H. O. Havemeyer. Cassatt advised her new friend on her first purchase, a Degas pastel; from this small beginning was to grow the collection that became eventually the Havemeyer Collection, now in The Metropolitan Museum of Art. And through the prestige of the Havemeyer family, other prominent Americans began to take interest in French impressionism. This taste would redound, eventually, upon American artists who also worked in the impressionist manner later in the 19th century and into the 20th century.

The triumvirate of the so-called "American expatriates" is completed with the name of John S. Sargent. In Sargent's case, the title is erroneous; he was born in Europe, lived there most of his life, and his tastes were cosmopolitan. His appearance in middle age was that of an Edwardian gentleman, and his worldly detachment was the source of enmity between himself and the impassioned critics of his art. Both Whistler and Cassatt seemed to have held him in fine scorn; Whistler once referred to him as "a sepulchre of propriety," and Cassatt once told her brother that he ought not to have a portrait by Sargent hanging in his house. Their criticism was well-founded; Sargent did represent the establishment in art, but there was another side to his creative abilities which went beyond the seemingly endless procession of portraits for which he is best known.

Early in his career as a student in Paris, Sargent came to admire the paintings of Monet. Although his career was being directed by his teacher Carolus-Duran toward financial security in the field of portrait painting, Sargent made his first important statement with a landscape painting, *The Oyster Gatherers of Cancale*. (This painting won him an honorable mention at the Paris Salon of 1878.) When the circumstances of his career obliged him to move from Paris to London in 1885, Sargent was forced to abandon portrait painting for a time and embarked upon an entirely new career as a landscape painter. During the summer of each year from 1885 until 1889, Sargent painted in the fields of rural Worcestershire. Evidence of Monet's influence is particularly strong during these years. It is to be seen, especially, in Sargent's informal handling of composition. Later, during the years in which he found himself a prisoner of his portrait commissions, Sargent periodically returned to the self-satisfying pleasures of painting from nature.

The light and color found in Sargent's landscape paintings is not vibrant and lyrical as in the French plein-air manner, however. More often, Sargent chose to paint the reflected light of nature, avoiding effects of direct sunlight. This oblique approach to impressionism provided him with additional difficulties, testing his abilities as an artist. As if to increase the challenge to his skill, Sargent turned to the watercolor medium after 1900 and made for himself a significant place in the history of watercolor painting.

Few artists can match Sargent's brilliant rendering of the surface phenomena of nature; if he does not seem to penetrate beneath those surfaces, neither do the great exponents of French impressionism. Impressionism is, after all, a feast for the eye; it appeals instinctively to man's delight in nature.

For Whistler, Cassatt, and Sargent, who spent most of their lives in Europe, there was no intellectual isolation comparable to that which other American artists, returning from their years of study abroad, found waiting for them at home. The supreme arbiter of taste in American art, the National Academy of Design in New York was a conservative counterpart of the French Academy of Fine Arts. Even as late as 1882, a writer for the *Nation*, one of the more liberal journals of its day, warned against "dangerous tendencies rapidly gaining ground in what is now called our new art movement."

Not to be dismissed by the elements of reaction, the young European-trained artists, under the leadership of William M. Chase, formed in 1877 a group known as the Society of American Artists. In the same year, the autonomy of the National Academy School of Art was chal-

lenged by a rival, the Art Students League. Dissident teachers from the Academy formed the faculty of the new League; both the instruction at the League and the exhibitions held by the Society of American Artists were dominated by the style of the Munich Academy—a somber, painterly realism. Chase gradually abandoned the Munich style; with artists like J. Alden Weir and John Twachtman, he helped bring the blond palette of impressionism into favor at the Art Students League.

The importation of the impressionist style by native American artists was, in many respects, self-defeating. Where impressionism did find favor with prominent American collectors, they wished to possess examples by French artists, not by Americans. On the other hand, the conservative collectors, who abounded, remained faithful to the old-fashioned schools of naturalism. Samuel Isham summed up the problem facing the young generation of American artists when he said in 1905, "When the younger men went abroad to study, painting was a lucrative profession; when they returned, they found it was not possible for a man to live by it, even if he were talented, well taught and hard working."

It is ironic that, at the very moment when America had produced sufficient numbers of men of great wealth to support a large artist population, the younger generation of artists found themselves virtually without support. The explanation lies in the character of the newly rich—those men who created their fortunes in the period following the Civil War. Tending to think of themselves as American royalty, they surrounded themselves with possessions that reflected European culture. And how much more secure they were, basking in the reflected glory of Renaissance art and old master paintings. The builders of their eclectic palaces scoured the past for architectural ideas; picture dealers ransacked impoverished European families for masterpieces for the walls of the private galleries of the great American houses.

Only a few fortunate artists found champions among the industrialists: Charles Freer of Detroit amassed a sizeable collection of the works of Whistler and Dwight Tryon, while Abbott Thayer and Thomas Dewing found patronage from John Gellatly of New York.

A profound sense of cultural inferiority gripped Americans during these years of the Gilded Age; Harvard's Professor Charles Eliot Norton proclaimed to his students that "even in America the shadows are vulgar," and the writer Henry James said, through one of his characters in a short story written in 1879, "The soil of American perception is a poor little barren artificial deposit." How inevitable it was, then, that most young American artists sojourned in France, where to be poor and a student of impressionist painting was no crime.

Fortunately for the cause of American art, there existed also in the final quarter of the 19th century a sense of public responsibility for culture, shared by certain influential civic leaders in the major cities of America. Around 1870, public museums were opened in Washington, New York, and Boston; and throughout the remainder of the century, city after city followed their example. The Centennial Exposition in Philadelphia in 1876, an event of profound significance for American arts and industry, included a special section devoted entirely to painting and sculpture. The Centennial inspired a series of subsequent expositions, all of which presented important exhibitions of fine arts. In the same era, artists' societies proliferated. Perhaps most significantly for the future, dealers began to establish galleries in New York and elsewhere.

While the National Academy of Design continued to exclude the new art from exhibitions in its elegant Venetian-Gothic building in New York City, the rebellious young artists, most of whom formed the Society of American Artists, found the dealers receptive to their work. From the time that the Society held its first exhibition at the Kurtz Gallery in 1878 until the momentous exhibition of "The Eight" at the Macbeth Gallery in 1908, the emerging talents of American painting found their greatest ally to be the dealer.

During the decade following the founding of the Society of American Artists, the beachhead of the impressionist invasion of America was being widened; partisan support was slowly gathered from men of prestige, such as John F. Weir, brother of J. Alden Weir. As an established member of the National Academy and a director of the Yale School of Fine Arts, he fervently defended the cause of the Paris-trained innovators. Published in 1882, his article "American Art: Its Progress and Prospects" advanced the idea that "our art will not be overturned by this new upheaval, though it may be greatly shaken by it."

During the decade of the 1880's, the leaders of American impressionism—Chase, Twachtman, Robinson, and Hassam—were moving constantly between America and Europe. The year 1886 was the critical turning point for impressionism in America, and it saw the capitulation of the conservative art establishment of the National Academy as well. For in that year, the French dealer, Paul Durand-Ruel, brought to New York a group of 300 paintings by Barbizon and impressionist painters.

The circumstances surrounding Durand-Ruel's extraordinary New York exhibition involved not only his financial difficulties in Paris, but also the interest of one of his artists, Mary Cassatt. Despite the tremendous energy with which

Durand-Ruel attempted to advance the cause of impressionist painting, his best efforts had met with little success. In 1882, besides acting as representative for a number of the impressionist artists in Paris, he also took an active part in the organization of the seventh group exhibition of impressionism. But the bank crash of that year and the bankruptcy of one of his associates imperiled his position, a condition which continued to worsen until, in 1884, he owed over one million francs to his creditors.

Mary Cassatt came to his aid as much as she was able, lending him money and arranging sales of his artists' works to her American friends. She had been elected to the Society of American Artists in 1880 and was active in their exhibitions. Undoubtedly through her good offices, an invitation arrived in Paris for Durand-Ruel from the American Art Association of New York. With nothing but disaster facing him at home, the dealer probably wished to risk everything on the chance that his fortunes might change abroad, and he began gathering the works for shipment to New York. His name was known in America through his handling of Barbizon pictures; the exposure of his impressionist canvases was, thus, cushioned from a shock by the older, more conservative paintings which he exhibited as well.

The reviews of the New York exhibition were mixed, but the overall reaction was generally favorable. A writer for *The Critic* even went so far as to say, "It is distinctly felt that the painters have worked with decided intention, that if they have neglected established rules it is because they have outgrown them, and that if they have ignored lesser truths, it has been in order to dwell more strongly on larger." Durand-Ruel's exhibition of French paintings was so popular that, when it was obliged to close at the galleries of the American Art Association on Jackson Square, the directors of the National Academy of Design were persuaded to provide gallery space for an extended run of the exhibit. This amounted to an official blessing, and impressionism would, henceforth, be given serious recognition in America.

Meanwhile in Paris, a few staunch members of the old impressionist group—reduced now to Degas, Pissarro, Morisot, and Seurat, with the addition of a newcomer, Gauguin—were holding the eighth and final group exhibition of the impressionists. So much dissension had grown up over the term "impressionist"(it had never really lost its pejorative implications) that the word was omitted intentionally from the poster of the Paris exhibition. Disputes among the artists themselves over theories and practices continued to plague French art in the latter half of the 19th century, much as it had in the beginning. In 1884, there was founded in Paris a new organization entitled "The Society of Independent Artists." Former companions in the struggle for the impressionist cause soon became enemies. Pointillism, a meticulous, doctrinaire form of impressionism, was once described by Gauguin as the work of "the little green scientists of the tiny dots." By 1890 in France, the issue in art was not that of schools but of individuals, each of whom championed various aspects of realism-impressionism, "art for art's sake," or plein-air.

Curiously, it was Gauguin who foresaw the fate of impressionism not only in France, but in America as well. He observed that the "impressionists studied color exclusively in terms of decorative effect but without freedom, for they kept the shackles of representation . . . they are the official painters of tomorrow." In America, the widespread acceptance of the impressionist idiom that followed in the wake of its triumph over the National Academy of Design in 1886 began to create a new academic mode, fulfilling Gauguin's prophecy.

In its early days, the Society of American Artists, struggling against the dead hand of naturalism that guided the course of the National Academy of Design, was a rallying point for many of the strongest talents in American art. One of these was Thomas Eakins, who joined the Society in 1880. By 1892, the pendulum had swung so far in the direction of impressionism that the Society rejected Eakins' painting *The Agnew Clinic* from an exhibition over which it was presiding. Clearly, the genteel tradition, which had formerly resided in traditional American luminist painting, had now been transmogrified into the body of the new impressionist manner. In his letter of resignation to the Society, Eakins put the matter squarely: "For the last three years, my paintings have been rejected by you, one of them the Agnew portrait, a composition more important than any I have ever seen on your walls. Rejection for three years eliminates all elements of chance, and while in my opinion there are qualities in my work which entitle it to rank with the best in your Society, your Society's opinion must be that it ranks below much that I consider frivolous and superficial. These opinions are irreconcilable."

In spite of his precise, academic manner of painting, Eakins never subscribed to the genteel tradition. His forthright views of American life—such as the operating room subject of *The Agnew Clinic*—were searching, and sometimes disturbing, penetrations into the human condition. The years between the Civil War and the First World War were confident ones for Americans; faith in material progress and prosperity could be found mirrored in almost every aspect of American life during this era. Where Eakins rejected the rampant materialism of his time, and was

shunned by the leaders of industry and society who might have otherwise commissioned portraits from him, the age demanded more glamorous and superficial images.

The art of portraiture was ably served by a large number of gifted painters; Sargent was the giant among them, but working in the immense shadow of his fame were a number of extremely able artists. Sargent's bravura style, with its slashing brushwork and incisive drawing, was freely adapted even by artists nominally of the impressionist persuasion, such as Joseph De Camp, Frank W. Benson, and Edmund Tarbell.

Human institutions, like the people who create them, tend to atrophy unless they are constantly reinvigorated. In 1826 the National Academy of Design had been a rebellious youth, born out of discontent with the older American Academy. In its 50th year, it too spawned its own group of dissident rebels. While one of these, The Art Students League, continued to reinvigorate itself from decade to decade, the Society of American Artists so far lost sight of its original goals that, by the turn of the century, it returned to the fold of the National Academy. Largely in reaction to the inevitable demise of the Society, a group of Boston and New York artists formed a new association which they called "Ten American Painters." The "Ten" espoused no novel or controversial movement; its members were bound together by a common faith in the impressionist mode. And by the time of its founding in 1898, the "Ten" represented no threat to the conservatism of the National Academy; the group really was little more than a fraternity of the most distinguished of American impressionist painters of their time. The three Boston members—Benson, De Camp, Tarbell—were known primarily for their portraits. Willard Metcalf, Robert Reid, John Twachtman, and J. Alden Weir were principally landscape painters. Childe Hassam, whose style most closely resembled the flickering color of French impressionism, often concerned himself with scenes of city life. Thomas Dewing devoted his entire career to figure painting; and the last member of the group, Edward Simmons, made his major contribution as a mural painter.

The field of mural painting was opened to American artists quite spontaneously in the final decade of the 19th century. It was prompted by the proliferation of public and private building in most of the major American cities. The prominent New York firm of McKim, Meade, and White regarded their architecture as a collaborative process with artists providing the necessary decoration; their new building for the Boston Public Library called for the participation of artists whose work was in sympathy with the eclectic Renaissance style of the library's design. The World's Co-lumbian Exposition, held in Chicago in 1893, was the occasion for the greatest accumulation of eclectic classical and Renaissance buildings ever to be gathered in one place in America. This tendency in American architecture brought forth a profusion of new opportunities for American artists. Some members of the "Ten," principally Robert Reid and Edward Simmons, devoted a great portion of their careers to mural painting. Their works may be seen from Boston to Washington, in public buildings such as the State House and the Library of Congress as well as in hotel buildings. Impressionism as a technique does not readily lend itself to the uses of mural painting, and Reid and Simmons modified their styles to accommodate the requirement for strong pattern that was imposed by the architectural space in which they worked.

Faith in material prosperity and the benefits accruing from it characterized American life at the turn of the century. Rather than addressing themselves to the problems of reality, the artists of the Gilded Era seemed all too willing to reflect the genteel sentiments of the upper classes for whom they worked. Abbott Thayer's pseudo-Renaissance angels, dressed in white with wings attached to their shoulders, seem quite as appropriate to the esthetics of the Gilded Era as do the madonnas with children of George de Forest Brush. A few landscape paintings attest to Thayer's considerable talents as an artist in this genre, making one wish that he had been able to free himself from the conventions of his time. In like manner, Joseph De Camp busied himself as a portrait painter, emerging only occasionally to show glimpses of his considerable abilities as a landscape artist.

As a group that came to represent the dominant Academy of American Art at the turn of the century, the "Ten" exerted a mixed influence; the innocuous charm of Benson or De Camp was more than outweighed by the sensitive colorism of Hassam, Twachtman, and Weir. When Twachtman died in 1902, the "Ten" were reinforced by the considerable presence of William Chase.

The influence of both Chase and Hassam as teachers was evident during the 1890's: Chase at Shinnecock, Long Island, and Hassam at Old Lyme, Connecticut. Under Hassam, the shoreline of Connecticut became a kind of Giverny of America. Those who benefited by an association with Hassam included Charles Davis, Walter Griffin, and Guy Wiggins. The latter founded his own school at Essex, Connecticut, and so carried on the impressionist tradition, as handed down by Hassam, into the middle of the 20th century.

In France, Monet, already a living legend, did not discourage artists from seeking him out at his retreat at Giverny. Theodore Robinson, who died at a tragically young

age before his art could mature, owed much to Monet's guidance. Other students, like Theodore Butler, became devoted disciples, enthralled by Monet's powerful personality and style. Frederick Frieseke, on the other hand, developed his own impressionist idiom, characterized by a penchant for bold design and astringent color.

If impressionism ran like a fever through the blood of American culture in the period around the turn of the century, it did not go unopposed. Andrew Carnegie—the industrialist millionaire who insisted that learning, writing, the arts, and public benevolence were really his goal in life—as early as 1886 fulminated in the *North American Review*, expressing his, "heartfelt regret that this new art society is far too much French." And the novelist William Dean Howells pleaded for a "democratic art," one that would ". . . front the everyday world and catch the charm of its workworn, careworn, brave, kindly face, need not fear the encounter, though it seems terrible to the sort nurtured in the superstition of the romantic, the bizarre, the heroic, the distinguished, as the things along worthy of painting or carving or writing. The arts must become democratic, and then we shall have the expression of America in art."

The leadership of this "democratic art" was taken up by Robert Henri, who said, "what is necessary for art in America is first an appreciation of the great ideas native to the country and then the achievement of masterly freedom in expressing them." Henri's principal contribution to American art was in his teaching and his inspiration to a group of younger men who formed "The Eight." Its original nucleus consisted of a group of newspaper illustrators: John Sloan, William Glackens, George Luks, and Everett Shinn. These four, with Henri as their leader, were joined eventually by Ernest Lawson and Maurice Prendergast, both of whom brought a vigorous reworking of impressionist ideas to the group. The eighth member, Arthur B. Davies, a painter of idyllic visions and dreams, lent his strong personality and organizational genius to the new association.

Reacting to the continued intransigence of the National Academy of Design, whose jury had rejected the work of Luks, Sloan, and Glackens from its 1907 exhibition, "The Eight" was born. Their exhibition, organized by Davies, was held at William Macbeth's gallery, which had been founded in New York in 1892 as the first picture dealer's gallery devoted to contemporary American art. In their choice of subject matter, the painters of "The Eight" asserted the importance of American life and daily experience as their thematic material. Of John Sloan, whose work represents the most significant achievement of the group, Lloyd Goodrich commented that, "his art had the quality of being a direct product of the common life, absolutely authentic and unsweetened, that has marked the finest genre of all times."

Henri and his friends had made two distinct breaks with the past: namely, the break with the dominance of European traditions and a break with dependence upon organized societies of art. When in 1910 he participated in the Exhibition of Independent Artists, Henri wrote, "If an institution were formed and I were to become a member of it, I would probably be the first man to secede from it, because I can see no advantage to art in the existence of art societies."

Henri's call for independence and individualism in art was expressed with even greater force when the "Armory Show" opened in New York in 1913. Drawn from the work of the most advanced artists in America and Europe, this exhibition opened the door for the modernist movement in America. It offered the opportunity for American artists to compare their work with the most advanced being produced in Europe. Critical lines were more sharply drawn in 1913 than they had been in 1886 on the occasion of Durand-Ruel's exhibition; and the critics themselves—largely of a conservative persuasion—had grown more potent and influential. Royal Cortissoz, dean of the critics of his time, unleashed his considerable invective against some of the more radical, as he saw them, European artists: Cézanne was a "complaisant ignoramus," Van Gogh a "crazy incompetent," and Picasso "a man whose unadulterated cheek resembled that of Barnum."

From 1913 onward, there was to be no turning back for American art into the comfortable sanctuaries of the established academies of painting. Although the public itself was largely hostile to modern art, the growing number of dealers in modern art in New York—such as Alfred Steiglitz—was a portent of the future. Henri was right: the art of the future would be made by men who were individuals, standing alone, and as individuals, responding powerfully to the visual stimuli of nature and life.

A generation of Americans had been fascinated by the surface brilliance of French impressionism; Hassam and his fellow members of the "Ten American Artists" had remained loyal to its charms and mannerisms while Monet and his generation in France had already passed into history. The younger men of the new realist persuasion—particularly Bellows, Glackens, and Sloan—borrowed freely from impressionism, adapting the best of it to their own purposes. The early works of each of these artists bears the unmistakable stamp of the best of the impressionist tradition—awareness of the tactile value of paint, informality of composition, and frequently vibrant color.

The foundations of academic impressionism and realism were severely shaken by "The Eight" and the revolutionary

event of The Armory Show, but such forms of academism were not to be extinguished by the momentous changes taking place in American art during the first decades of the 20th century. The innovations being made by the new realists, the post-impressionists, and the abstractionists found little immediate public support. Writers for the popular journals of the day, such as *American Magazine of Art*, were frequently given to fulsome praise for the qualities of serenity and dignity to be found in the works of such traditional painters as Benson and Redfield, admiring them for their deliberate avoidance of anything unpleasant in their work.

The First World War ended the dream of a rational world, and anarchy lay waiting in the wings. In an uncertain world, conservatism in American life became the controlling passion. The exhibitions of old, established institutions like the National Academy of Design and the Pennsylvania Academy of Fine Arts were dominated by the painters of a bland impressionism and a kind of patriotic regionalism.

Implied, too, in this retreat from the present to a more secure past was the phenomenon of the summer artists' colony, where the harsh realities of the 20th century could be temporarily forgotten amid the pleasures of a more or less rustic existence. Provincetown on Cape Cod, Woodstock in the Catskills, and New Hope in rural Pennsylvania drew summer populations of artists who wished to escape city life. In the period between the two World Wars, New Hope served as the locus of the American impressionist landscape tradition. Here was nurtured a brief dynasty of American artists, beginning with Edward Redfield who imparted to his student, Daniel Garber, all that he had to know about the impressionist view of the American landscape. Although Redfield survived him by many years, it was given to Garber to reinvest the impressionist idiom with poetry. In Garber's mature works, there exists a masterful dissolution of form in light and a certain monumentality of composition that distinguishes the best of French impressionism.

Color Plates

To the end of his days, Inness denied any connection between his art and impressionism. He once wrote, "Long before I ever heard of impressionism I had settled to my mind the underlying law of what may properly be called an impression of nature, and I felt satisfied that whatever is painted truly according to any idea of unity will, as it is perfectly done, posses both the subjective sentiment—the poetry of nature—and the objective fact sufficiently to give the commonest mind a feeling of satisfaction and through that satisfaction elevate to an idea higher than its own."

Inness's development as an artist may be traced from his early years when his work resembled closely that of the Hudson River School painters, to his early maturity when he was influenced by European painting—first by that of Claude and Poussin—and finally, to his mature years which reflect the art of Barbizon. Although many of the works for which he is celebrated partake of the dark palette of Barbizon and dwell on the elegiac mood of sunset scenes of nature, Inness's late works reveal an interest in dissolving subject matter into the veils of translucent color.

The mood of melancholy reverie in *Gray Day, Goochland,* a kind of tonal painting, is reinforced by a glimpse of subject matter—the ruined remains of a plantation house, indicated by the forlorn chimney stack and the indistinct figures wandering through the landscape. The composition is dominated by the budding trees of spring, which symbolize the eternal resurgence of life. Symbolic values are central to Inness's paintings, for he steadfastly refused to see art as a purely visceral experience: he saw his art as that which "consists not of thought alone or of feeling alone but of both, the compound being will and understandingly."

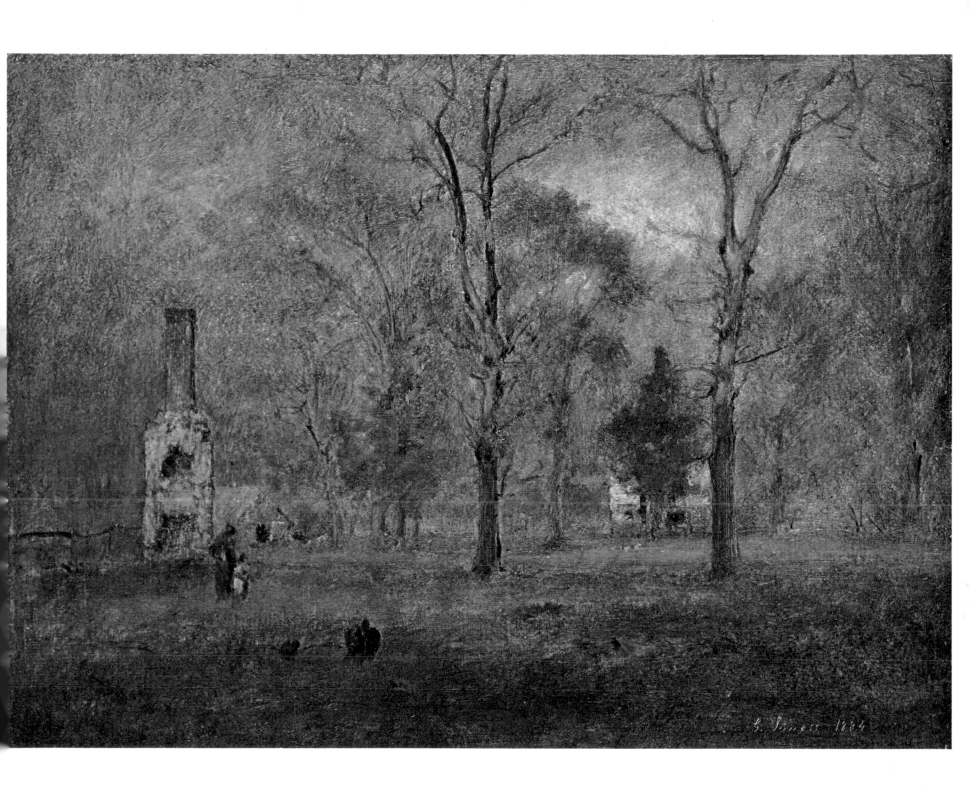

Plate 2
JAMES McNEILL WHISTLER (1834–1903)
The White Girl, Symphony in White Number 1, 1861–62
Oil on canvas, 84½″ x 42½″ (213.3 cm. x 107.9 cm.)
The National Galley of Art, Harris Whittemore Collection

Whistler painted *The White Girl*, a portrait of his mistress, Joanna Heffernan, in the winter of 1861; it was promptly rejected by the Royal Academy to which Whistler had submitted the painting for inclusion in the spring exhibition the following year. The painting reveals much about Whistler's precocious talent for invention; there are intimations in it of Manet's bold design and subtle references to the languid sensuality of the Pre-Raphaelitism of Rosetti. Whistler later sub-titled the painting *Symphony in White Number 1*, following the hostile reception that it was accorded in Paris in 1863.

That year more than 4,000 works were refused from the official Salon, and because of the ensuing general uproar, the French Government created the now-famous Salon des Refusées. Along with the other artists whose works had been turned down—Manet, Pissarro, Fantin- Latour, and Cezanne—Whistler shared in the withering abuse heaped upon the exhibition by the press.

One critic described *The White Girl* as representing "a powerful female with red hair, and a vacant stare in her soulless eyes. She is standing on a wolf-skin hearth rug—for what reason is unrecorded." But Whistler's reasons were not literary, as the crowd demanded, but purely pictorial. His desire to create an art based on color relationships and composition, enlivened by brushstroke technique expressive of his individual force, allied him with Manet and the others. Whistler's spiritual link with modern French painting was publicly acknowledged the same year when his friend Fantin-Latour painted him along with Manet and other friends in a picture entitled *Hommage A Delacroix*.

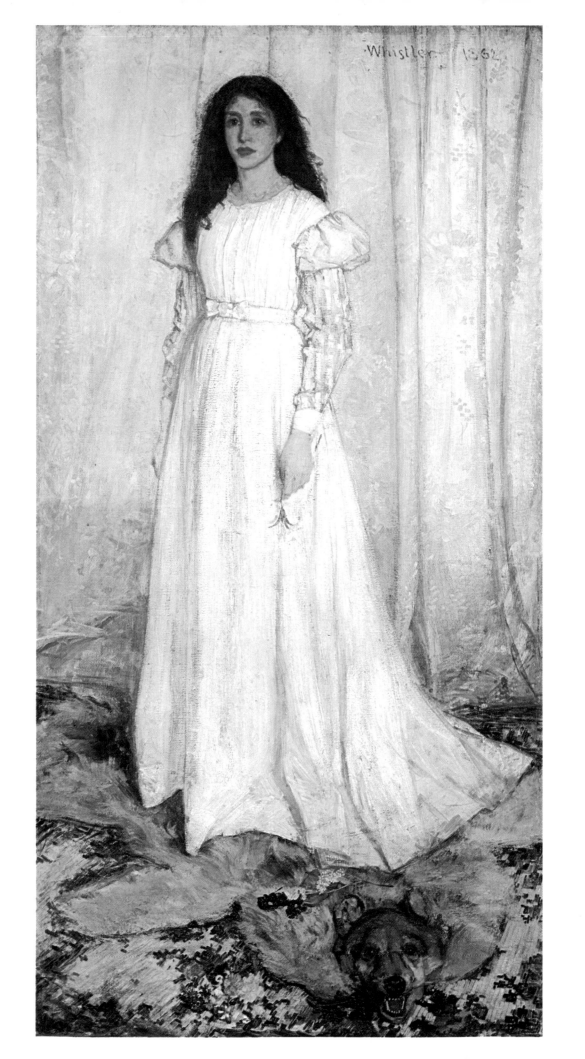

Plate 3
JAMES McNEILL WHISTLER (1834–1903)
Nocturne in Black and Gold: The Falling Rocket,ca. 1874
Oil on wood panel, 24¾" x 18⅜" (60.3 cm. x 46.6 cm.)
Detroit Institute of Arts, The Dexter M. Ferry, Jr. Fund

By the 1870's, Whistler had begun a gradual transition in his art from figurative to essentially abstract paintings. Even in his portraits of this decade, there is to be seen an increasing simplification of composition, as well as explicit references to dominant thematic values: his portrait of the writer Thomas Carlyle he titled *Arrangement in Gray and Black Number 2*, and the famous portrait of his mother received the same designation, being known as Number 1 in the series. While both of these portraits were conceived as bold, flat patterns, their subjects were plainly recognizable. As early as 1867, he had repudiated Courbet's realism as an obvious and easy solution to the problem of painting, when, in a letter to his friend Fantin-Latour, Whistler observed that he ". . . had only to open his eyes and paint what happened to be before him, beautiful nature and the whole mess. It was just that! . . . canvases produced by a spoiled child swollen with the vanity of being able to show painters splendid gifts, qualities that required only a strict training to make their possessor a master. . . ."

His determination to avoid facile and obvious solutions to the problems of landscape painting led Whistler away from objective reality into subjective mood. His inspiration for painting *Nocturne in Black and Gold* was a display of fireworks in London's Cremorne Gardens, but the actual scene provided him with merely a starting point for an adventure in tonal poetry.

This nocturne is the first deliberately abstract painting in the history of modern Western art. It so completely departed from the conventions of its time that the most eminent critic of English art, John Ruskin, publicly denounced Whistler as a fraudulent artist. Writing in the influential journal *Fors Clavigera*, Ruskin said, "I have seen, and heard, much of Cockney impudence before now; but never expected to hear a coxcomb ask 200 guineas for flinging a pot of paint in the public's face."

Whistler sued Ruskin for libel. The matter was brought to trial in London 1878, and in the proceedings Whistler was called upon to explain why he chose to paint such a picture. Asked for a definition of the word "nocturne," Whistler replied, "I have, perhaps, meant rather to indicate an artistic interest alone in the work, divesting the picture from any outside sort of interest which might have been otherwise attached to it. It is an arrangement of line, form, and color first; and I make use of any incident of it which shall bring about a symmetrical result."

The painter Albert Moore added his testimony to the proceedings saying, ". . . Whistler's works have a large aim not often followed. People abroad charge us with finishing our pictures too much. In the qualities aimed at I say he has succeeded, as no living painter, I believe, could succeed in the same way in the same qualities. I consider his pictures to be beautiful works of art. There is one extraordinary thing about them, and that is, that he has painted the air. . . ."

Whistler succeeded in winning his libel suit against Ruskin; he had won his right to paint whatever he pleased and to offer it for sale. But it cost him dearly—Whistler was forced into bankruptcy to pay court costs for his action.

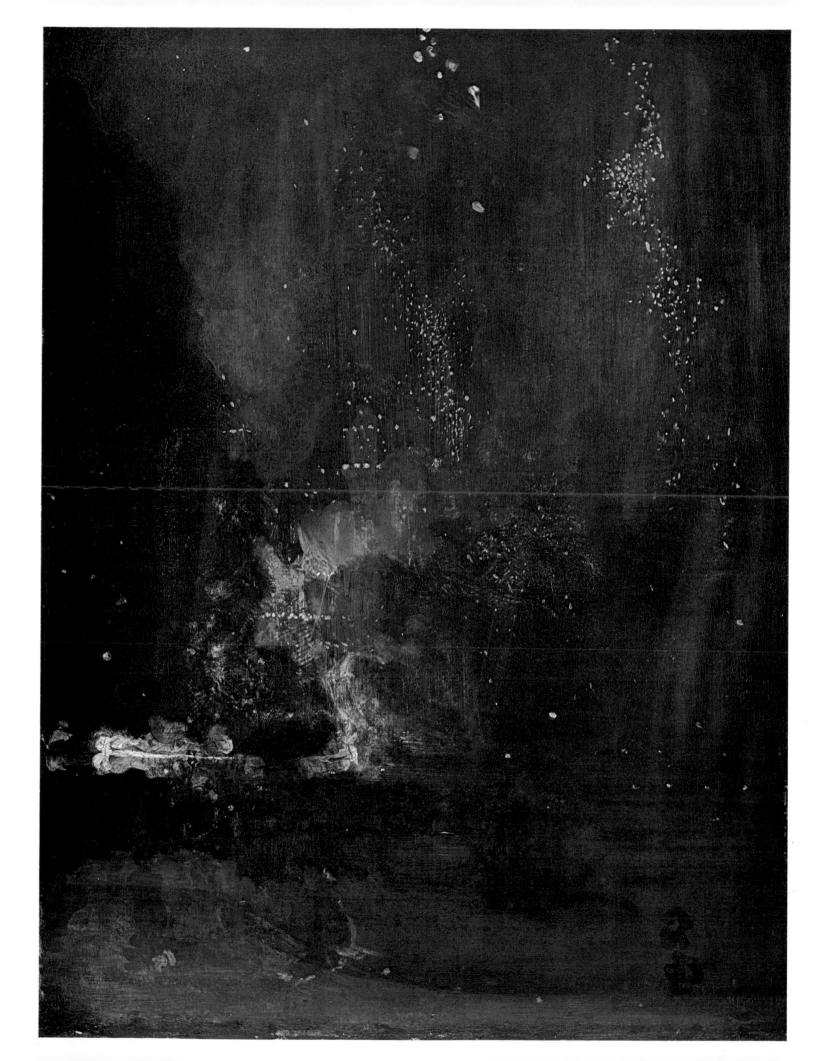

Plate 4
JAMES McNEILL WHISTLER (1834–1903)
Note in Blue and Opal: The Sun Cloud, before 1884
Oil on wood panel, 4⅞" x 8½" (12.4 cm. x 21.7 cm.)
Freer Gallery of Art, Smithsonian Institution

As Whistler rejected Courbet's realism, with its deep space and solidly modeled objects, he began to simplify his representation of landscape. While the nocturnes represent nature as seen through a veil, Whistler painted his sunlit landscapes as if they were composed of horizontal strips of alternating color. There is very little depth in any of them, and certainly, no attention to detail of the objects represented. Whistler was rarely interested in the light of nature, and he never presents forms modeled by sunlight and shadow. These are impressionist paintings to the extent that they have been distilled by his thought, rather than having been analyzed by his eye, as one might see a landscape from the window of a fast-moving train.

Note in Blue and Opal offers a minimum of reference to the visual world: it is only through the acceptance of well-defined conventions that the viewer accepts this to be, actually, the representation of nature. The strip of green, punctuated by angular forms, becomes a field and houses; the larger area of pale blue, with its irregular masses of gray and white, becomes sky.

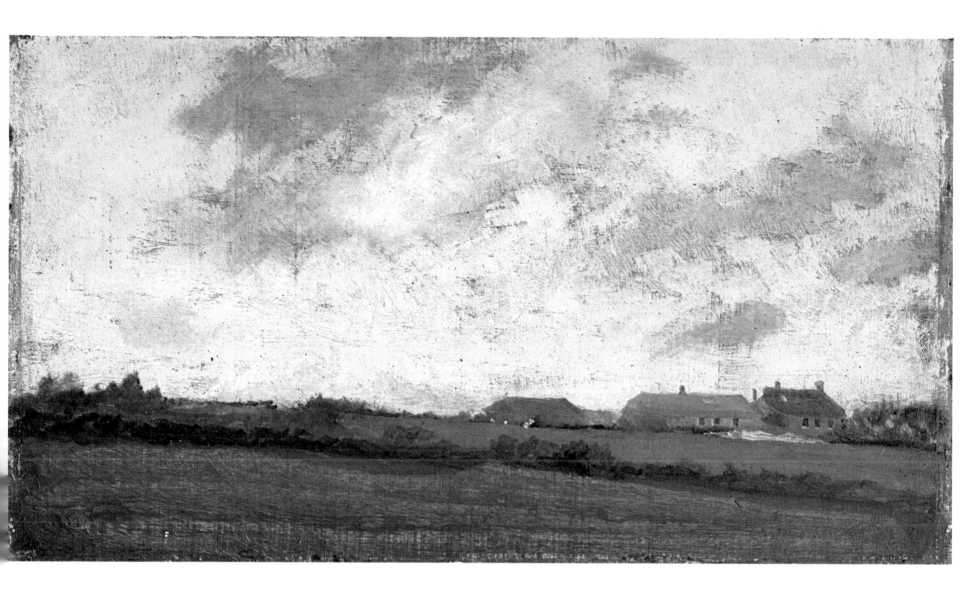

Homer Martin has been called "a painter of grave purpose and serious imaginings." While his approach to the art of painting may reflect his admiration for Whistler, with whom he made a lasting friendship in 1876 during a trip to England, it is more probable that a physical defect—an impaired optic nerve—contributed not only to his working habits but also to the result of his art. Because of his impaired eyesight, it became Martin's habit to study nature through half-closed eyes, making mental notes of the scene before him rather than on paper. Martin's very personal manner of painting combined his awareness of impressionist color with his own special technique of painting: he frequently used the palette knife to work his heavily applied colors together in a way that produced a more solid appearance of form than the impressionists were given to.

His apparent distortions of nature, with his high-keyed—yet somber—color sense, made his pictures unpopular. As Charles Caffin noted, "Without early education, and despite a desultory appreciation of good literature and a taste for music, unregulated by any sort of intellectual discipline,

he remained in a very special and unusual way a child of nature; subject to variableness of mood, reckless of consequences." Perhaps because of his inability to intellectualize, Martin was able to become thoroughly, and emotionally, involved in the moods of nature.

In his last years, Martin's art was guided by pure instinct; by 1890 his health had been completely broken, and he painted nearly without the aid of his eyesight. Only an indomitable will carried him forward. When nearly blind, he could say, "I have learned to paint at last. If I were completely blind now and knew where the colors were on my palette, I could express myself." *Harp of the Winds*, painted in 1895, is a picture of the artist's memory of his beloved France.

As an expression of his imagination, Martin preferred the *Harp* title; but fearing that this might seem too sentimental (he had a horror of painting anything that might be suspected of a literary motive), he changed that title to *View on the Seine*. After Martin's death, his paintings became appreciated and the more poetic title was restored.

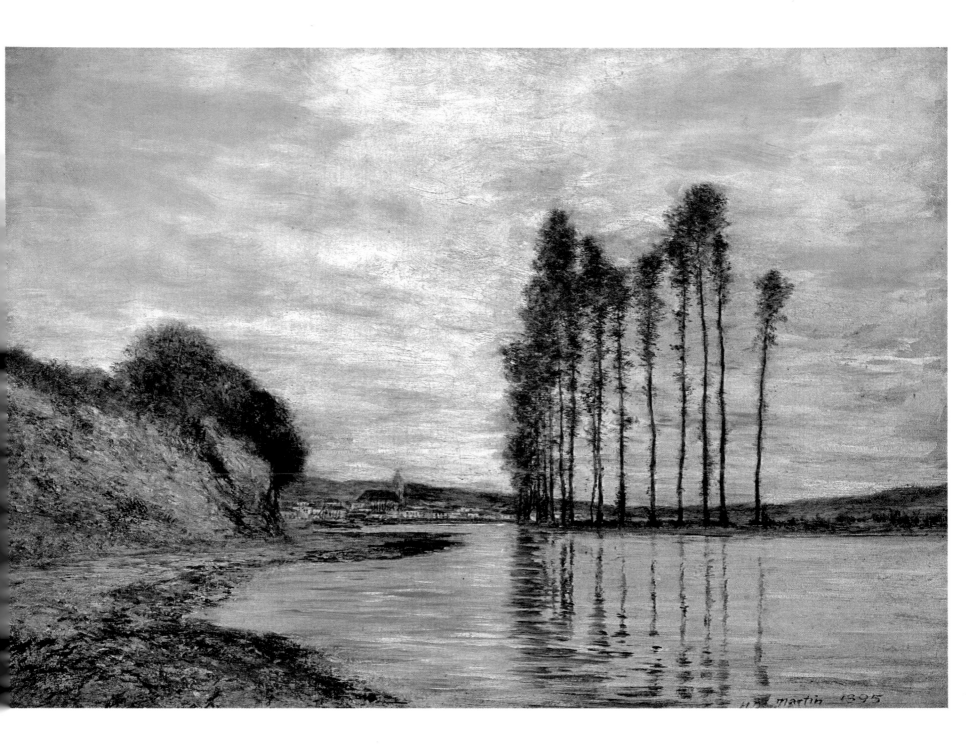

H. Martin 1895

Plate 6
MARY STEVENSON CASSATT (1844-1926)
Young Girl Reading, 1876
Oil on wood 13⅝" x 10½" 13⅝" (34.6 cm. x 26.7 cm.)
Museum of Fine Arts, Boston, Bequest of John T. Spaulding

By the time Mary Cassatt arrived in Paris in 1866, she had already accomplished several years of diligent study in drawing at the Pennsylvania Academy of the Fine Arts. Her early years in Europe were marked by an enthusiasm for the paintings of Frans Hals and Rubens; and by 1872, when she exhibited her first picture in the Paris Salon, her painting demonstrated a solid grasp of form.

Although Cassatt was the nominal student of Benjamin Constant, she evidenced no desire to continue in the conservative routines of her teacher. Ten years before, Manet had demonstrated that his art could be invigorated by a return to a study of the 17th century Spanish masters Velasquez and Ribera. Cassatt's choice of subject matter for her first Salon entry was picturesquely Spanish and was painted in a solid, precise realism that was aimed at pleasing the conservative jury. By the next year, 1873, Cassatt had met Louisine Elder (later to become Mrs. H. O. Havemeyer) and advised her new friend on the purchase of a Degas pastel. This purchase was a symbolic act in her own development as an artist; for, from this time forward, her work began to advance in the direction of impressionism and away from the academic realism of her student days. (She seems to have admired Degas from a distance, allow-

ing her art to be subtly influenced by his work, and Degas had seen her picture in an exhibition as early as 1874.) As her work departed from the expected conservative norms maintained by the juries of the Paris Salons, Cassatt found it increasingly difficult to be accepted by those juries.

The delightfully informal *Young Girl Reading,* identified as a portrait of her friend Mrs. Duffee, is a reflection of the comfortable, upper-middle-class milieu that was Cassatt's life style in Paris, even as a student. The work suggests an awareness of 18th century French art, particularly that of Fragonard, while in point of technique (simultaneously drawing and modeling with the brush in color) it is a modern concept. The darkened background suggests that Cassatt conceded to the stereotype demanded by the Salon jury of 1876—she had, in fact, repainted the background of another portrait that had been rejected the previous year for just this reason. But Cassatt had never been comfortable following academic conventions, and after her rejection by the Salon jury in 1877, she joined the impressionist group at the invitation of Edgar Degas. As she explained later, "I accepted with delight . . . at last I could work in complete independence. . . ." She exhibited for the first time with the impressionists in 1879, at the fourth group exhibition.

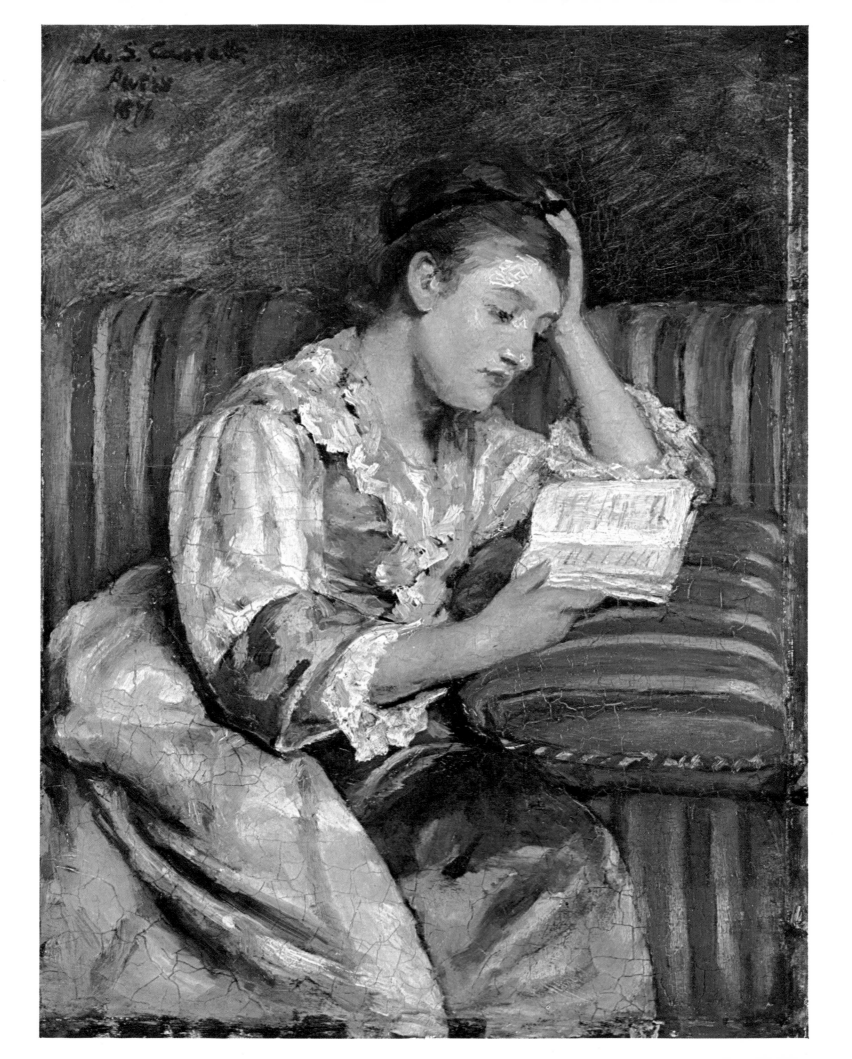

Plate 7
MARY STEVENSON CASSATT (1844-1926)
Lydia Working at a Tapestry Frame, ca. 1881
Oil on canvas, 25¾" x 36¼" (65.5 cm. x 92.0 cm.)
Flint Institute of Arts

By 1881, the date probable for the creation of this brilliant oil sketch, Mary Cassatt had transformed her art completely, a change that was hinted at in her portrait of Mrs. Duffee. She had never at any time been a real pupil of Degas, but she was always influenced by his work. She shared with him a cool intellectualism and possessed the same elegant and disciplined mind of the true draftsman.

Mary Cassatt's first picture exhibited with the impressionists, at the fourth group exhibition of 1879, was a portrait of her sister Lydia, and during the brief years before Lydia's untimely death in 1882, the sister posed for many pictures. (Her mother, Mrs. Robert Cassatt, and her sister Lydia had come to Paris to live in 1877.)

This flashing oil study of Lydia working at a tapestry frame seems especially imbued with the spirit of Degas. As Degas said of Cassatt, "She is someone who feels as I do." But it is her feeling for subject matter, rather than a similar manner of execution that invests Cassatt's work with an essentially French style. In point of color, this picture is a very personal, and in many ways, a very daring statement. It departs from the usual impressionist concern for light and develops the somewhat strident but jewellike notes of pink and blue through nervously charged passages of brushwork. The subject matter is one that Degas would have admired, but Cassatt added to such scenes of domestic genre a kind of sentiment and a crispness of feeling which are distinctly hers.

By the turn of the century, she began to focus almost exclusively upon the subject of mothers with their children; the settings for these portraits become relatively unimportant, and we miss the inventive compositional devices that so greatly enhance her earlier pictures, particularly those created under the influence of Degas.

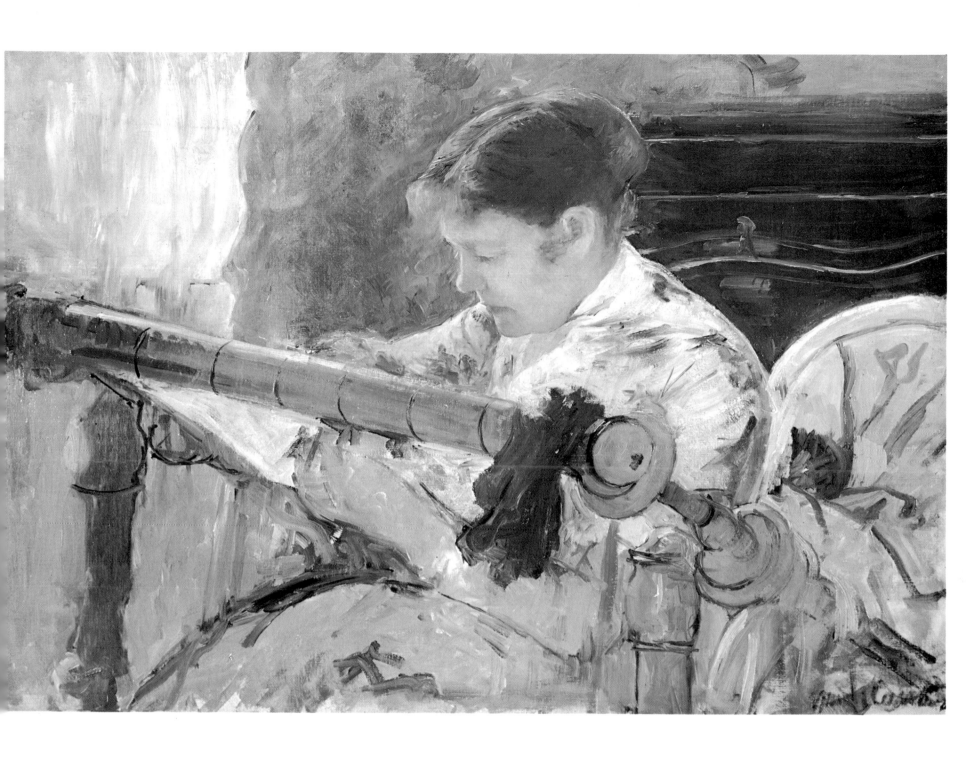

Plate 8
MARY STEVENSON CASSATT (1844-1926)
Lady at the Tea Table, 1885
Oil on canvas, 29" x 24" (73.6 cm. x 61.0 cm.)
The Metropolitan Museum of Art, Gift of Miss Mary Cassatt

In 1882, a dispute erupted among the original members of the impressionist group in Paris concerning the formation of the seventh group exhibition. The issue was over the continued presence of a protégé of Degas, named Raffaelli. Gauguin, with the encouragement of some of the organizers like Gustave Caillebotte, insisted upon Raffaelli's exclusion. As a result, Degas himself refused to participate in the exhibition. Out of a sense of loyalty to her friend, Mary Cassatt declined to exhibit as well. Having previously abandoned the Paris Salon, she was thus left temporarily without a place to exhibit.

From about this time, her work began to reveal a growing awareness of Japanese art, and she began to experiment with new approaches to painting. *Lady at the Tea Table*, a portrait of her mother's cousin, Mrs. Robert Riddle, represents a turning point in her career. It is conceived as an arrangement in flat pattern and color, with very little modeling, and conveys great visual impact.

Perhaps it was too advanced for the purpose Cassatt wished the painting to serve. Mrs. Riddle's daughter had sent the Cassatt family a tea service as a present and Mary Cassatt offered to paint the portrait as a gesture of appreciation. As Mrs. Cassatt wrote in a letter, "The picture is nearly done but Mary is waiting for a very handsome Louis XVI frame to be cut down to suit before showing it . . . I don't know what the results will be . . . both Degas and Raffaelli said it was 'La distinction même.' "

In spite of the obligatory inclusion of the export porcelain tea service, which is given somewhat too much emphasis, the sitter was not pleased with the portrait, and it remained for years in Cassatt's Paris studio-apartment. Despite its failure to please an old lady who, as Mrs. Cassatt noted, "is not very artistic," the portrait was a serious effort requiring over two years to complete. In 1914, at the end of her painting days and nearly blind, Cassatt permitted the portrait to emerge from storage at the insistence of her old friend Louisine Havemeyer. Recognizing its merits once more, and the important place it occupied as a turning point in her career, Mary Cassatt presented it to The Metropolitan Museum of Art.

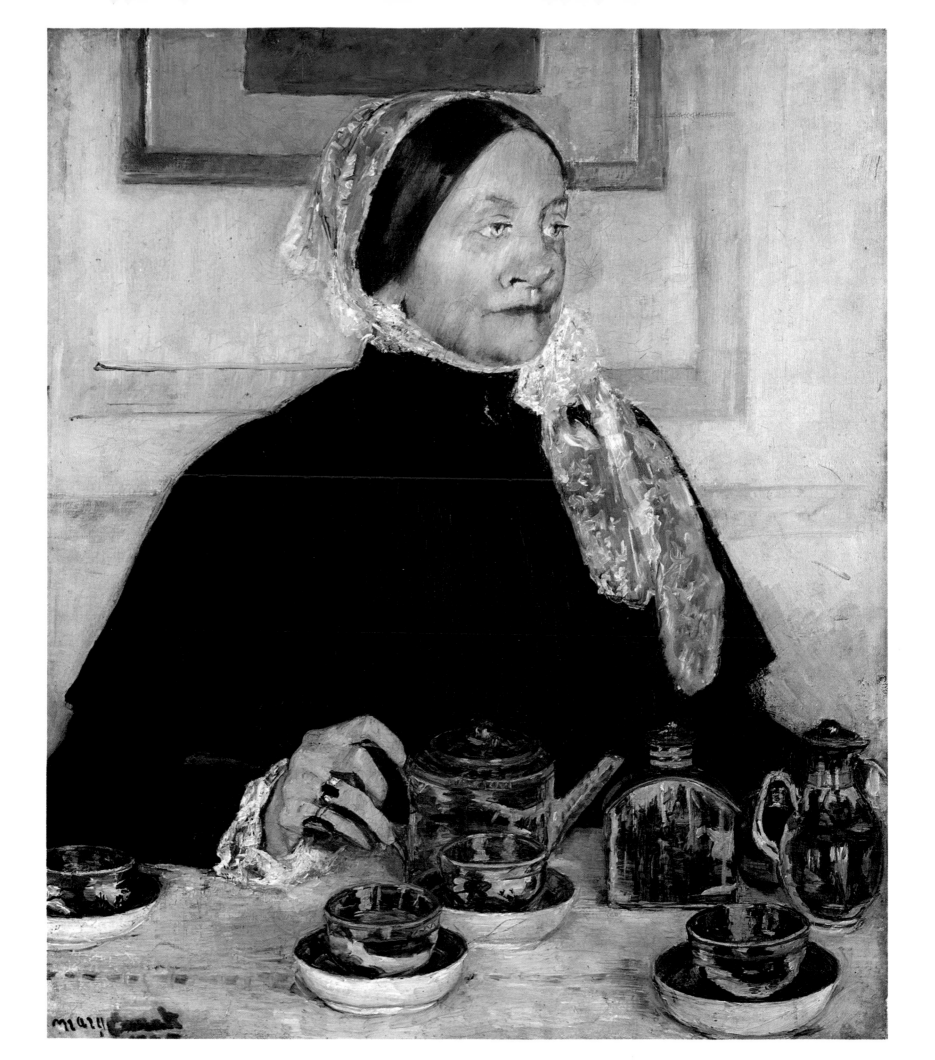

Plate 9
MARY STEVENSON CASSATT (1844-1926)
The Bath, ca. 1892
Oil on canvas, 39" x 26" (99.0 cm. x 66.0 cm.)
The Art Institute of Chicago

In 1890 Cassatt saw and was greatly influenced by an exhibition of Japanese prints that was held at the Ecole Nationale des Beaux-Arts in Paris. She had been encouraged to look at Japanese prints by Degas, whose own work had been shaped by the Japanese influence to a certain extent as early as the 1860's.

The beginnings of the Japanese influence in French art may be traced back to 1852, when the etcher Felix Bracquemond discovered a small volume of the woodblock prints of the Japanese artist Hokusai. These little compositions offered an entirely novel approach to the planning of pictorial space, employing an exaggerated and unscientific perspective and frequently placing the center of interest in a composition to one side rather than at the center, as was customary in European art. Novel also were the linear and decorative qualities of Japanese art. In the 1860's, several artists experimented with ideas gained from this new enthusiasm; James Whistler painted his mistress Jo as an Oriental princess in 1865, and Manet painted a portrait of the writer Zola, seated amidst a great profusion of reminders of the Japanese.

For many artists, the Japanese influence was only superficial; they appreciated the exotic costumes and the decorative elements of Japanese culture without really incorporating the design innovations of Japanese art into their own work. Degas, on the other hand, eschewed the obvious aspects of Japanese art but adapted its underlying principles to his own special vision of the world. His scenes of ballet dancers practicing or women bathing in the privacy of their own apartments—genre of a most poetic sort—employ daring foreshortenings of space and form, with a subtle use of line that reveals his indebtedness to Japanese art.

As a protégé of Degas, Mary Cassatt was inevitably led in this direction. Her art was also enhanced by a profound admiration for Persian miniature paintings, with their emphasis upon lyrical, decorative line and flat, rich color. Cassatt brought all of these influences to bear upon a set of ten color prints made in 1891. Employing drypoint, aquatint, and sometimes soft ground etching, she created a set of prints whose subject matter is the intimate world of women.

The same decorative line and color in the ten color prints of 1891 is to be seen in subsequent paintings, such as *The Bath*. The subject matter—a mother and her child—is a theme which concerned Cassatt for the rest of her life. While her preoccupation with this subject may stem from the fact that she never married and had no children, she was, undoubtedly, also aware of the work of the illustrator of children's books Kate Greenaway, whose works were extremely popular in France at this time.

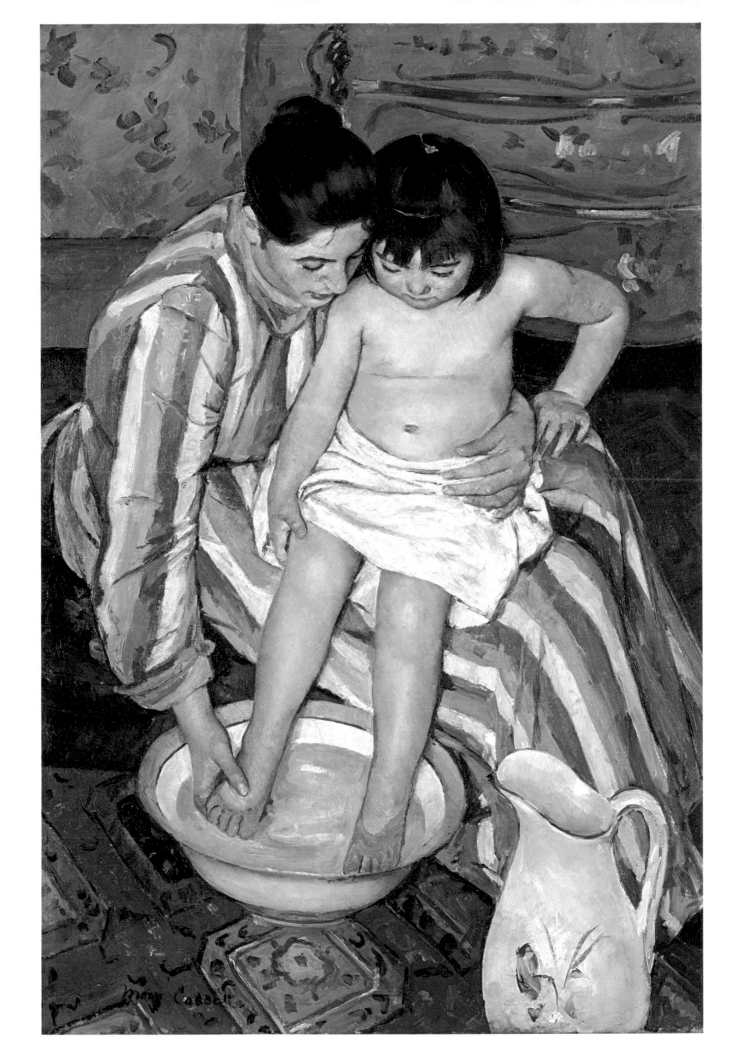

Plate 10
WILLIAM MERRITT CHASE (1849-1916)
Sunlight and Shadow, 1884
Oil on canvas, 65½" x 77¾" (166.3 cm, x 197.5 cm.)
Joslyn Art Museum

Chase's early training at the Royal Academy in Munich in 1872 and his subsequent study with the realist painter Frank Duveneck seem an unlikely preparation for a career as an impressionist painter. The heavy, dark realism of the Munich School found an ardent follower in Chase, and he became famous in the United States for his still lifes and portraits painted in that rich, heavily charged impasto of the Munich manner. By the late 1870's he was already enjoying a successful career as a teacher at The Art Students League of New York, where his style of painting had already earned him comparisons with the old masters of the 17th century.

Chase's ideas about the nature of realist painting began to change in 1881 with a trip to Spain, where he admired and studied the paintings of Velasquez. Manet had called the Spanish master "the painter of painters," and Chase, in his own time, came to appreciate that realism, as he learned it at Munich, could be approached in a way that was less dependent on heavy tonalities and more inclined to pure color. He observed that Velasquez frequently built up his forms from skeins or layers of overlying color, rather than broad applications of a few tones. Annual trips to Spain, France, and Holland during the early 1880's brought Chase into closer contact with the new colorism emerging in European painting. By this time, Chase was a respected member of that formidable group, the artists of the Tenth Street Studios in New York, and his European trips were always made in company of some of the members of this group.

Sunlight and Shadow, one of his earliest and most successful attempts in the direction of impressionism, was painted in Zandvoort, Holland, where he had gone with the painter Robert Blum in the summer of 1884. The painting includes a portrait of his friend Blum and an unidentified lady in a hammock—Chase's biographer asserts that a secondary title exists for this picture, *The Tiff*—but, in spite of the moody, pensive figures represented, the subject of the painting is really the effects of dappled sunlight on broadly painted figures and objects in the composition. There is at once a delicacy of color and a strength in the realization of this picture that illuminates Chase's successful marrying of the new colorism to a strength of drawing and composition that was rooted in his earlier years as a realist painter.

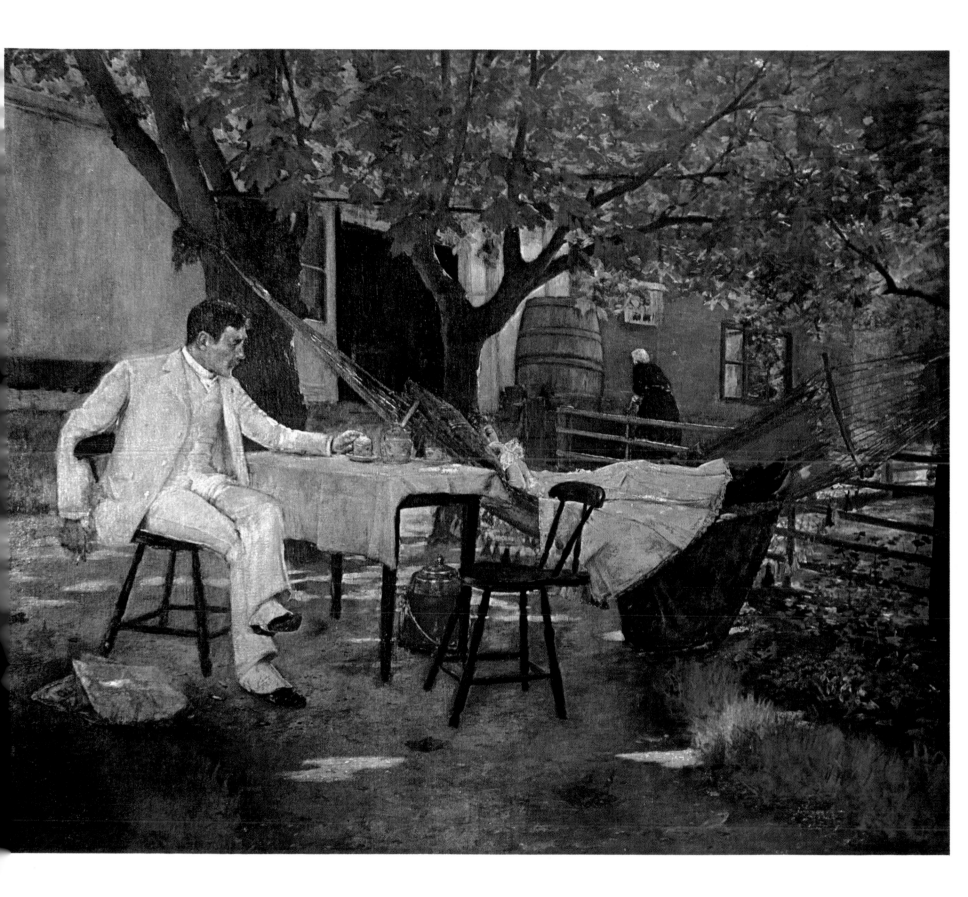

Plate 11
WILLIAM MERRITT CHASE (1849-1916)
Hide and Seek, 1888
Oil on canvas, 27½" x 36" (69.8 cm. x 91.4 cm.)
The Phillips Collection

Chase arrived in London in 1885, bearing a letter of introduction to the illustrious James Whistler. Recalling the event some years later, he wrote, "I hastened to his studio on King Street, determined not to beard the lion in his den, but at least to salute him . . . Most callers waited at Whistler's door in those days, and few were admitted. The door opened guardedly, and a dapper little man appeared and eyed me keenly . . . Our camaraderie began at once. For some reason he dubbed me 'Colonel' and in a moment we were chatting like old friends."

While Chase was not given to the same kind of eccentricities for which Whistler had become notorious, Chase was fond of the grand gesture and personal elegance in his life style. His personal habits of dress—finely tailored morning coats, elaborate and colorfully brocaded waist coats, and immaculate linen set off his distinguished Van Dyck beard and his ever-present pince-nez with its flowing black ribbon—marked Chase as a kindred spirit of the "Butterfly," as Whistler called himself. As Chase observed of him, "few men were as fascinating to know."

The full impact of Whistler's impressionistic tonalism surfaced in Chase's art some three years later in the painting *Hide and Seek.* The scene is a room in Chase's house on West 4th Street in Greenwich Village, New York; and the little girls represented are the daughters of the poet Joaquin Miller. While there are suggestions in this picture that Chase had studied the paintings of the Dutch little masters—particularly De Hoogh and Vermeer—*Hide and Seek* owes its inspiration to the "arrangements" of Whistler. The pictorial space is divided into relationships of rectangles, and against these are played the irregular shapes of the little girls. It is a magnificent study in contrasts; solid object against void, brilliant highlights against darkness, textures against solid mass.

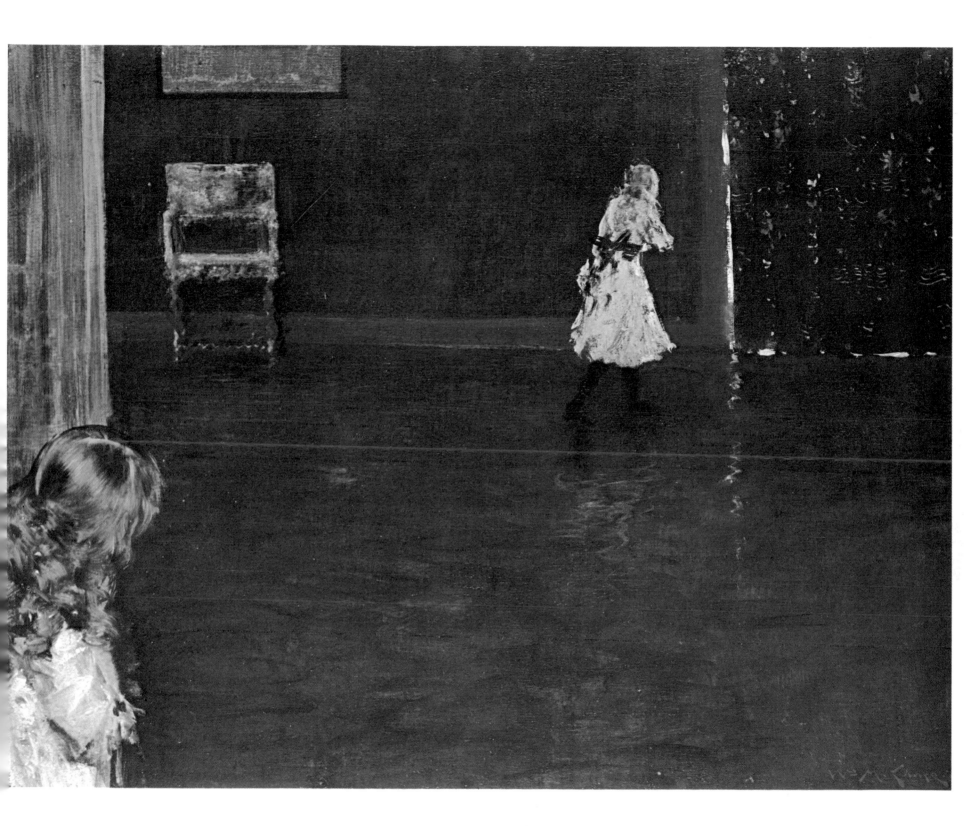

Plate 12
WILLIAM MERRITT CHASE (1849-1916)
A Friendly Call, 1895
Oil on canvas, 30¼" x 48¼" (76.8 cm. x 122.5 cm.)
The National Gallery of Art, Chester Dale Collection

Chase entered the final decade of the 19th century resplendent in honors awarded by art societies in the United States and by medals won in competitions abroad. He was President of the Society of American Artists, a member of the prestigious National Academy of Design, and most importantly, he was generally regarded as one of the most successful teachers in America.

Chase enjoyed life enormously; he was one of the central figures in that large fraternity of artists and architects which graced New York and which was one of the chief ornaments of American culture in this period. He indulged a passionate taste for collecting beautiful paintings and rare objects, and with these he filled his townhouse in New York on Stuyvesant Square and a summer home, built for him by the architects McKim, Meade, and White, at Shinnecock, Long Island.

Nevertheless, in an era that strove to achieve effects of overwhelming clutter in interior spaces, Chase's view of a corner of one of the rooms in his Stuyvesant Square house, seen in *A Friendly Call*, seems austere by comparison. By 1895, the date of this painting, Chase had experienced financial difficulty and had sold off a large part of his collection. What remained of it—the small drawings, watercolors, large mirror and a few wall hangings—probably contributed to the feeling of restraint in decoration that is obvious in this painting.

It is obvious, also, that Chase wished to explore again the compositional possibilities of flat "arrangements." Pictorial space is here divided into three main components: the floor, the banquette, and the wall. Further divisions occur within these areas, so that one does not realize at first that Chase has neatly split his composition in half. The mysterious lady in white in her half of the room is a kind of mirror image to the right half, a notion that is reinforced by the inclusion of an actual mirror in the picture, a device which recalls Chase's admiration for Velasquez's masterpiece *Las Meninas*. Despite its apparent profusion of rich colors, the painting achieves a cohesion through the pervasive, but subtle, influence of ochres and related warm colors. In spite of its complexities of organization, *A Friendly Call* achieves a spontaneity—the very moment in time—that was the aim of the impressionist painters.

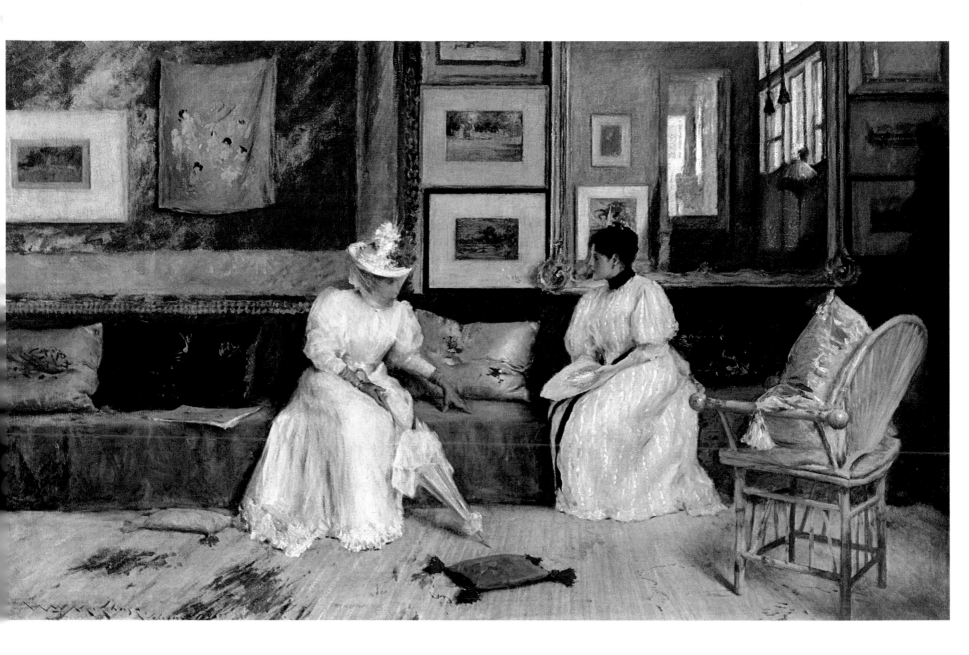

The impressionist movement in painting had won a convert in Chase as early as 1881, when, on his trip to Paris that year, he had met and persuaded J. Alden Weir to purchase two paintings by Manet for an American collection. Chase was instrumental in organizing an exhibition in New York in 1883, a fund-raising venture for the purpose of creating a pedestal for the new Statue of Liberty. Appropriately, Chase favored French artists—particularly the Barbizon painters and a large sampling of the new impressionist painters. And by 1891, when he accepted an invitation to establish an art school at Shinnecock, Long Island, his interest in plein-air impressionism was already established.

This Art Village, as it came to be known, was the first organized school in America in which painting was taught to students in the open air. Chase's working habits ideally suited him to be a teacher of impressionism: he frequently advised students, ". . . take as much time as you wish. Take two hours to finish that painting if necessary."

Chase was as much in love with painting as he was with Europe; he once said, "I would rather go to Europe than go to Heaven." And, indeed, his paintings of the Shinnecock shoreline might just as well have been made on the coast of Brittany, for in Chase's art there is no place, only time and light. Especially in his landscape paintings, he conveys a sense of joy in his feeling for light and color that breathes life into his paintings and makes them viable importations of French impressionism.

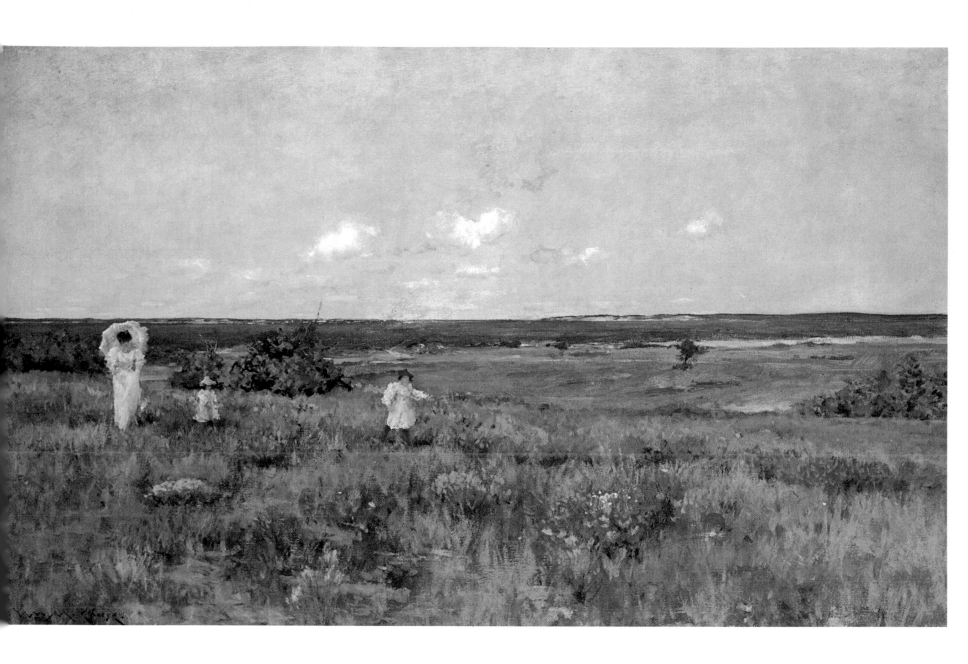

Plate 14
WILLIAM MERRITT CHASE (1849-1916)
Interior: Young Woman at a Table, ca. 1897
Pastel on paper, 22″ x 28″ (55.8 cm. x 71.1 cm.)
The Joseph H. Hirshhorn Collection

The technique of painting in pastel is an ancient one; its history can be traced back as far as the 16th century when Jacopo Bassano and Federigo Barocci were notable practitioners. But the pastel medium has been most closely associated with French art, particularly since the 18th century when it achieved a more painterly and uniform appearance in the hands of Latour and Chardin. In the early 19th century, Delacroix and Millet revived the medium. In the latter half of the 19th century, pastel was embraced by the impressionist artists, and the medium was elevated to a place of importance beside oil painting. The most prolific artist in the medium was Edgar Degas, but others—principally Renoir, Toulouse-Lautrec, and Vuillard—adapted it to their own particular styles and subject matter with great effect. Of the American artists, Whistler, Cassatt, Chase, and Hassam employed pastel with distinction.

Pastel, a dry, powdered-pigment medium, manufactured in the form of chalk sticks, was ideally suited to the uses of impressionist artists: it lent itself to rapid sketching techniques, and it required no drying time. Its major defect was fragility—it could be damaged easily since the powdered pigment rested on the surface of the paper and was not bound to it.

Chase's interest in pastel may be dated from 1881, following his return to the United States from Paris when he became a member of the American Society of Painters in Pastel. Chase used pastel with great freedom; his rapid studies are little more than line drawings in color. However, for finished works, he was capable of using pastel in a way that resembles his oil technique.

In this interior subject, he balances the figure's delicate mass of flickering color against the heavier, nearly monochrome passage of the stairs at the left. Chase has achieved a daring composition by placing the principal subject so extremely far off center that the picture is nearly divided in half. The design reminds one of the occult balance of Japanese art and carries intimations, as well, of Whistler's "arrangements." The artist has unified this difficult schema by employing a secondary axis, a sequence of brightly colored passages that passes diagonally left to right through the picture. The setting is the opposite side of the room shown in *A Friendly Call*, where this area appears in the mirror.

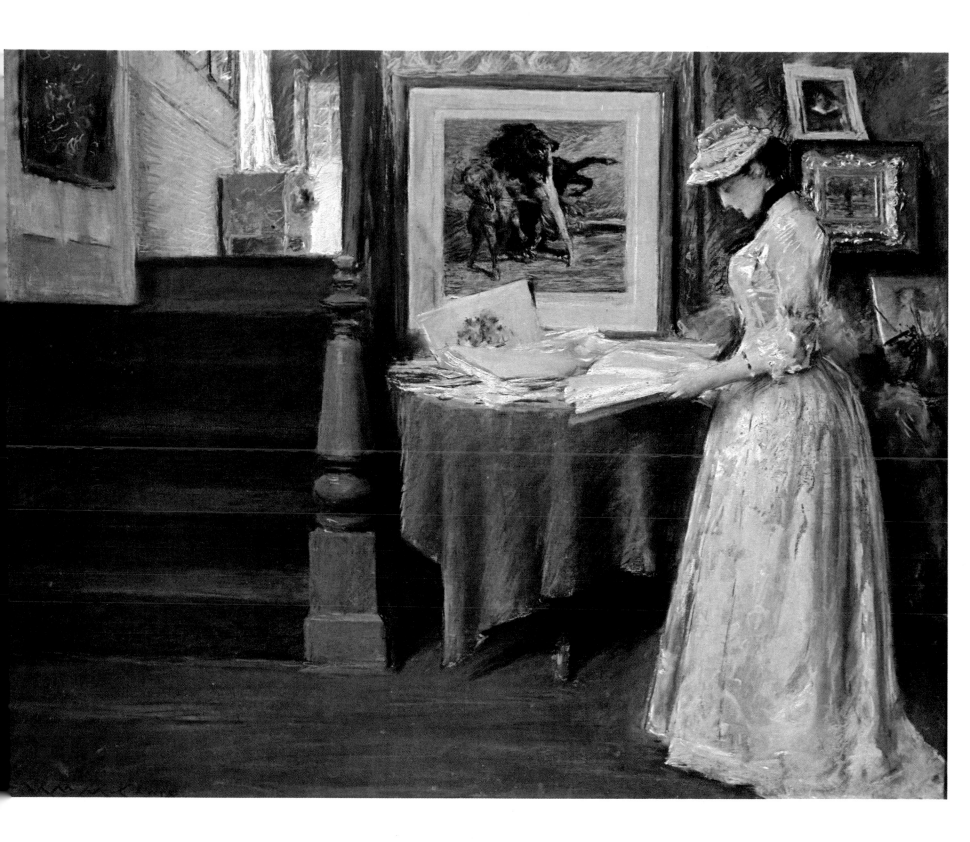

Plate 15
THEODORE ROBINSON (1852-1896)
The Vale of Arconville, ca. 1888
Oil on canvas, 18⅛″ x 22″ (46.3 cm. x 55.8 cm.)
The Art Institute of Chicago, The Friends of American Art Collection

One of the most promising American talents ever to embrace impressionism was Theodore Robinson. He died tragically early—he was only forty-four years old—but he created an extraordinary number of paintings during his brief life. While he made his first trip to Paris in 1876, there is no indication that he took any notice of the impressionists, who were having their second group exhibition at that time.

Like many young American students of his generation who sought to advance themselves as artists in the French capital—Mary Cassatt and Alden Weir were among them—Robinson sought instruction from the most famous academic realists of the day. He first entered the studio of Carolus-Duran, where John Sargent was also a pupil. Carolus-Duran taught a rather modern, direct approach to painting, that was somewhat related to the style of Manet. Robinson's departure for the more academic class of Gérôme indicates that the young artist's preferences still lay with the tight realism of traditional American painting. His summers, until his return to America in 1879, were spent painting landscapes in and around the village of Grez, on the edge of the forest of Fontainebleau where a colony of American artists were working under the influence of the Barbizon School. Just prior to his return, Robinson spent some time in Venice, where he met James Whistler, from whom he may have gained his first impetus toward impressionsim. Until his return to France in the spring of 1884, Robinson worked principally in New York and Boston as a teacher and as an assistant to John La Farge in mural decoration. Having thus accumulated sufficient funds, he re-

turned once again to his principal occupation, landscape painting.

Like many of his contemporaries, the struggling, impoverished young artist found France a more congenial place to live and work than his native America. And the intimate, more orderly landscape of France also lent itself more readily to painting. The turning point in his art came in 1887 when Robinson visited Giverny for the first time and met Claude Monet. The American spent his days there painting and spent his evenings discussing art with Monet and his family.

Robinson said that Monet's paintings were "... overwhelming and—as often—gave me the blues—the envious blues. They are so vibrant and full of things, yet at a little distance broad tranquil masses are all one sees. They are not spotty or unquiet."

Monet had helped to awaken an impulse that probably was always within Robinson; the young American was a spiritual disciple, not an imitator, and he established a tonal poetry in his work that was at both distinct and personal. Robinson's color is soft, his brushstroke at once tentative and tender, and the mood of his paintings is wistful, if not melancholy. This sense of color, so opposite to Monet's opulent colorism is present even in an early picture such as *Vale of Arconville.* Robinson had a horror of "sweet" paintings, as he noted in his diary: "I have a horrible fear that my work pleases women and sentimental people too much...." But there is a suggestion of sentimentality in the inclusion of a figure in this picture—that of his friend Marie—a rare note in his otherwise dispassionate landscapes.

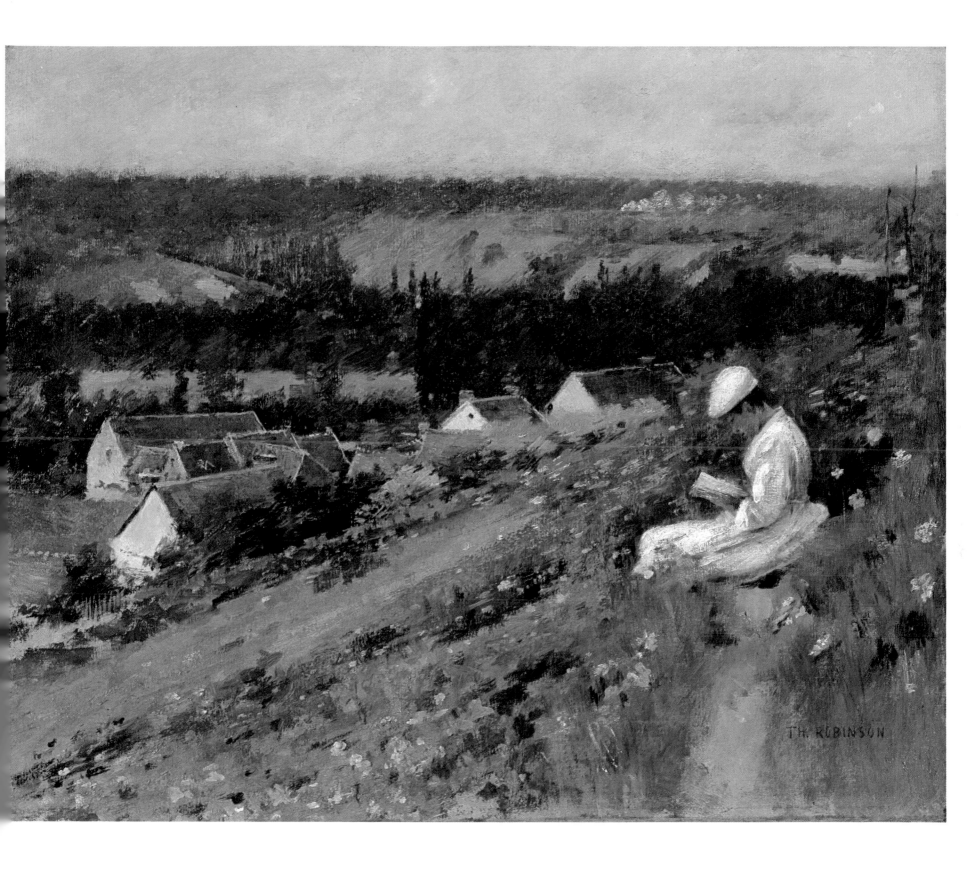

Plate 16
THEODORE ROBINSON (1852-1896)
Bird's Eye View: Giverny, France, 1889
Oil on canvas, 26" x 32¼" (66.0 cm. x 81.9 cm.)
The Metropolitan Museum of Art, Gift of George A. Hearn

In spite of his close association with Monet, Robinson always maintained that he had never been a pupil of the French painter. His conversion to impressionism was not made without difficulty, for Robinson ever attempted to join his native American realist tendencies with the visual realism of impressionism. These two factors are at work in the Giverny landscape, where an impulse to create panoramic description is modified by the softening blur of impressionist color. Robinson's characteristic diagonal brushstroke alternates in direction, defining the sequential progression of pictorial space. He was, paradoxically, distrustful of the impressionist potential for the dissolution of form in color: "Altogether the possibilities are very great for the moderns, but they must draw without ceasing or they will 'get left,' and with the brilliancy and light of real out-doors—combine the austerity, the sobriety, that has always characterized good painting."

For Robinson, like most American artists who embraced impressionism, was guided by traditions of American art; mainly, a linear style and realistic representation. Impressionism, for American artists, had not the same quality of revolution as that obtained with French artists. Rather, it was an adaptation to realism that marked American impressionism.

So successful was Robinson at this that in the spring of 1890, following his return to America, he received the Webb Prize at the annual exhibition of the Society of American Artists for "the best landscape in the exhibition." Robinson struck a happy balance between the plein-air painting of advanced French art and his own native open air tradition, as practiced by the established realists Winslow Homer and Eastman Johnson.

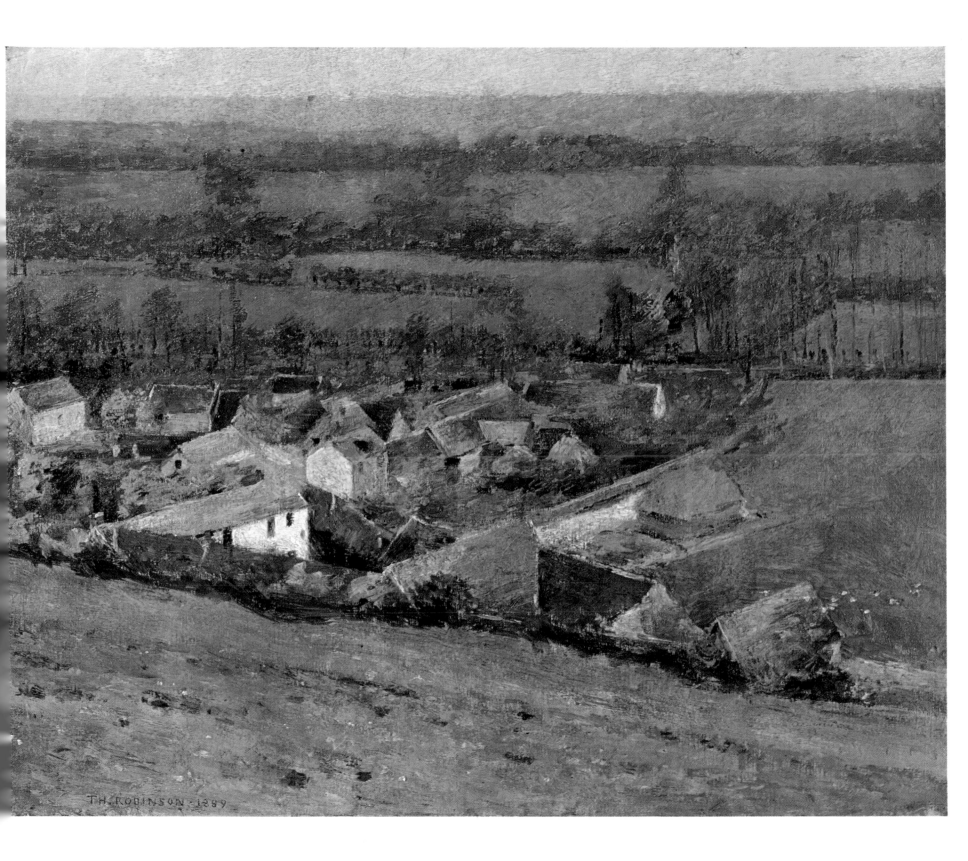

TH. ROBINSON - 1889

Plate 17
THEODORE ROBINSON (1852–1896)
The Watering Pots, 1890
Oil on canvas, 22″ x 18⅛″ (55.9 cm. x 46.0 cm.)
The Brooklyn Museum

Although Robinson did produce some paintings with genre subjects during the years immediately preceding his conversion to impressionism, anecdote never infected his works. Scenes of farm and peasant life, so much a part of the Barbizon School to which he had once been attracted, are transformed in his impressionist paintings and become more integrated with the compositions.

Robinson never eludes the difficulties inherent in painting a figure from a posed model. There is an undeniable stiffness to these pictures, recalling more the work of Bastien-Lepage than Robinson's idol Monet. Thus, his efforts seem to be largely attempts at integrating the figure into an impressionist landscape, a problem fraught with difficulties because of Robinson's tendency to observe a figure in a rather academic way.

A further clue to Robinson's approach to figure painting lies in his use of photography. He once commented, "Painting directly from nature is difficult, as things do not remain the same, the camera helps to retain the picture in your mind." The use of the camera was also, undoubtedly, a matter of economy. And it must be observed that Robinson was not slavish in his use of photographs: the figure represented in *The Watering Pots* is a variation on a theme which only has its origins in a photograph. Later, Robinson, with his characteristic self-criticism reconsidered and ruled out the use of the photograph as an aid to painting.

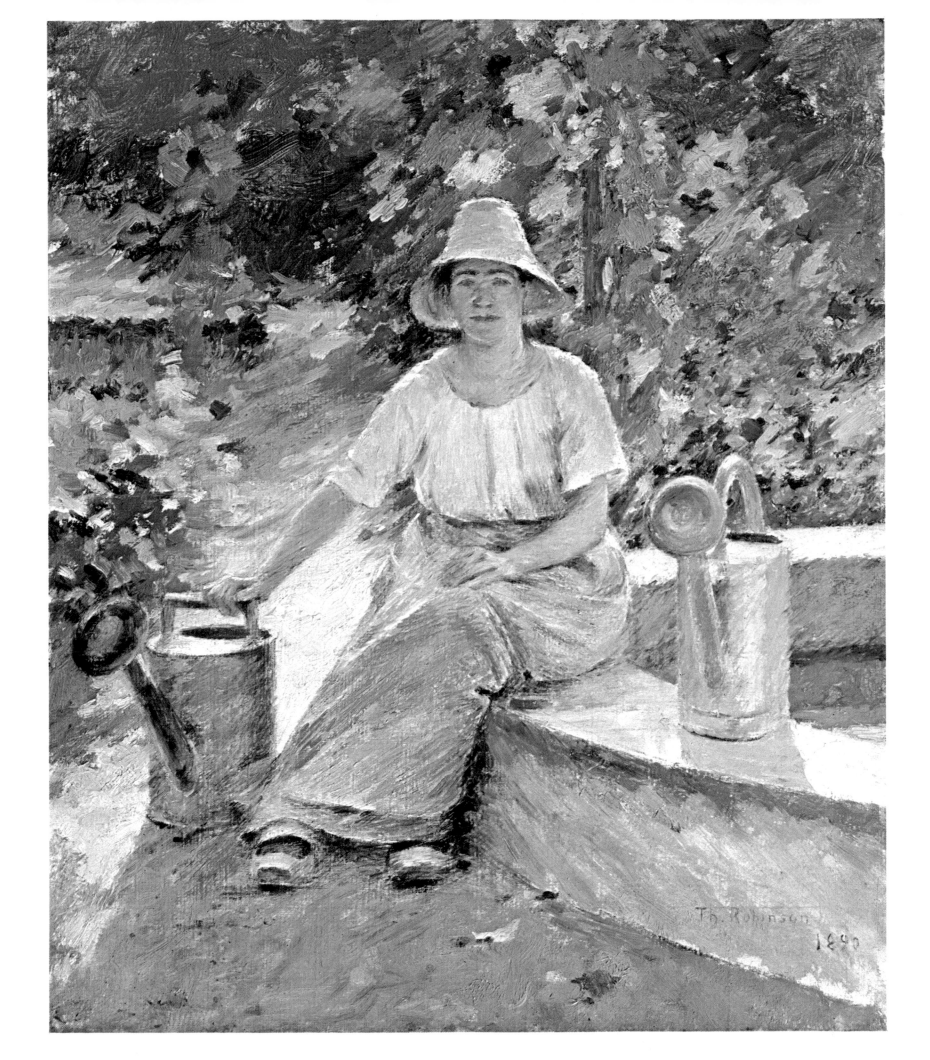

Plate 18
THEODORE ROBINSON (1852–1896)
Willows (En Picardie), ca. 1891
Oil on canvas, 18″ x 21⅞″ (45.7 cm. x 55.6 cm.)
The Brooklyn Museum, Gift of George D. Pratt

By the 1890's, impressionism had been generally accepted in America, and the young students at the Eastern art schools were avidly striving to become initiates of the new movement. Robinson commented disapprovingly on young students who were trying to see colors of the impressionist palette in nature. His own interpretations of nature never admitted colors that he could not readily apprehend, for Robinson did not strive to be original in his use of color. His natural reticence, a heritage from his Puritan forebears, made him distrust the sensual appeal of color, and it is not surprising that Robinson preferred Monet's earlier paintings rather than the "later, wrought-out, elaborate visions."

Robinson, beset by physical weakness and lingering doubts about the direction that his own art was taking, found reassurance in Monet's friendship. Following a winter of desultory sketching in Italy, Robinson returned to Giverny in the summer of 1891 and there reverted to his most impressionistic style of painting.

Willows dates from about this time and its subtitle *En Picardie* suggests that Robinson was working in the northwest of France as well as in Giverny. It is directly and energetically painted, and reflects the best of Robinson's mastery of gentle lyricism.

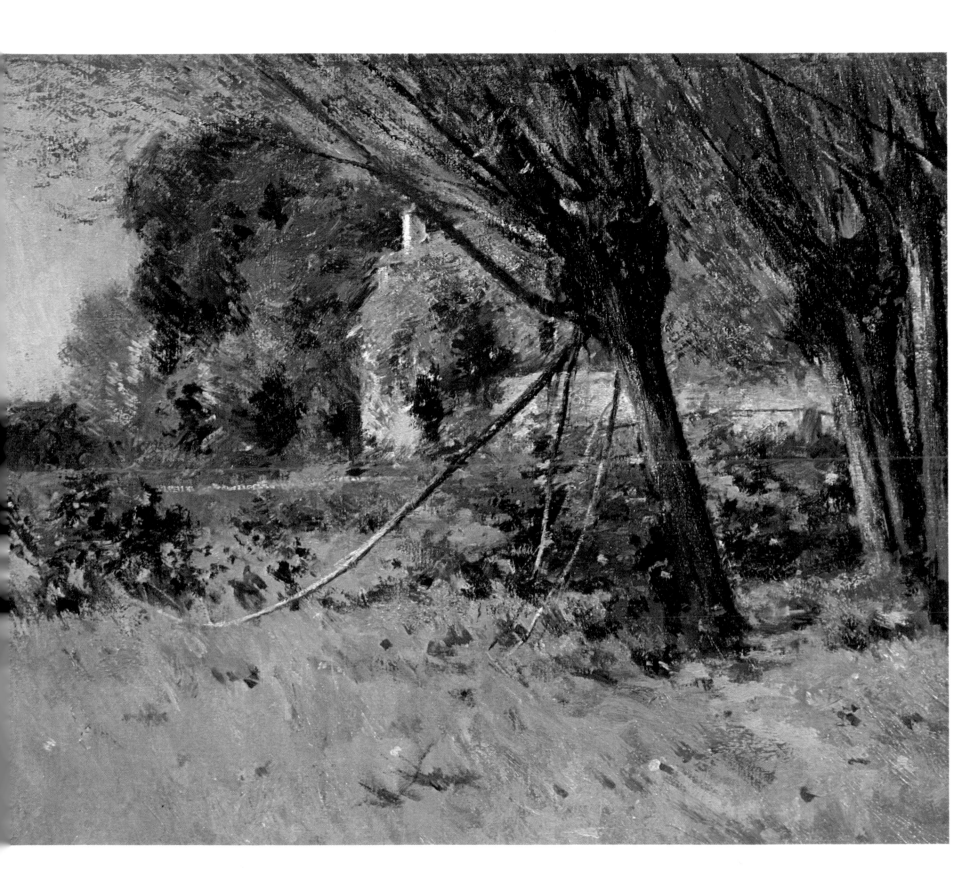

Plate 19
DWIGHT WILLIAM TRYON (1849–1925)
Early Morning, September, 1904
Oil on canvas, 19¾" x 30" (50.2 cm. x 76.2 cm.)
Museum of Fine Arts, Boston, Ernest Wadsworth Longfellow Fund

The development of modern art in France took fairly well-defined paths, so that the achievements of the Barbizon painters appear logically to prepare the ground of impressionism. American artists who were arriving in France in the 1870's frequently sought out the surviving masters of the Barbizon School, rather than the impressionists, because the newly arrived artists were the products of a cultural time-lag. While the Barbizon movement had reached its senescence in France by the 1870's, it was only then finding general acceptance in America.

Therefore, most of the young American students sought out either the Barbizon painters or went to the academies in Paris. It was only after some months or years of exposure to the crosscurrents of French painting, that these Americans began to appreciate the existence of impressionism. Some, like Cassatt, Robinson, and Hassam, swung fully in line behind the impressionist movement; others, like Martin and Tryon, created a hybrid form of impressionism, combining the pastoral romanticism of the older tradition and the atmospheric colorism of the new movement.

This hybrid form is a peculiarly American development of impressionism and relates to the American luminist persuasion of half a century before. The fusion of luminism and impressionism was defined by the critics of the day as tonalism. Samuel Isham best describes the appearance of tonalism in his book on American painting, "The color is kept within one milky, luminous tone that softens and transmutes whatever more violent tints may lie beneath to something in harmony, though there is no monotony. It is not a messing together of warring colors into one solid monotone but each is pure and distinct for all its delicacy." While these words come from a discussion of the work of Tryon, they might just as well pertain to the art of J. Francis Murphy and Alexander Wyant, two other Americans of his generation.

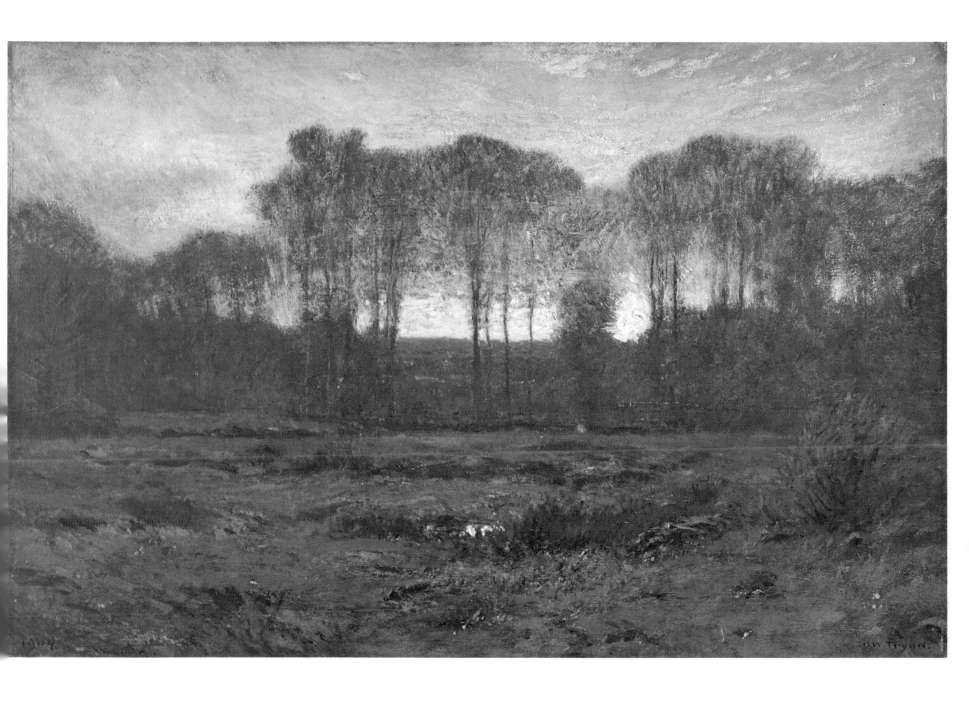

Plate 20
JOHN SINGER SARGENT (1856–1925)
Home Fields, 1885
Oil on canvas, 28¾" x 38" (73.0 cm. x 96.5 cm.)
The Detroit Institute of Arts

Although he met Monet as early as 1876 and was fully conscious of the experiments of the impressionist painters, Sargent never worked in the new manner until his removal to England in 1885. To be sure, his early salon paintings, especially the landscapes, reveal an awareness of plein-air, but Sargent's principle occupation was that of portrait painter. Because his most famous portrait *Madame X* caused a scandal at the opening of the Salon of 1884, Sargent decided, temporarily, to turn to genre and landscape painting.

In the summer of 1885, he accepted an invitation from a friend and fellow American Edwin A. Abbey to spend some time in an art colony in rural Worcestershire, some twelve miles south of Stratford-upon-Avon. The colony centered in the town of Broadway which the writer Henry James described as a place "convertible" to the uses of the artist: "There is portraiture in the air and composition in the very accidents. Everything is a subject or an effect...." Here Sargent returned to plein-air painting once more.

The English poet Edmund Gosse watched Sargent at work and described his method of attacking the problem of landscape painting that summer: "He was accustomed to emerge from the house carrying a large easel, to advance a little way into the open, and then suddenly to plant himself down nowhere in particular, behind a barn, opposite a wall, in the middle of a field. The process was like that in the game of musical chairs ... his object was to acquire the habit of reproducing precisely whatever met his vision...."

Gosse was observing Sargent's aversion to the academic concern for subject matter and composition, which, in the overemphasis then so prevalent among French and English academicians, robbed the art of painting of vitality. What Sargent was doing in 1885 was to be reiterated six years later in Monet's celebrated Haystack series: that is, the effects of light and color in painting should represent the true appearance of objects in nature. Sargent embraced the new realism which affirmed that what counted in painting art was not the object itself, but the total effect of the artistic translation in terms of pigment.

Home Fields, painted at Broadway near the end of his 1885 visit, shows that Sargent was working toward a realization of the quality of light apprehended at a specific time of day. The lengthening shadows, the orange glow of objects bathed in the waking light describe as brief a segment of time as ever Monet attempted in the Haystack series. *Home Fields* is painted without dependence upon impressionist technique, however. Broadly brushed passages vie with small flickering strokes of brilliant color, and the whole effect shows the most direct observation.

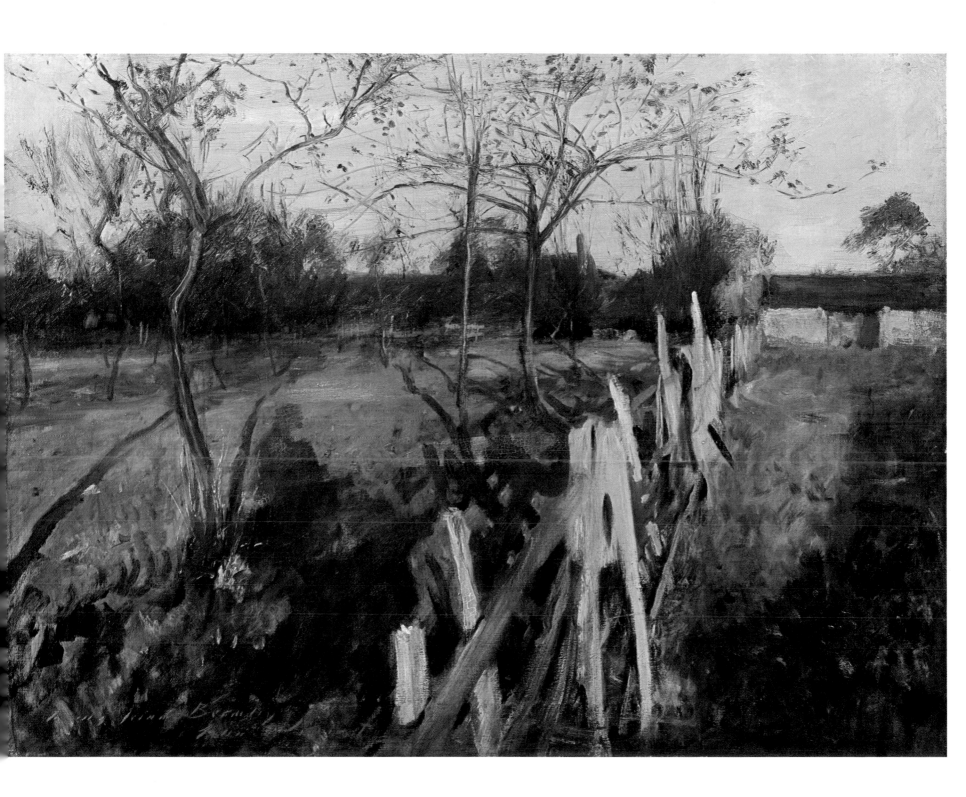

Plate 21
JOHN SINGER SARGENT (1856-1925)
Claude Monet Sketching at the Edge of a Wood, ca. 1887
Oil on canvas, 21¼" x 25½" (54.0 cm. x 64.8 cm.)
The Tate Gallery, London

In September, 1885, Sargent wrote to a friend: "Just now I am rather out of favor as a portrait painter in Paris . . . I have been coming to England for the last two or three summers and should not wonder if I some day have a studio in London. There is perhaps more chance for me there as a portrait painter, although it might be a long struggle for my painting to be accepted. It is thought beastly French." The following year he did move to London and took up residence in Whistler's old studio in Chelsea. He quickly found himself in opposition to The Royal Academy, the bastion of academic English painting. And with his reputation for being "beastly French," he found a natural association in a group of some fifty dissident young English artists who founded in 1886 the New English Art Club.

Although he was still struggling, and hard pressed financially, Sargent acquired in 1887 Monet's painting *Rock at Tréport*; this was the same year that Sargent painted a profile portrait of Monet at Giverny. Their personal friendship is underscored in a letter which Sargent wrote to Monet that year, concerning his delight with the Tréport painting, "I have remained before it for whole hours at a time in a state of voluptuous stupefaction, or enchantment, if you will. I am overcome to have in my house such a source of pleasure."

The little outdoor conversation piece *Claude Monet Sketching at the Edge of a Wood* shows the artist and his wife in the context of a very rapidly executed canvas. Sargent looked over his friend's shoulder, as it were, and the technique employed in this work is generously laden with Monet's fluid manner.

Sargent's early training under Carolus-Duran, far from miring him in academic routines, equipped him to paint directly and strongly from nature. Thus, his transition from realism to impressionism was a natural outgrowth of his development as an artist; while he modified his style toward realism in the decade that followed, it always was influenced by impressionism.

Still largely ignored in London during these years of the late 1880's, Sargent found a growing audience in America. During the winter of 1887 to 1889, he traveled to New York and Boston to paint portraits. And it was in Boston in the winter of 1888 that he was given an exhibition which signaled his first major triumph. One reviewer exclaimed: "No American has ever displayed a collection of paintings in Boston having so much of the quality which is summed up in the word style. Style is the predominant characteristic of the artist; all of his pictures are permeated with it. Nothing is commonplace; nothing is conventional."

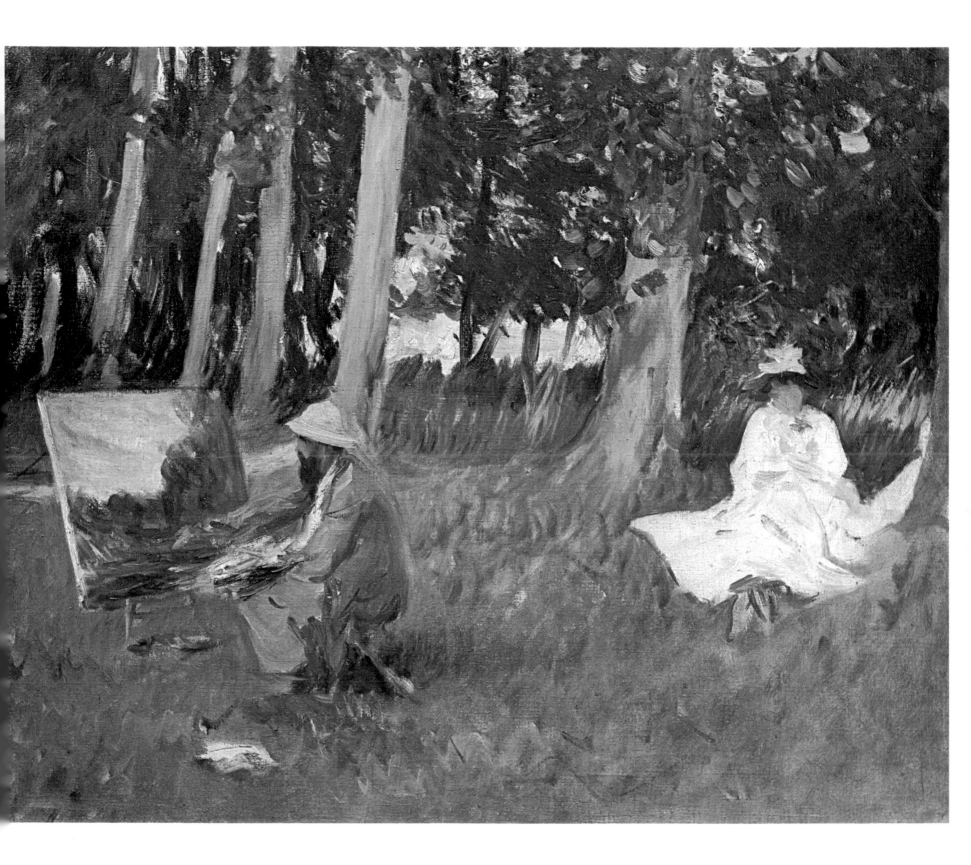

Plate 22
JOHN SINGER SARGENT (1856-1925)
Paul Helleu Sketching, and His Wife, 1889
Oil on canvas, 26″ x 32″ (66.0 cm. x 81.3 cm.)
The Brooklyn Museum

Sargent returned triumphant from America in the spring of 1888. During the eight months of his stay in New York and Boston he had completed nearly two dozen portraits, but his record in London for the balance of the year was hardly so impressive. During the summer he leased a cottage at Calcot near Reading, presumably for the benefit of his father, who had suffered a stroke the previous winter. His mother and two sisters were there also, and Sargent divided his time between the Chelsea studio and the cottage at Calcot. Perhaps because of the continuing problem of finding portrait commissions in London, Sargent returned with ardor to impressionism that summer. In 1889, however, a transformation took place. The greater part of Sargent's production that summer deals not with the full, golden light that he achieved in his earlier impressionist pictures, but reverts to his underlying interest in the effects of light observed as indirect or reflected illumination.

In August, 1889, he rejoined his family who had taken a cottage at Fladbury Rectory, near Broadway and the River Avon. As was their custom, the Sargents received a continuous procession of summer visitors. To Fladbury that summer came Paul Helleu and his bride, Alice Guerin. Although he had obtained a respected, if not a distinguished, reputation during his career, at age thirty Helleu was still emerging from his poverty-haunted student experience.

Of all the paintings that come to us from Sargent's impressionist interlude, the one that comes closest to the ideal of pictorial harmony and balance between subject matter and technique is *Paul Helleu Sketching, and His Wife.* (The charming Alice, just turned eighteen, did not paint but insisted upon accompanying Helleu on all of his sketching trips.) Here the two are pictured seated side by side, bathed in that vague, indirect light of which Sargent was so fond. He employs a staccato brushstroke in the surrounding rushes and thereby creates a foil for the minutely adjusted color relationships that take place in the painting of the two heads and the flatly rendered hats. Far more attention is given to the unity of the color and to the quality of the light than to the subjects; yet Sargent's eye could not fail to register the differences in characterization between the almost emaciated figure of his friend and the calm, doelike form of Alice.

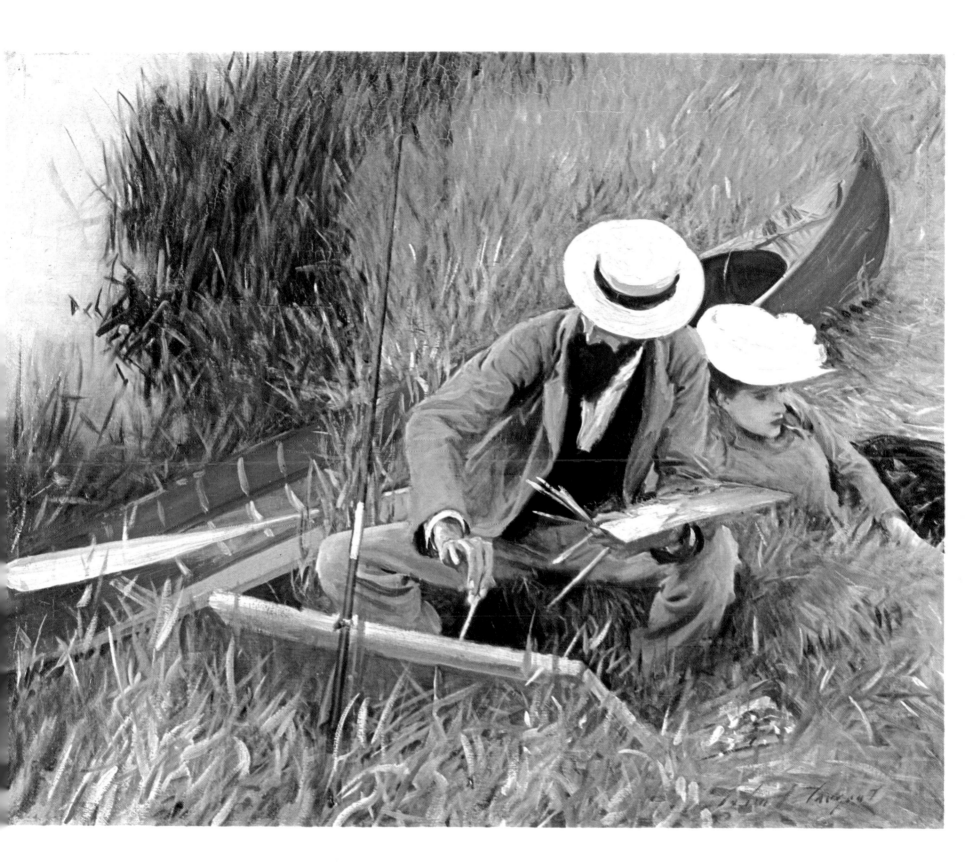

By the turn of the century, Sargent was firmly established as the leading portrait painter of America and Europe. His bravura style of painting, with its flashing brushwork and its elegant, if mannered, compositions, set a standard by which all other portrait painters were judged. By 1908, the year in which he resolved to have nothing more to do with portrait painting, he had produced nearly 400 commissioned portraits. A rare note of bitterness attended this transition in his career: "No more portraits . . . I abhor and abjure them and hope never to do another, especially of the Upper Classes." Portrait painting no longer stimulated the creative impulse, and Sargent abandoned this career rather than compromise his integrity.

But portraiture was only a part of his wide scope of interests, and after 1908, Sargent threw himself fully upon the monumental mural decorations for the Boston Public Library, as well as a second project for the Museum of Fine Arts in the same city. The last twenty years of his life also saw a prodigious outpouring of oils and watercolors as he roamed the shores of the Mediterranean and the Swiss and Italian Alps in search of landscape and genre subjects. The clear air and the intense sunlight of the high Alps especially attracted him; and the oil and watercolor studies he made from nature in the Val d'Aosta are full of brilliance and a nervous intensity that recall his earlier efforts at impressionist painting.

Sargent did not paint landscapes in the traditional sense of the word; rather, he selected small patches of nature to study. Sometimes the views in his picture offer little more than a few square yards of nature; he once remarked, "I don't paint views, I paint objects." The canvases of this period take on a new richness of pigment; the whites are thick and sensuous, with luminous tans and blues and brilliant greens. In this "view" of a flashing Alpine mountain stream, skeins of paint are overlaid in a complicated web of color and texture, seemingly chaotic at close range, but masterfully organized when perceived at a distance of a few feet from the canvas.

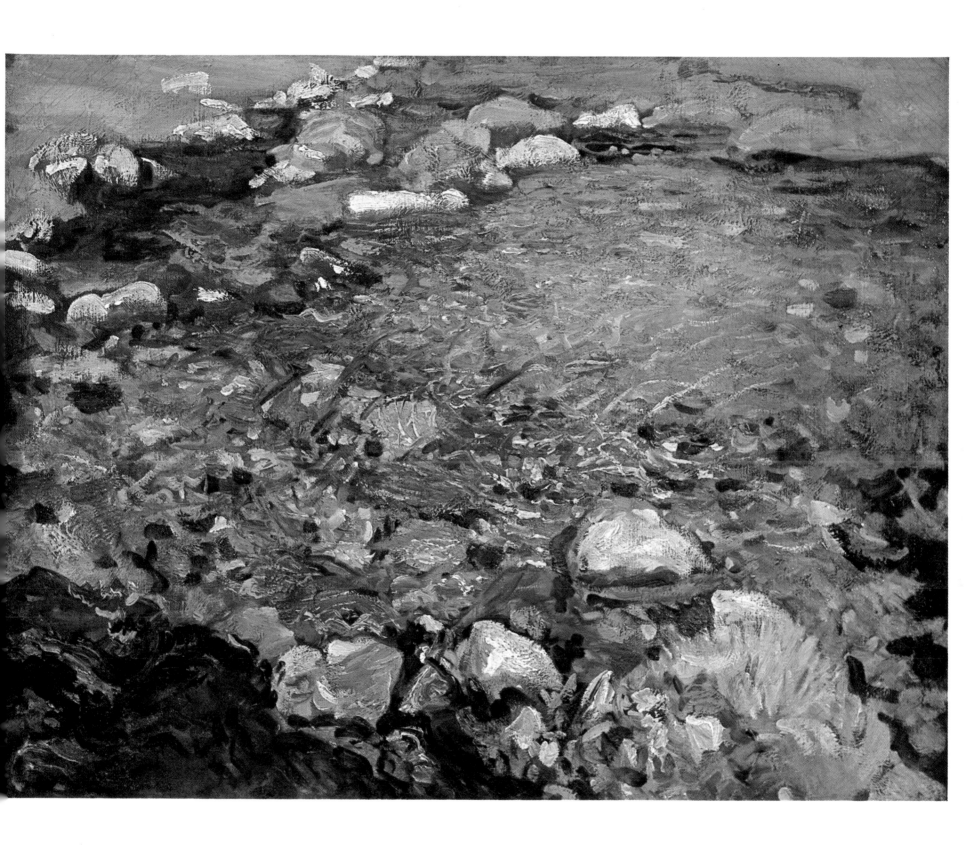

Plate 24
FREDERICK CHILDE HASSAM (1859-1935)
Grand Prix Day, 1887
Oil on canvas, 24" x 34" (61.0 cm. x 86.4 cm.)
Museum of Fine Arts, Boston, Ernest Wadsworth Longfellow Fund

The history of American art is studded with careers of notable talents who began their rise to fame as apprentices in the printing industry. Winslow Homer began as an apprentice in a lithographic workshop in Boston and developed a pictorial sense that even in his late years reflected the illustrator's interest in human affairs. Hassam similarly received his first instruction in the graphic arts, becoming an accomplished etcher and lithographer. Before he was twenty-four years old, Hassam's work appeared in such magazines as *St. Nicholas*, *Harper's*, *Scribner's*, and *Century*.

Although he was probably working in oils in the 1870's, Hassam received his first public notice in 1883, when a series of sixty-seven of his watercolors, made during a trip abroad in 1883, were exhibited in Boston. But it was not until his second European visit in 1886 that Hassam decided to become a painter, settling down in Paris.

Although he followed the prescribed means for advancement in art in Paris, attending the Académie Julian where he studied figure drawing, Hassam embarked almost immediately upon painting the street scenes of Paris. Generally, his style appears to have been influenced by the dark palette of Barbizon, rather than the blonder one of impressionism. There was also a tendency in his work to affect a broad, buttery manner in the application of paint to canvas. He often chose to paint scenes observed in the rain, a predisposition for subject matter that gives his early works a decidedly gloomy cast. However, when he chose to paint a bright, sun filled day, his paintings have the éclat of a brass band.

Grand Prix Day is a joyous expression of light and color and is one of the first indications that Hassam had been truly won over to the impressionist camp. In *Grand Prix Day*, the excitement of the subject is felt in the sustained intensity of the picture's high-keyed colors. Hassam conveys a feeling about the moment through an intense color vibration.

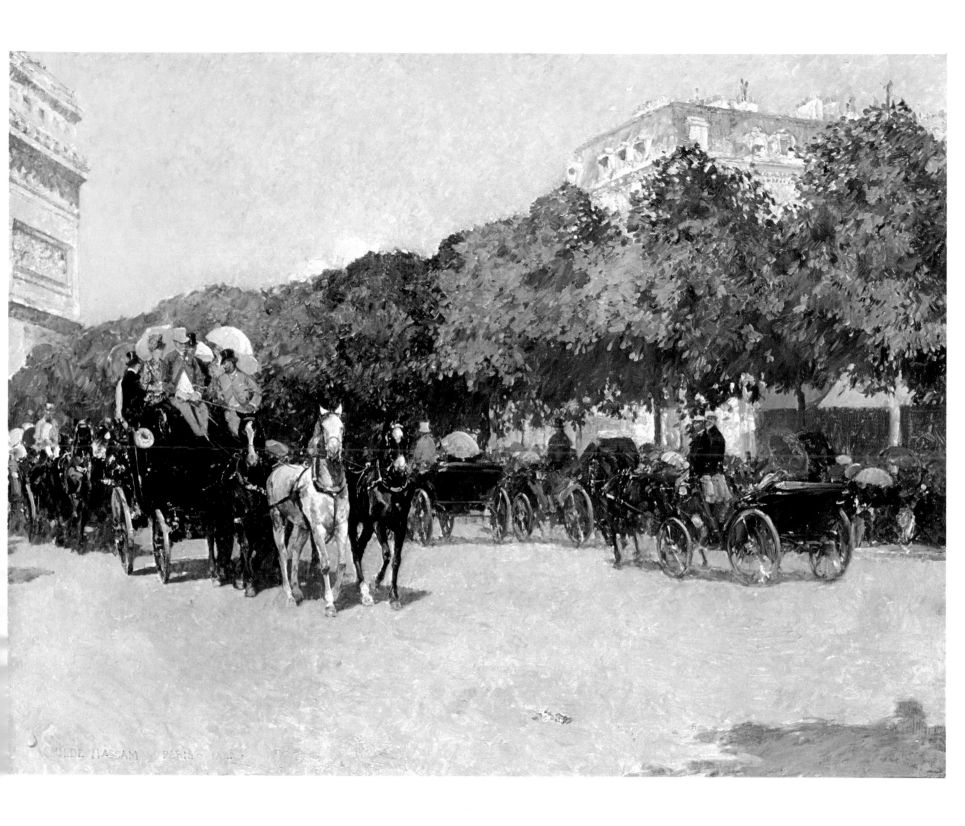

Plate 25
FREDERICK CHILDE HASSAM (1859-1935)
The Flower Garden, 1888
Oil on canvas, 28" x 21⅝" (71.1 cm. x 54.9 cm.)
Worcester Art Museum, Theodore T. and Mary G. Ellis Collection

His early work as an illustrator for magazines like *Harper's* gave Hassam a keen feeling for people and a special quality of place. His first paintings are full of interest in deep pictorial space, and he frequently achieved his spatial effects in a purely mechanical way, using the converging lines of perspective to indicate depth rather than relying on the more subtle use of atmospheric effects. But by 1888, the somewhat hard drawing so obvious in his early pictures was beginning to soften, indicating that he was already becoming a serious student of impressionism. Some six years before, in 1882, he had made a prophetic little watercolor which he entitled *An Impression*.

Whether he had ever heard of Monet's famous example, or the movement in French art that had come out of it, is uncertain; however, one is always struck by Hassam's pictorial acuity—his ability to succinctly state the essence of his subject matter. He presents that subject matter in a natural and plausible way, yet his pictures are always infused by a thoroughly artistic sensibility.

In the paintings of his early maturity—*The Flower Garden* is one of the most charming and intimate statements of these years—the artist's personality is submerged within his subject matter. Here he is not given to self-conscious flights with the mannerisms of impressionism, but combines a variety of painting styles to achieve his desired effects. *The Flower Garden* is an ingratiating mixture of flat and agitated brushwork in which the artist attempts to achieve a palpable realism without completely abandoning impressionist color or mood. His interest in interlocking pattern and the flattening of pictorial space, despite the suggestion of perspective in this picture, combines with a somewhat vivid color scheme that anticipates the later work of Bonnard. It is a theme that Hassam would return to years later with his figure studies of women in interiors, but this garden picture and other variations based upon it stand as Hassam's most intense statements of purely lyrical color.

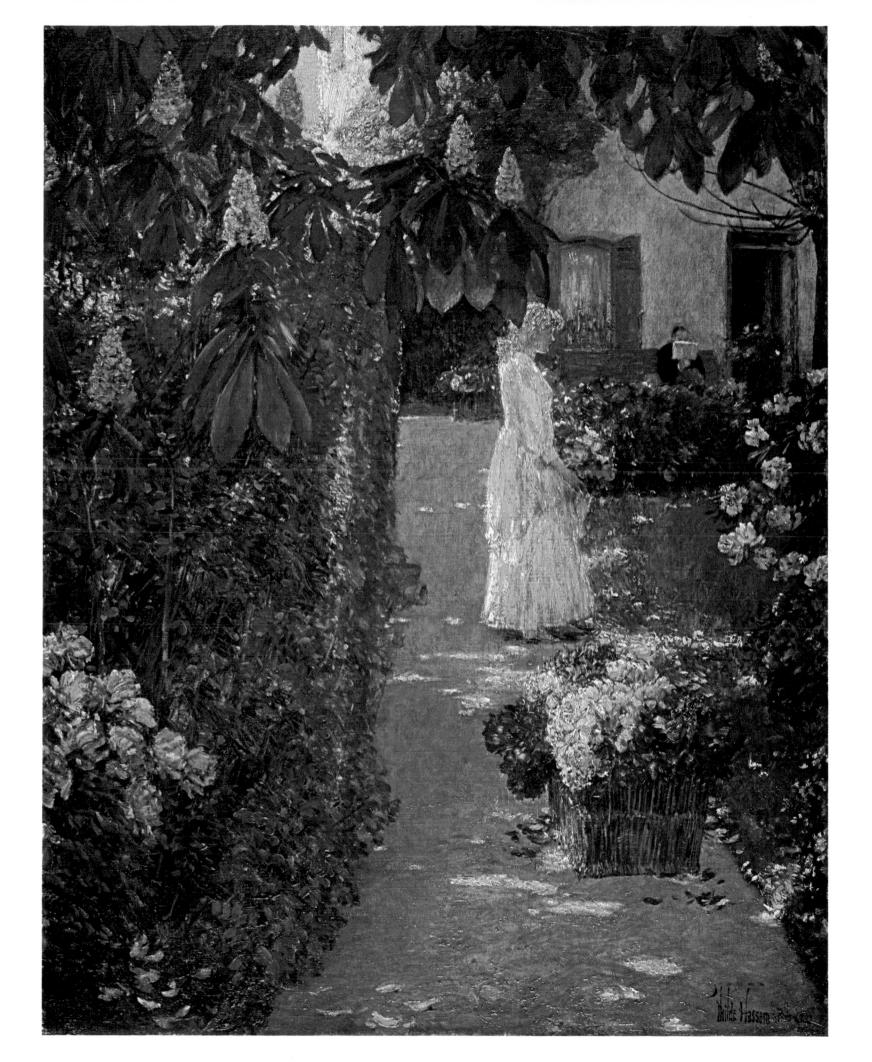

Plate 26
FREDERICK CHILDE HASSAM (1859-1935)
Washington Arch in Spring, 1890
Oil on canvas, 26" x 21½" (66.0 cm. x 54.6 cm.)
The Phillips Collection, Washington, D. C.

Hassam returned to New York in 1889, bringing with him a medal which he received for a painting submitted to the Paris Exposition of that year. During his years abroad, New York had continued in its prodigious construction of public and private buildings of the greatest magnificence. The decade of the 1880's had seen the construction of the great Vanderbilt House on Fifth Avenue, the opening of the Brooklyn Bridge, the unveiling of Bartholdi's *Statue of Liberty,* the opening of the Metropolitan Opera House, as well as the dedication of public art such as the bronze statue of Admiral Farragut by Augustus St. Gaudens, in Madison Square.

New York, in many respects, was beginning to rival Paris as a cultural capital, as well as a burgeoning metropolis. As the decade of the 1890's opened, few cities in the world could rival Fifth Avenue's splendid, if eclectic, procession of stately town houses. At the foot of this splendid avenue in 1889 stood a wooden arch, designed by one of America's most prestigious architects Stanford White, to commemorate the 100th anniversary of Washington's Inauguration. Painted to simulate stone (it was replaced six years later in actual stone), the arch undoubtedly reminded Hassam of its more famous ancestor in Paris. The artist's impressionist treatment of the subject completes this allusion, relating the pre-eminence of the two cities by painting this thoroughly American scene in the best French manner.

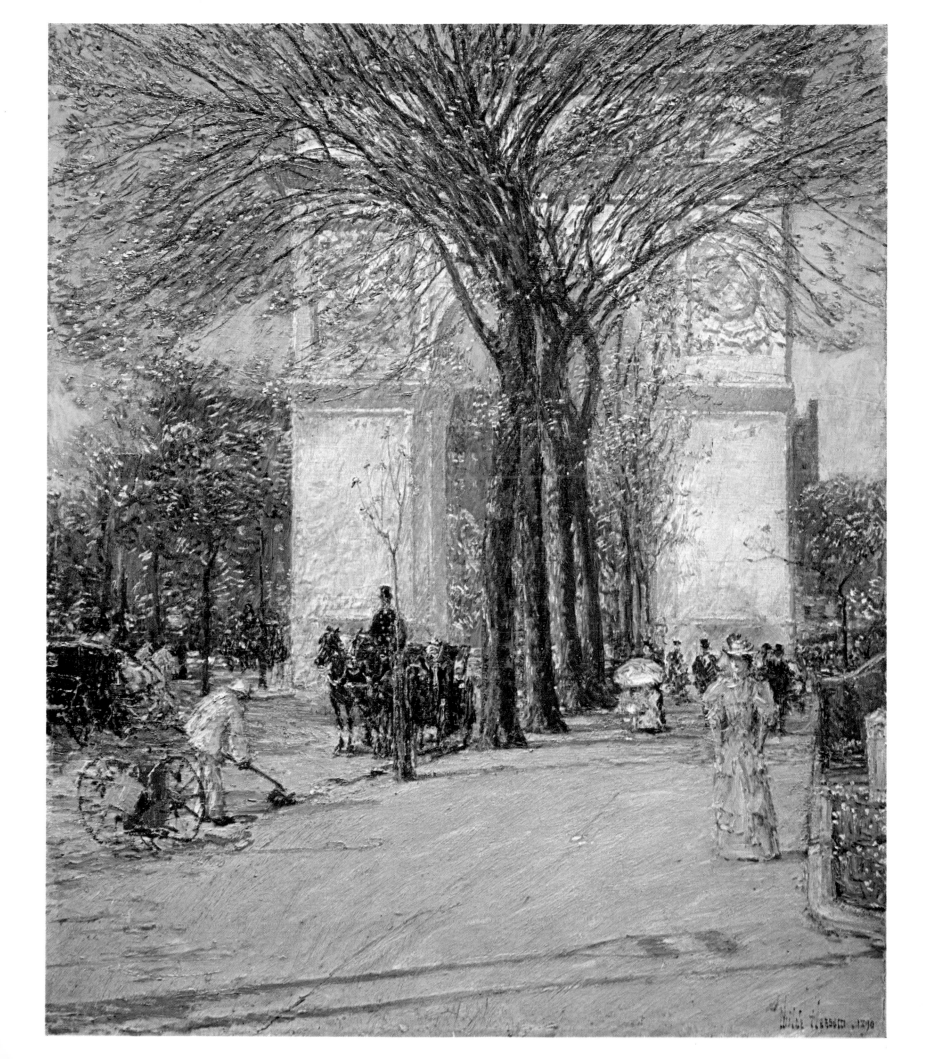

Plate 27
FREDERICK CHILDE HASSAM (1859-1935)
Late Afternoon, Winter, New York, 1900
Oil on canvas, 37¼" x 29⅛" (94.6 cm. x 74.3 cm.)
The Brooklyn Museum, Dick S. Ramsay Fund

New York was formally introduced to impressionism in 1886, when Durand-Ruel exhibited his large group of pictures at the invitation of the American Art Association. The exhibition was generally conceded to have been a triumph. The organizer, Durand-Ruel, commented: "The exhibition was an immense success. For reasons of curiosity, but as opposed to what happened in Paris, it provoked neither uproar nor abusive comment, arousing no protest whatsoever. . . ." When the exhibition subsequently moved to the prestigious galleries of the National Academy of Design in 1886, the movement was formally canonized in America.

America's conversion to impressionism was completed in 1894 when the young novelist Hamlin Garland wrote his famous book *Crumbling Idols.* Garland, a colorful teller of stories from the American Middle West, harbored a burning belief in "the mighty pivotal present" and rejected the dead hand of the past on contemporary life. More than any other literary influence of his time, Garland welcomed impressionism in American art as a reinvigoration of our cultural life. Garland defined the impressionist method as "a complete and of course momentary concept of the sense of sight; the stayed and reproduced effect of a single section of the world of color upon the eye."

This kind of public support smoothed the way of the American impressionist painter; there was never any struggle here as in France, and the public eagerly embraced the new movement. Impressionism presented the smiling aspects of nature, not the sordid realities of life.

Hassam has been called the "Sisley of Madison Avenue," and no example of his work better illustrates that comparison than *Late Afternoon, Winter, New York.* The creation of the blurred and dimly perceived street scene was not a matter of direct observation, obviously, but was a product of Hassam's studio. In this painting the artist engages in that brand of impressionism that the historian Samuel Isham labeled "tonalism."

In retrospect, the impetus toward "tonalism" seems to have been a wish to escape from the unpleasant realities of life. Perhaps the new, tall office buildings that were rising everywhere in Manhattan struck discordant notes among the otherwise harmonious architecture of the city. Hassam offers veils of poetic atmosphere to soften the harsh outlines of the giant building in the distance and so returns this changing world to a more gentle time.

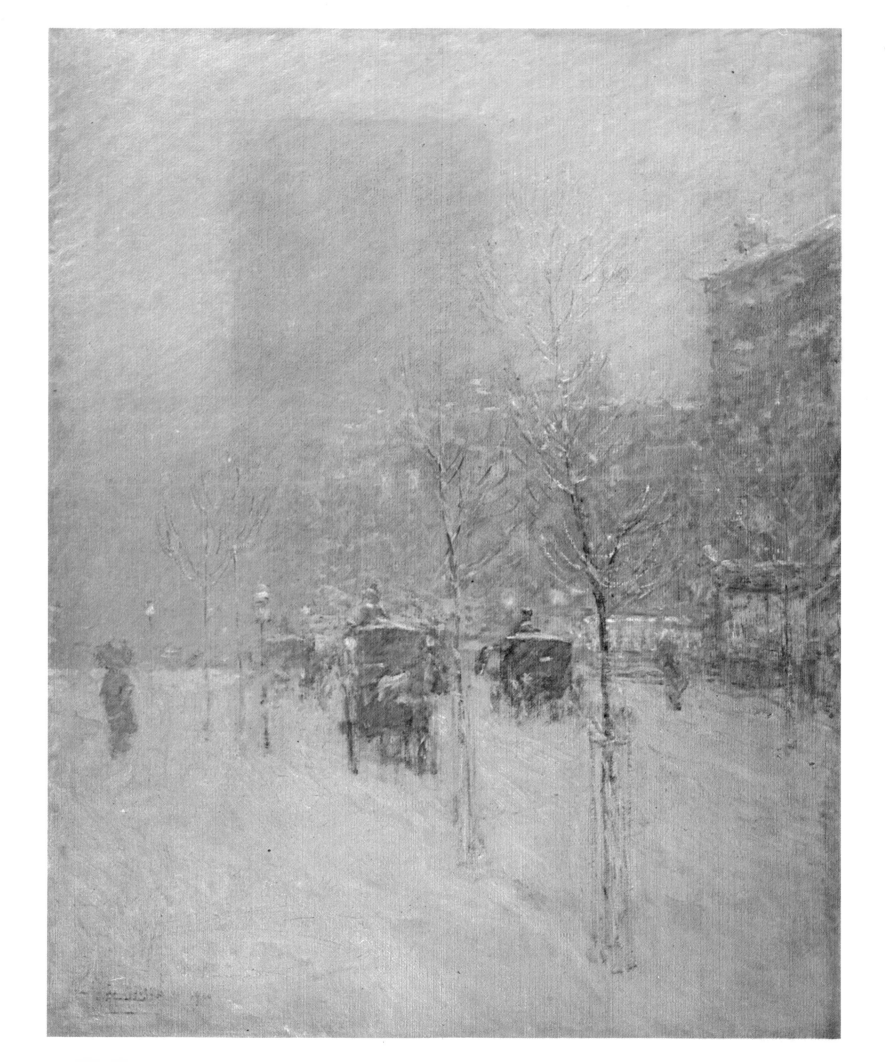

Plate 28
FREDERICK CHILDE HASSAM (1859-1935)
Southwest Wind, 1905
Oil on canvas, 25" x 30" (63.5 cm. x 76.2 cm.)
Worcester Art Museum, Theodore T. and Mary G. Ellis Collection

The "Ten American Painters" group was formed in 1898 with Hassam, Twachtman, and Weir as its principal founding members. The group comprised a sort of new academy of American painting; they were, for the most part, well-established artists who regularly won medals and prizes in all of the major American exhibitions of the day, and who were all well-represented in the principal public collections. New England became the locus for their activities, probably because that section of the country offered the greatest diversity of scenery.

Hassam, like his colleagues in the "Ten," maintained a studio in New York during the winter but fled to his favorite haunts in New England during the summers. After the turn of the century, he preferred painting the colonial architecture of churches at Old Lyme, Connecticut, and the picturesque fishing village of Glovcester, Massachusetts, rather than the city. He also enjoyed the isolation of the Isle of Shoals off the coast of New Hampshire, with its colony of writers, composers, and artists, where he could totally escape from the pressures of urban life.

As America turned increasingly toward industrialism, its artists—with the "Ten" at their forefront—turned toward nature. Indeed, from the record they left for posterity, one would not suspect that urbanization was the real concern of American life in their day. Yet their joy in the presence of nature was for them a reality.

In *Southwest Wind,* Hassam reaches a palpable realism that goes beyond mere picture making. He achieves a sharpness of color in the pale silver and greens of his trees, seeming to recreate for the beholder the actual rustling of leaves. The rhythm of the bending saplings stimulates the eye to move in an imagined accompaniment to the force of nature. The simplicity of the composition is disarming, yet the painting's feeling for movement and life is complete.

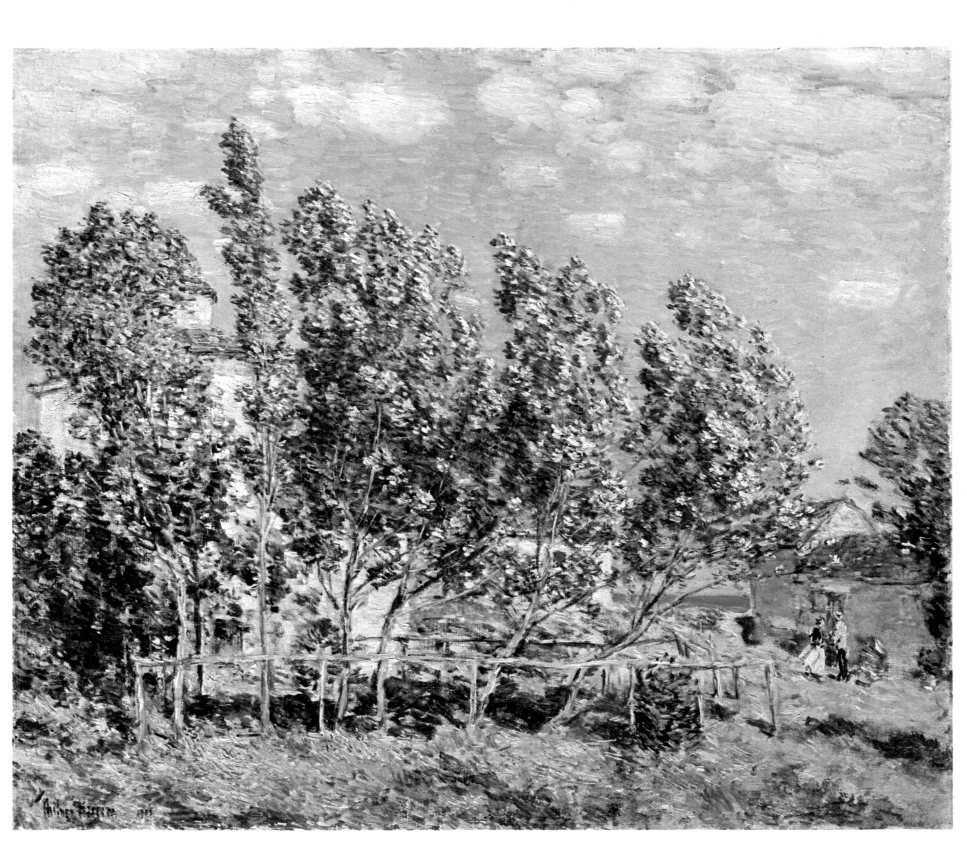

Plate 29
FREDERICK CHILDE HASSAM (1859-1935)
Union Jack, New York, April Morn, 1918
Oil on canvas, 37" x 30" (94.0 cm. x 76.2 cm.)
The Joseph H. Hirshhorn Collection

In 1910, Hassam made his final trip to France. The post-impressionists, and more recently the fauves, were dominant in French art in the opening years of the 20th century; Hassam undoubtedly saw evidences of this new trend toward a more decorative use of color, which had supplanted the tonal poetry of impressionism.

However, the impulse to employ brilliant color and flat pattern so reminiscent of the newer French painting remained dormant in Hassam until a suitable occasion presented itself. Conservative by nature and governed by a need to remain objective in his art, he waited for life to present him with a plausible excuse. Nor, when that moment came, was his style basically altered from that of his past performances. As the critic Royal Cortissoz observed, the new influences "opened his eyes rather than governed his brush, that he exercised in a way of his own."

Hassam's flag paintings, a series of some dozen works executed between 1916 and 1919, are as much expressions of his patriotic fervor as they are of his visual excitement with subject matter. Fifth Avenue, in New York, is traditionally the route taken by public demonstrations and parades, and at the time of the entry of the United States into the First World War in April, 1917, it became the custom along Fifth Avenue to display banners of the Allies.

Union Jack, New York, April Morn commemorates the first anniversary of the American entry into that war. By placing the flag of the United States behind that of Great Britain, the artist has symbolically suggested the aid given by America to its ally. In this picture, as in many of the others, the brilliant geometry of the flags dominates the composition. Although Hassam suggests an atmospheric setting for this picture, the exaggerations implicit in the drawing and the vigorous brushwork, which denied depth and emphasized surface, carry his achievement beyond impressionism into a newer style of painting. Fittingly, the man who introduced impressionism to America, Paul Durand-Ruel, paid honor to Hassam with an exhibition of the flag paintings in 1918 at the close of the war.

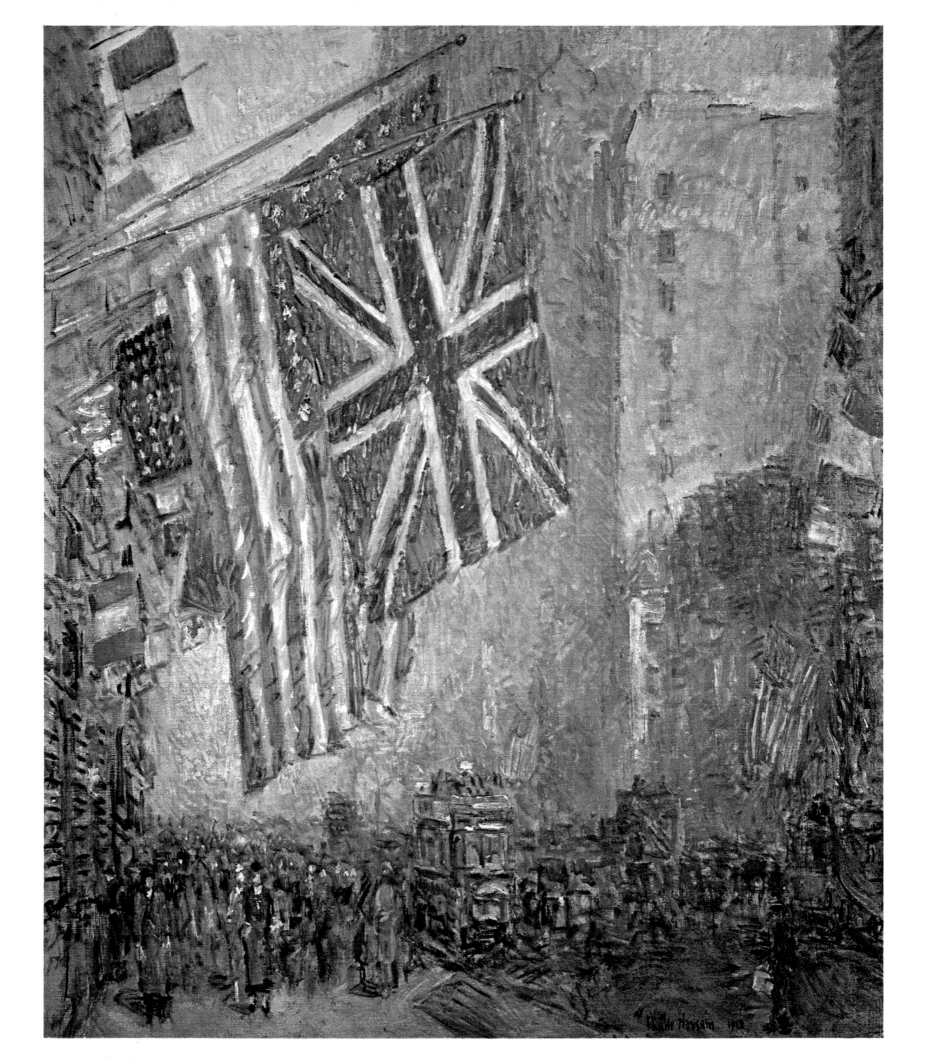

Plate 30
THOMAS WILMER DEWING (1851-1938)
Lady in Gold, ca. 1900
Oil on canvas, 24⅛" x 18⅛" (61.2 cm. x 46.3 cm.)
The Brooklyn Museum

The decades bracketing the turn of the century were fertile years for the development of a wholly new kind of subject matter. Image's of womanly purity and virtue flourished both in art and literature; the novels of Henry James contain as much of the same profound sense of mystery and admiration surrounding his conception of the feminine mystique as can be found in the works of Thomas Dewing. James, one of the most intelligent and penetrating writers of his generation, was, in spite of the complexity of the themes about which he wrote, primarily concerned with human relationships. His description of one of the women in *The Bostonians* reads like a transcription of one of Dewing's portraits: James described the enigmatic smile of a woman as, "a thin ray of moonlight resting upon the wall of a prison . . . exhilaration, if it ever visited here, was dumb."

Many of the most prominent artists of the era dedicated their careers to measuring the unfathomable depths of this mystique. The diverse images they produced in paint all tended toward a conception of woman as an ideal, spiritual being—comely, yet virginal; self-possessed, yet remote and untouchable. Henry Adams, that disenchanted esthete and philosopher of history, commented acidly that the American artist "had used sex for sentiment, never for force."

This accusation could be brought with equal justification to the works of a cosmopolitan portrait painter like John Sargent or to the magazine illustrator Charles Dana Gibson. Women were the ornaments of a male society; and if Abbott Thayer painted them dressed in white with angel wings, and if George de Forest Brush painted them as neo-Renaissance madonnas, their paintings were only reflecting the dominant attitude of their times, which relegated women to a cloistered segregation in life.

Dewing's *Lady in Gold*, like so many of these pictures for which he became famous, elevates the feminine ideal to yet another, higher pedestal so that his subject becomes ethereal and supremely chaste, as in James's words, "unmarried by every implication of her being . . . a spinster as Shelley was a lyric poet, or as the month of August is sultry."

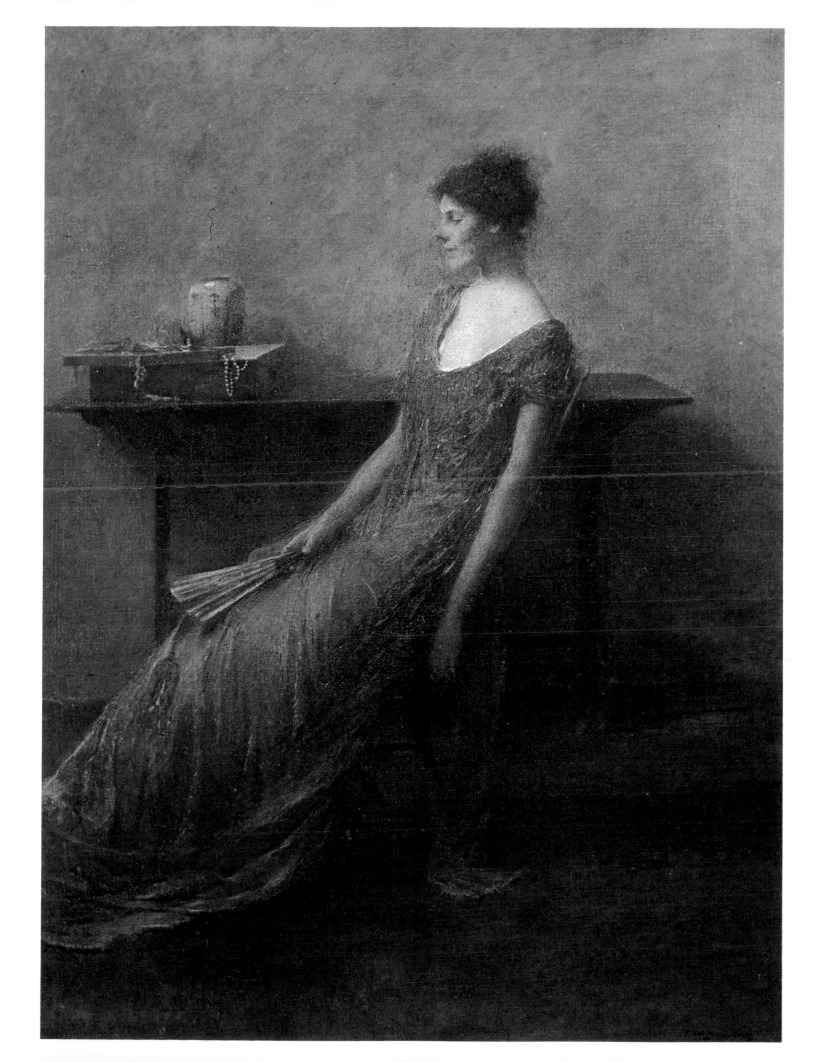

Plate 31
THOMAS WILMER DEWING (1851-1938)
The Spinet, 1902
Oil on wood panel, 15½" x 20" (39.4 cm. x 50.8 cm.)
National Collection of Fine Arts, Smithsonian Institution

The painters of tonalism, that peculiarly American variant of impressionism, generally found their subject matter in landscapes. Among all of the disciples of the idiom, only Dewing adapted tonalism to figure painting. Although the pictorial space in which his figures exist is extremely shallow, Dewing paints them as if seen through gauze or as if the air in his pictures were filled with some strange, smoky haze. He varied his pictorial devices, sometimes borrowing from Whistler and Japanese arrangements and sometimes, as in the case of *The Spinet*, apparently from an older tradition, that of the Dutch Little Masters.

Here, Dewing departs from his usual manner of painting in cool gray-greens and pale yellows and achieves a richness in color and texture that is almost unique in his work. An unfamiliar, sensuous note is also sounded in this work; an elaborate, flat pattern of the wall is only a momentary distraction from the real center of interest in the picture, the rounded and gleaming shoulders of the model. As in many of his pictures, Dewing indulges in symbolism here; another name for the spinet in the 17th century was "virginal," and the instrument's inclusion in this picture is a point of reference to the central theme of this and all of Dewing's paintings—the mysterious, inaccessible woman.

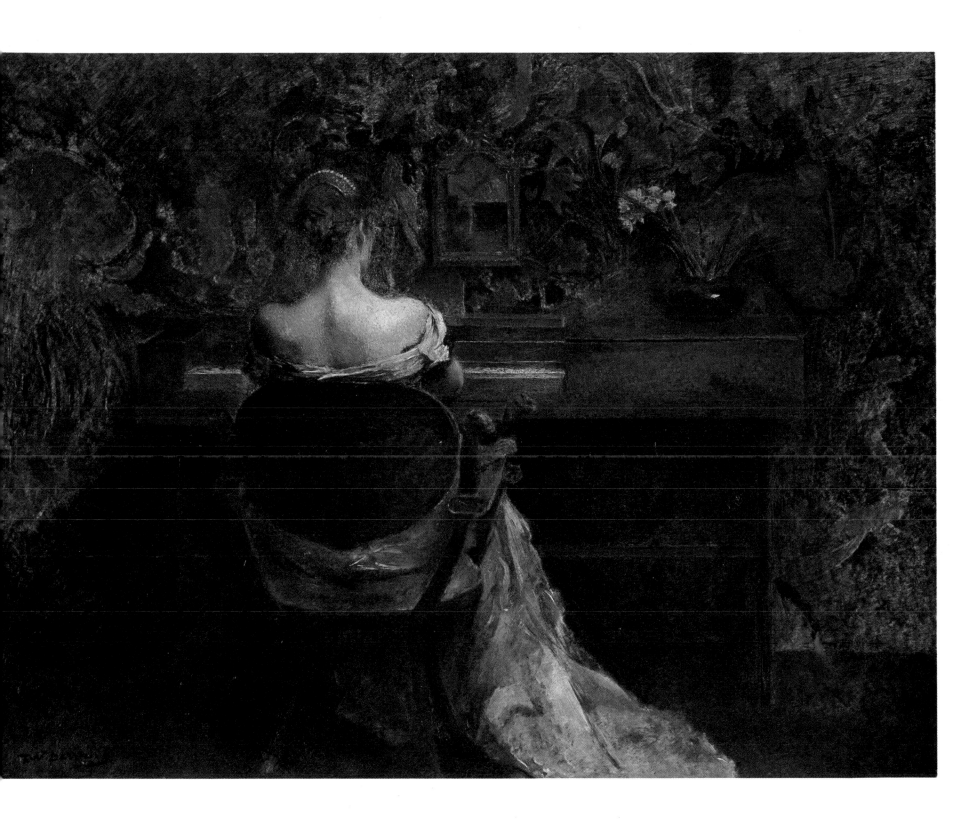

Plate 32
JULIAN ALDEN WEIR (1852-1919)
Upland Pasture, ca. 1905
Oil on canvas, 40" x 50¼" (101.6 cm. x 127.6 cm.)
National Collection of Fine Arts, Smithsonian Institution

J. Alden Weir came from a family of painters. His father was Robert W. Weir, who taught drawing at West Point and was a history painter whose mural *Embarkation of the Pilgrims* is in the Rotunda at the Capitol in Washington, D. C. Alden's brother, John F. Weir, was the first director of the Yale School of Fine Arts and specialized in genre pictures. Alden Weir had entered upon a career in art in his late twenties with a strong disposition toward academic routines. Largely through the influence of William M. Chase, he developed an enthusiasm for the works of Manet. But Weir was slow to develop his own art away from the academic mold that was both his heritage from his father and his schooling at the Académie des Beaux-Arts under Gérôme.

However, Weir was not a slave to fashion; his work proclaims a determination to adapt the methods of French painting to American portraiture and landscape. His career is an accommodation of independent vision to practical necessity: he could retain his membership in the prestig-ious National Academy of Design while teaching at the renegade Art Students League, and he could accept a commission to paint cold, neo-Classical murals for the New York State Pavilion at Chicago's Columbian Exposition while he experimented with impressionist methods in landscape painting.

Along with Hassam and Twachtman, the largest talents of the original founding members of the "Ten American Painters," Weir embraced a style of painting that depended entirely upon color and rejected the traditional American dependence upon line. In *Upland Pasture*, Weir makes evident his early enthusiasm for Barbizon subject matter, but he heightens the color range to the blond palette of impressionism. Nevertheless, he is not interested in merely translating the effects of natural light to canvas; Weir intensifies the drama of passing clouds which create spotlight effects on the landscape, and he sharpens his color, creating an optical vibration that goes beyond representational impressionism.

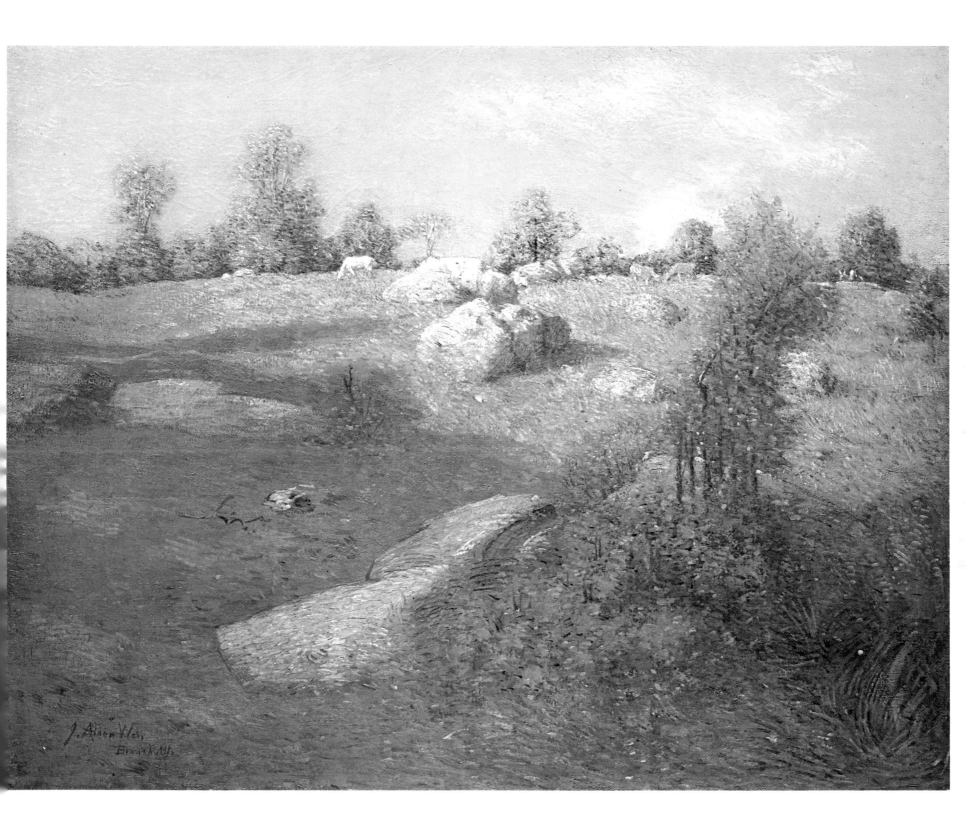

In the work of his later years, Weir was rarely interested in creating simple, picturesque views. There is often an amiable roughness in his work that blends with a fine sense of decorative picture making. He was a devoted friend to that poetic visionary of American art Albert Pinkham Ryder, and Weir's paintings frequently display a technique of scumbling and heavy impasto that creates a tactile richness reflecting a highly charged personal vision of some inner world.

The Red Bridge, with its refulgent reds and greens, is one of Weir's most decorative improvisations on nature. It is fully charged with that special shimmering light of which Weir was so fond. The collector and critic Duncan Phillips compared the figure painting of Weir and Renoir in 1919 when both artists died. Phillips saw a "reticent idealism" in Weir's figure painting; Weir reserved his sensuous responses for landscape painting.

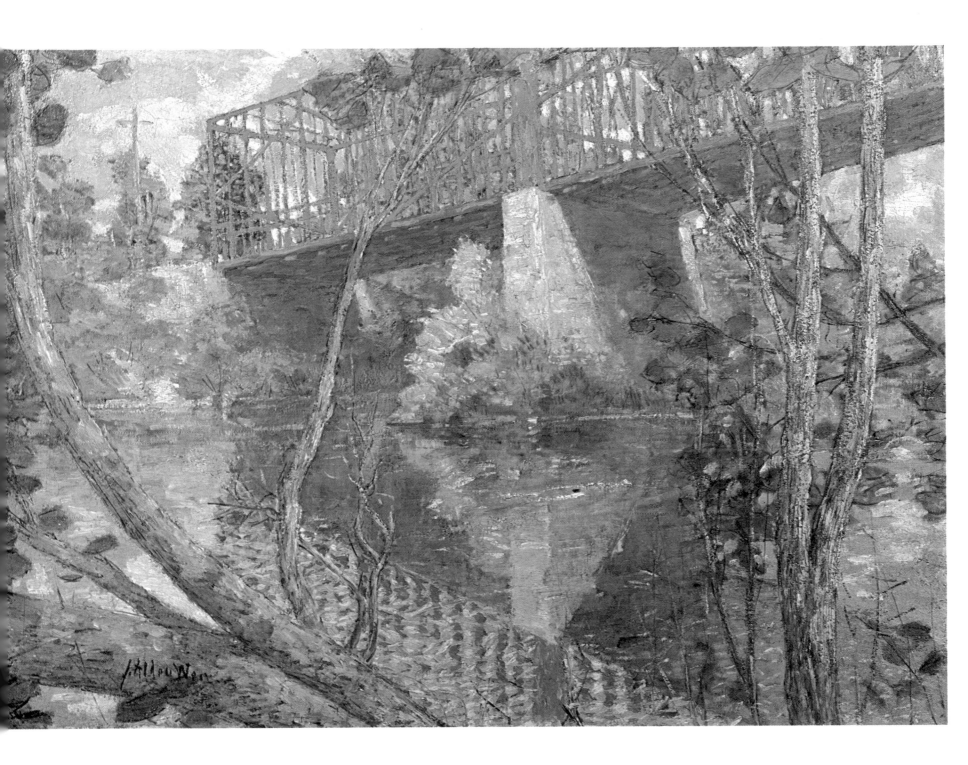

Plate 34
JOHN HENRY TWACHTMAN (1853-1902)
Arques-la-Bataille, 1885
Oil on canvas, 60" x 78⅞" (152.4 cm. x 200.3 cm.)
The Metropolitan Museum of Art

The most lyrical exponent of the school of American impressionism was, without doubt, John Henry Twachtman. No one observing the progress of his career in the 1870's could have guessed that this devoted follower of Frank Duveneck and the Munich School of dark realism would champion atmospheric colorism in American art.

Twachtman's progress as an artist was marked by frequent trips to Europe; these trips became nearly annual events between 1877 and 1883. It was toward the end of this period that Twachtman met James Whistler in Venice and also established strong ties of friendship with J. Alden Weir, with whom he traveled and painted in Holland. While Twachtman was in Holland, he met the landscape and genre painters Anton Mauve and Jules Bastien-Lepage, whose works he grew to admire

Twachtman had great difficulty in separating himself from his Munich period, for in his thirtieth year he returned to study in Paris at the Académie Julian under Lefebvre and Boulanger, two pillars of the old guard. It was not until the mid 1880's that Twachtman, having sloughed off the early influences of Munich and the later ones of Barbizon, began to emerge as a colorist.

Claude Monet had settled at Giverny in 1883, the year of Twachtman's return to France. This year also marked the beginning of what has been called Twachtman's French period. At this time he took his first, tentative steps in the direction of delicate color and created paintings which emphasize an almost monochromatic color scheme. He eliminated his Munich style of bravura brushwork in favor of a more even application of paint, directed toward a sensitive rendition of subject matter. The culmination of this phase of his work may be seen in the large *Arques-la-Bataille* of 1885.

Its composition recalls the combined influences of Whistler and Japanese art. The latter influence is especially evident in the elegant treatment of the reeds in the foreground of the picture. The artist provided a precise identification for the locale of this landscape, for the title of the painting is also the name of a town located at the confluence of the Arques and Bethune rivers some six miles southwest of the French coastal city of Dieppe. The concept underlying this painting is surprisingly simple and suggests a non-aesthetic requirement—the picture was destined to be seen in a Salon exhibition. Twachtman's paintings rarely approached these dimensions again, for he preferred to work within smaller formats.

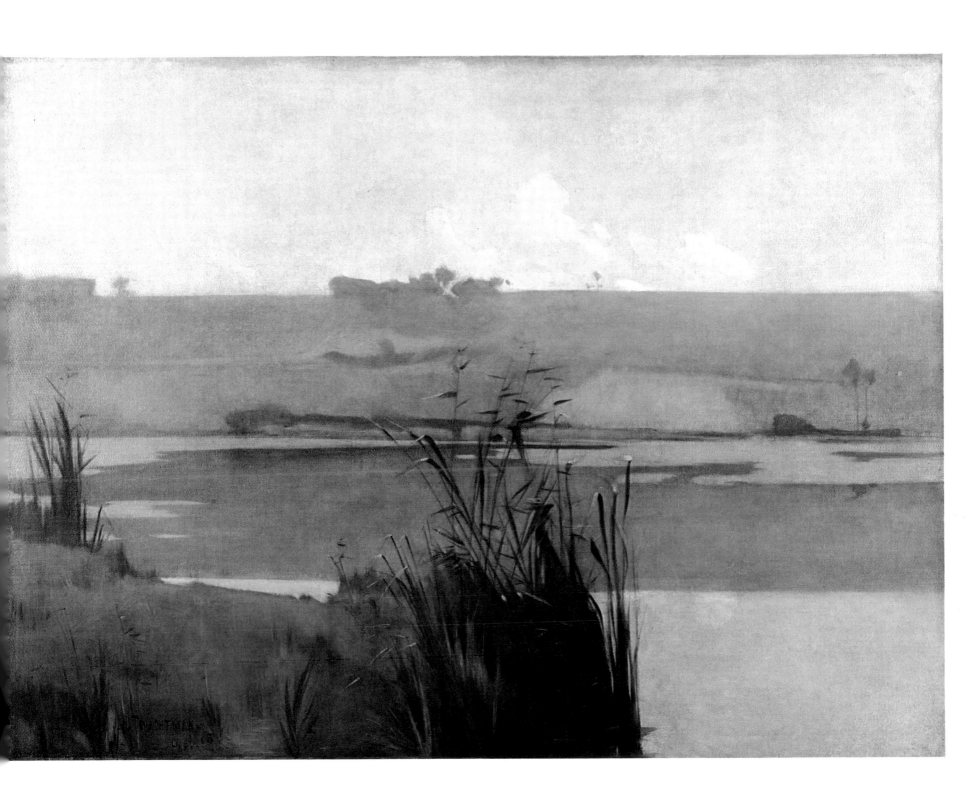

Shortly after his return to America in 1886, Twachtman bought a farmhouse at Greenwich, Connecticut. It was in this rural setting that he created the bulk of his works in the impressionist manner. His friend J. Alden Weir took an adjoining farm around this time, and the two properties formed a nucleus of what later developed into an impressionist colony.

Twachtman had formed a friendship with Theodore Robinson in Paris around 1884 and the latter was a frequent guest at the Twachtman farm in the 1890's. Robinson's painting *Twachtman's House*, done in 1892, bears striking similarities with the technique employed by his friend in *Snowbound*. In this work Twachtman employs a distinctly individual approach to impressionist painting. His palette is restricted to a very few colors, and these he employs in the brighest of tonalities.

During the final decade of his work, Twachtman took little interest in originality of subject matter. Frequently, he painted the same scene again and again, striving for a perfection of color adjustments and achieving a lyrical, visual poetry. *Snowbound*, although dated 1885, does not seem characteristic of his early works and relates closely in style to the paintings of the following decade.

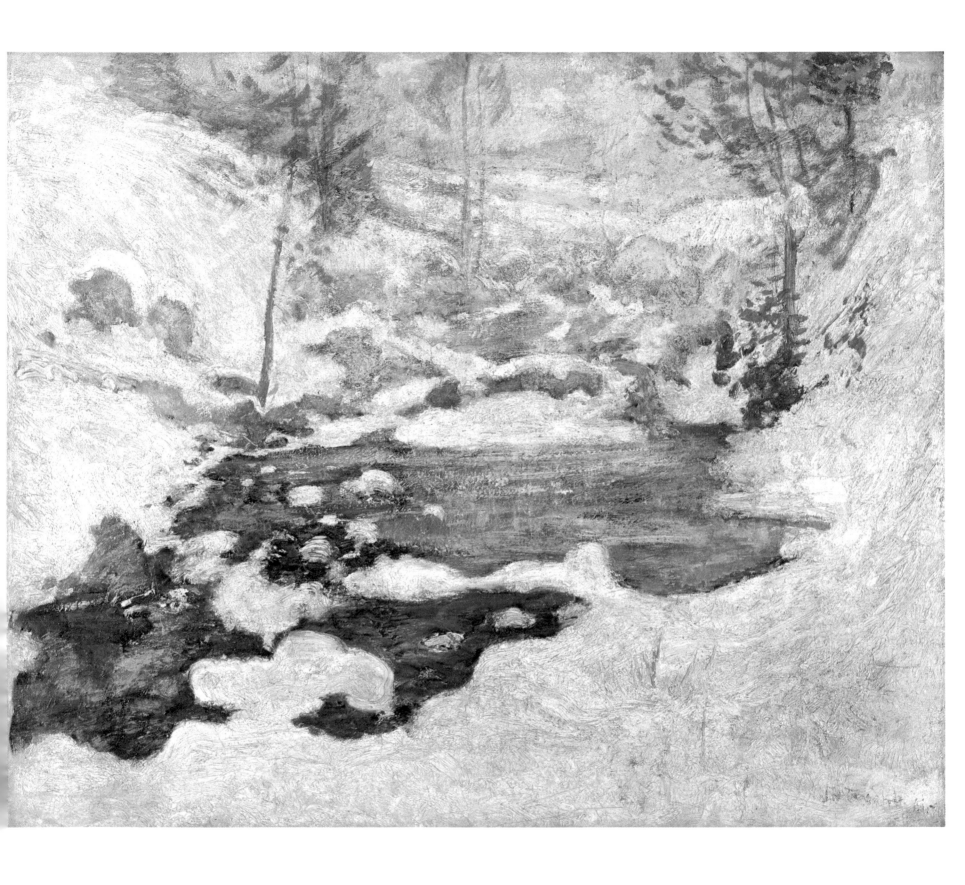

Plate 36
JOHN HENRY TWACHTMAN (1853-1902)
Summer, ca. 1890-1900
Oil on canvas, 30" x 53" (76.2 cm. x 134.6 cm.)
The Phillips Collection, Washington, D. C.

Although Twachtman possessed an authoritative command of the impressionist idiom and technique, his manner of painting was always dictated by his own special vision of the world. His art is contemplative, a matter of the inner eye rather than direct observation of nature. His many variations on similar themes represent his successive attempts to get closer to the essence of nature. As he wrote to his friend Weir, "To be isolated is a fine thing and we are then nearer to nature. I can see how necessary it is to live always in the country—at all seasons of the year." There is more than just an allusion to the closeness to nature in *Summer*, a view of his house and fields at Greenwich. The house merges with the landscape and both receive the same beneficial sunlight.

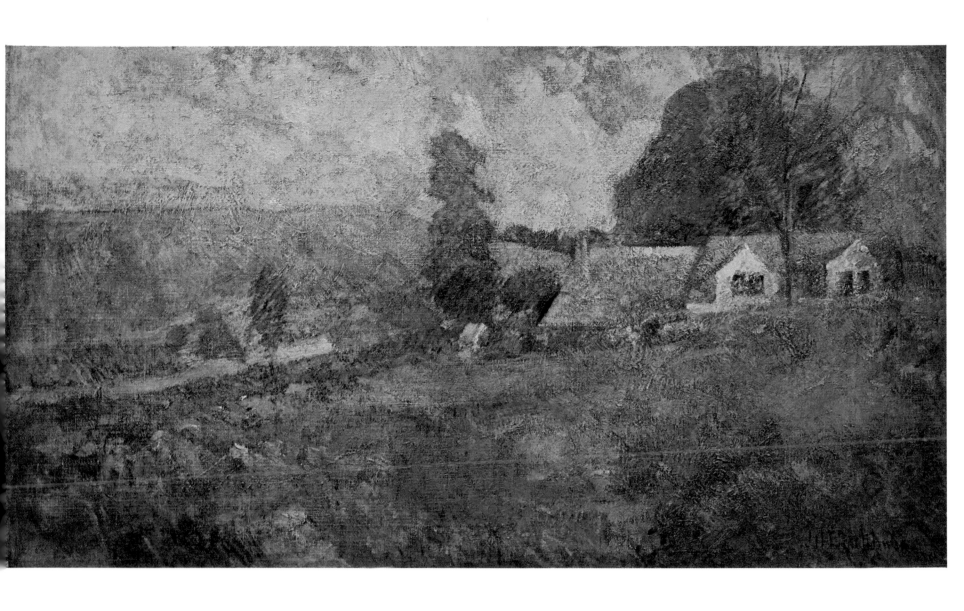

Plate 37
JOHN HENRY TWACHTMAN (1853-1902)
Reflections, ca. 1890
Oil on canvas, 30" x 30¼" (76.2 cm. x 76.8 cm.)
The Brooklyn Museum, Dick S. Ramsay Fund

As if to emphasize the central fact of his paintings—that they do not deal with a particular time or place, but are concerned with the mysteries of nature—Twachtman rarely dated his pictures. Often his work conveys the feeling that he was straining to capture a quality or a mood in nature that took him quite beyond the limits of paint and canvas. *Reflections* suggests a transcendental state of mind. As Thoreau symbolized the dematerialization of the world in his reflections on Walden Pond so Twachtman emphasizes the quality of nature rather than objective substance.

In *Reflections*, the thinness of the paint application in certain passages purposefully denies the spectator any foothold in reality. Paint itself, or the near absence of it, insists that we accept the picture as unreality; it becomes a two-dimensional image of the world, or a mirror reflecting the artist's poetic imagination. The painting's nearly uniform blue and silver tonality, aside from its intimations of Whistler, finds its immediate antecedent in the *Arques-la-Bataille* of 1885.

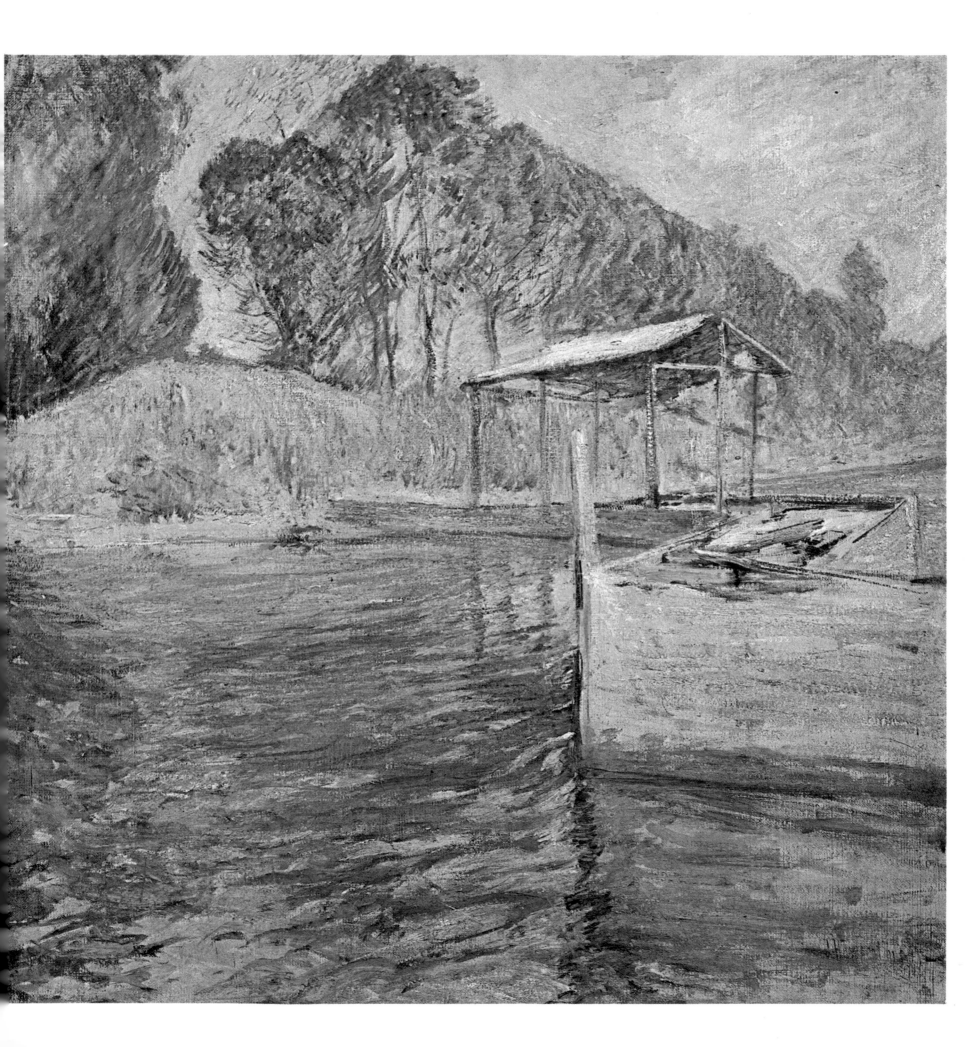

Plate 38
JOHN HENRY TWACHTMAN (1853-1902)
Sailing in the Mist, ca. 1890-1900
Oil on canvas, 30" x 30" (76.2 cm. x 76.2 cm.)
Pennsylvania Academy of the Fine Arts, Temple Fund

In the final twenty years of his life, Twachtman developed the entire oeuvre of his impressionist style. During this period he explored almost every medium available to the artist: oil, pastel, watercolor, and etching. By the time of his death in 1902, he had created paintings in which he took his creative powers to their very limits. He achieved a reversal of the goals of impressionism, as practiced by French artists such as Monet, with his nearly scientific objectivity to nature. Twachtman denied the objective reality of nature by turning his vision inward. His pictures are landscapes of the mind and heart rather than of the world. In this light, he may be added to the company of Ralph Blakelock and Albert Pinkham Ryder, in spite of his nominal position as an impressionist.

Childe Hassam, Twachtman's fellow member in the "Ten," acknowledged the enigma: "The great beauty of design which is conspicuous in Twachtman's paintings is what impressed me always; and it is apparent to all who see . . . that his works were . . . strong, and at the same time delicate even to evasiveness. . . ."

Sailing in the Mist, a painting of almost hypnotic intensity in its utter simplicity, echoes Twachtman's own words on the essence of mood in a picture: "A cloudy sky . . . and a fog to increase the mystery."

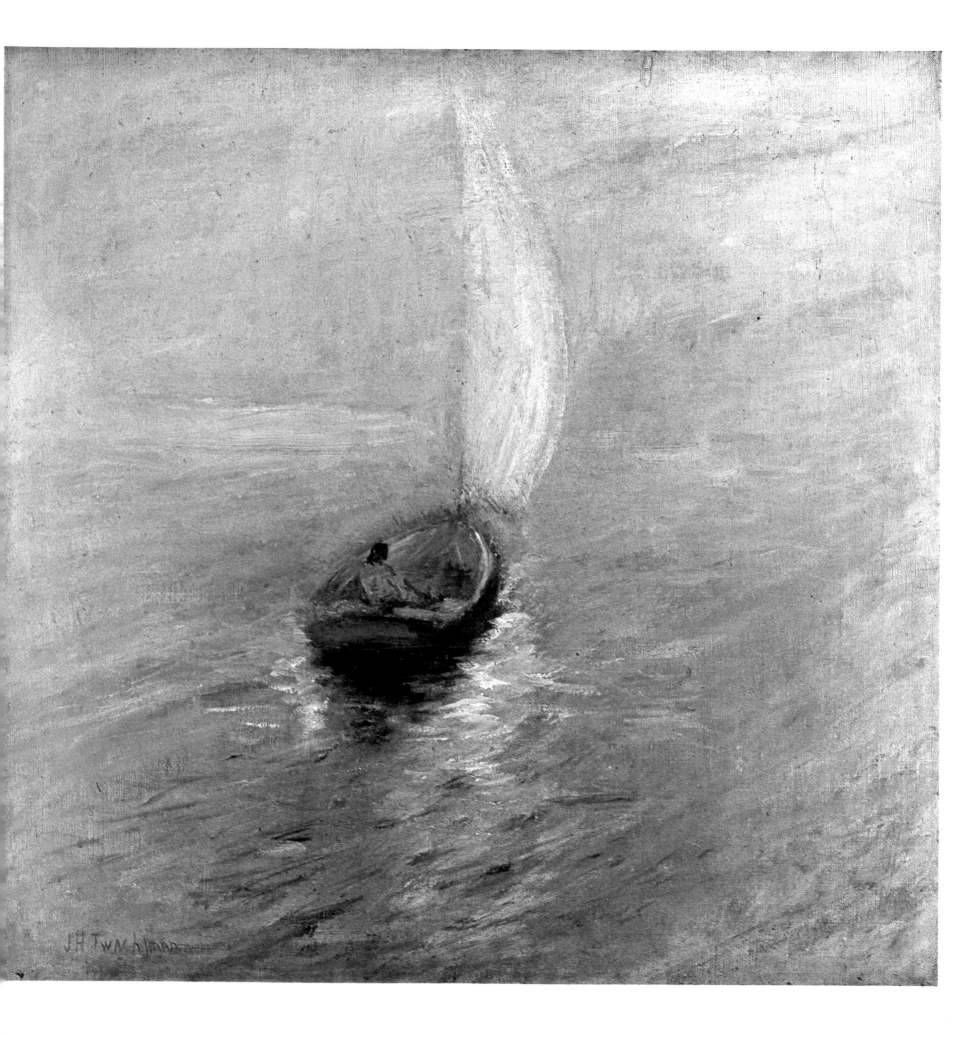

Plate 39
JOSEPH RODEFER DE CAMP (1858-1923)
The Guitar Player, 1908
Oil on canvas, 50½" x 46½" (128.2 cm. x 118.1 cm.)
Museum of Fine Arts, Boston, Charles Henry Hayden Fund

The "Ten American Painters" group permitted a wide range of artistic expression. When they embraced impressionism, it was not a doctrinaire adherence to the French manner that they required, but rather a common ambition to advance their reputations as artists within the scope permitted by the prevailing American enthusiasm for the impressionist mode. The extreme factions of the "Ten" were represented by Twachtman, the dreamer of the group, on the one hand, and Joseph De Camp, the pragmatist, on the other.

De Camp had begun his career as an artist when he and Twachtman were students of Frank Duveneck in Munich in 1875. Five years later, De Camp was back in his native Boston, established as a portrait painter. There he gradually established a reputation for solid, if somewhat undistinguished, portraits.

Undoubtedly, the meteoric appearance of young John Sargent in Boston during the winter of 1887-1888 provided De Camp with a formidable rival. Certainly, De Camp's former Munich style, which he learned under Duveneck, eventually gave way to more fluid brushwork and a more colorful palette, so far as his portrait painting was concerned. And too, in his commissioned portraits, De Camp arranged his sitters in poses reminiscent of Sargent's grand-manner approach.

Portrait work was De Camp's livelihood; it was competent, straightforward, and fairly dull. What redeems him as an artist is the sensitivity and poetry with which he invested his more ambitious exhibition pieces, such as *The Guitar Player*. While the immediate inspiration for such pictures can be traced to the Dutch masters, particularly to Vermeer and DeHoogh, the focus in *The Guitar Player* is softened and the color is grayed according to the prevailing taste of tonalism. In subject matter and treatment, De Camp worked very much along the same lines taken by Dewing, and to some extent, Benson—all members of the "Ten."

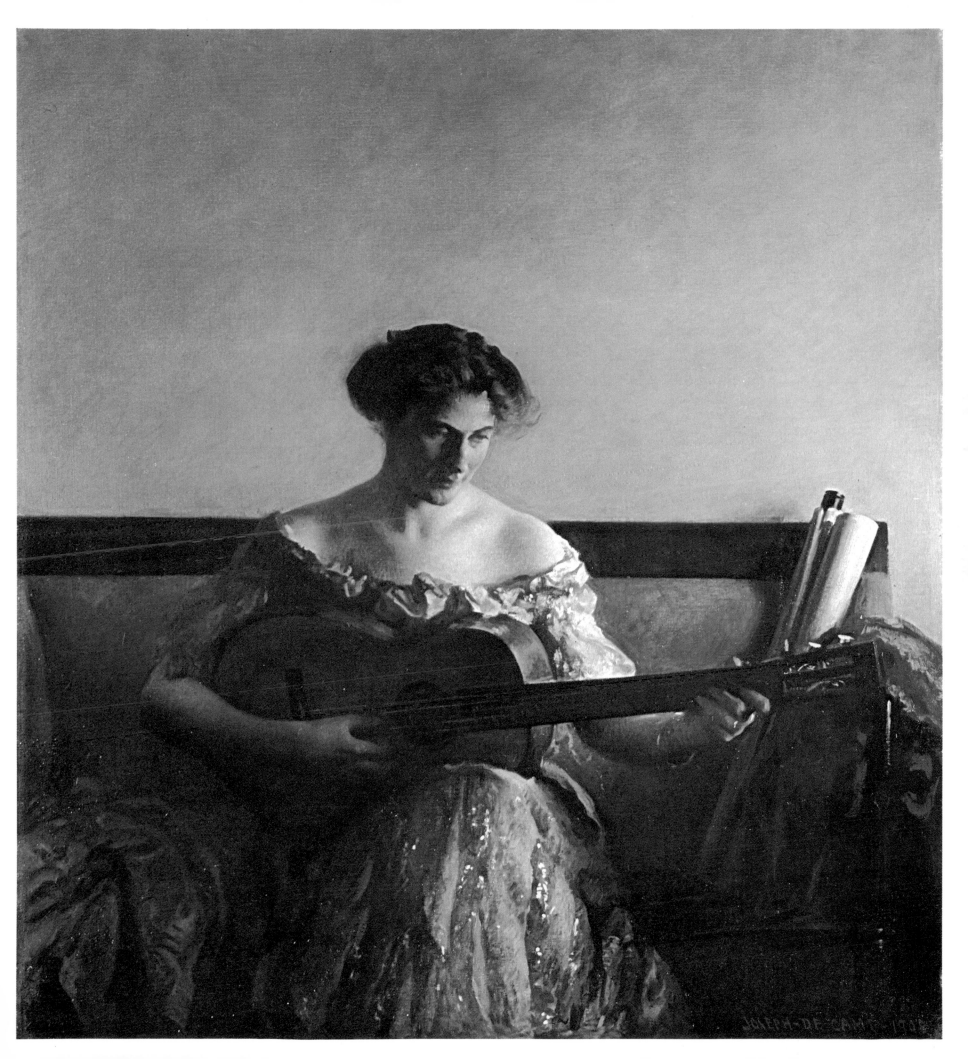

Plate 40
JOSEPH RODEFER DE CAMP (1858-1923)
The Little Hotel, 1903
Oil on canvas, 20¼" x 25" (51.4 cm. x 63.5 cm.)
Pennsylvania Academy of the Fine Arts

De Camp's landscape paintings are rare; there is a strong suggestion that he fell victim to the successes of his portrait painting career. Unlike Sargent, who turned to landscape painting as a release from the demands of such a career, De Camp usually varied his activities chiefly by shifting the emphasis in his work from the routine likeness of a commissioned portrait to the more generalized treatment of the human figure in a poetic setting, such as *The Guitar Player.* Like many artists who become closely identified with a particular kind of subject matter and style of painting and who become, perhaps, unwilling victims of their own mannerisms, De Camp was associated with portraiture and related genre. For the collectors who patronized him, and for the exhibitions to which he was a frequent contributor, this was the "authentic" De Camp. Moreover, the "Ten American Painters" group, to which he belonged, was not established for the purposes of experimentation and innovation in the impressionist idiom, but was the means by which already established talents could solidify their positions and their hegemony over American art at the turn of the century. It is revealing and refreshing to find that De Camp, painting "off duty," proved himself a talented landscape painter.

Apparent in *The Little Hotel* is Monet's powerful influence, especially noted in the treatment of the composition where the foreground, with its emphasis upon the reflections in the water dominates. The colors are soft and pellucid, and the light of nature is captured in an authentic plein-air manner. In subject matter and style, the painting is distinctly French and reminiscent of a description of the town of Giverny given by the French writer Pierre Toulgouat: "You went to Giverny across the old stone bridge that spanned the Seine where, quite possibly, a string of red-painted barges might be coming slowly upstream, or only slightly faster down between the willow-bordered bands—past a tiny carre-four with two inviting outdoor cafes. And the café terrassee of the town's little Hotel Baudy, of a weekend, you might see the same faces and hear the same talk you had seen and heard through the week on the terrasses of . . . Paris; and Giverny became, for a few years, a sort of outpost of Montparnasse."

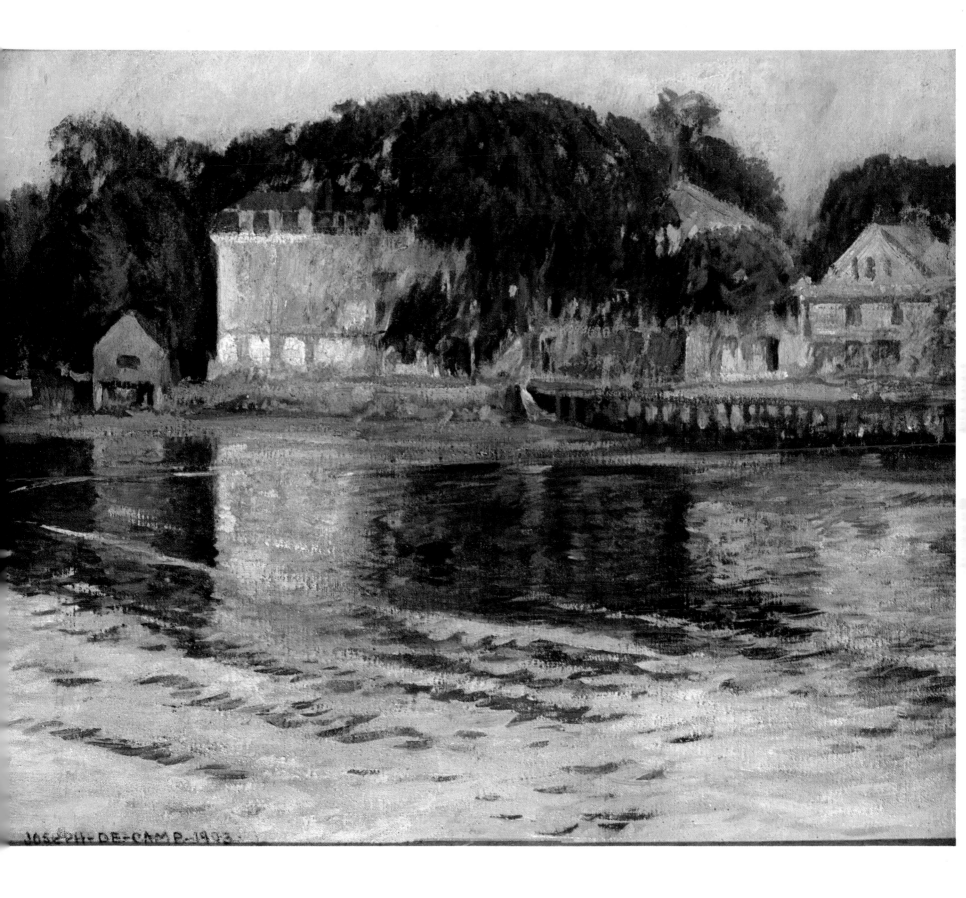

Plate 41
FRANK WESTON BENSON (1862–1951)
Rainy Day, 1906
Oil on canvas, 25″ x 30″ (63.5 cm. x 76.2 cm.)
The Art Institute of Chicago, Friends of American Art Collection

Benson was among the group of painters, including De Camp and Tarbell, who dominated the Boston art world at the turn of the century. Like them, also, he concentrated upon figure painting as his subject matter; and like them, his preference was for handsome women and children. Charles Caffin, the English writer, noted in 1907, in his book *Story of American Painting*, that this Boston group painted pictures "distinguished by manifest dexterity of brushwork and by animated and piquant rendering of the sitter's exterior. . . . The best of such portraits are those of women, which permit the added charm of attractive costumes and surroundings that are pervaded with the atmosphere of refined elegance."

The enthusiasm Benson displays for French painting of the plein-air sort were modified by his thoroughly academic training at the Académie Julian in Paris—principally as a student of G. Boulanger and J. Lefebvre and for a brief time under William T. Dannat, the Munich-trained pupil of Mihály Munkácsy. Thus, Benson's portraits often seem overly involved in matters of detail in drawing that detracts from the intended casualness of his compositions. When he painted figures in the open air, his art seems freer of those restraints; yet his color frequently took on a sweetness, and lacking in force, often diminished the effect of naturalness.

Rainy Day is one of Benson's most ambitious and beautiful works. Like his fellow Bostonian Joseph De Camp, Benson showed a special interest in the subject of single fig-

ures of women seated in sombre interiors. The women are totally self-absorbed, unlike those of Thomas Dewing, who invests his figures with a mystery that is proferred, tantalizingly, to the spectator. In *Rainy Day*, the figure is subordinated to the enveloping atmosphere of the room and becomes an object in the composition little more significant than the Canton jar on the table in the foreground. Benson has carefully orchestrated his color scheme to enhance the pensive, even melancholy, mood of the picture. Light bathes the scene, glancing off polished surfaces or being absorbed into darkness. The mood is also sustained by compositional devices—tensions exist in the picture between objects of similar shape (the jar in the foreground and the mirror on the wall, or the doorway and the fireplace) and create plastic, spatial relationships. In these compositional techniques Benson departs from his accustomed role as an artist who painted too often solely to please a genteel sensibility. That this genteel quality of mind persisted well into the second quarter of the 20th century is evident from the prevailing criticism of the day.

An evaluation of Benson's work, written in 1921 for the *American Magazine of Art*, places heavy emphasis on the notion that the artist who avoids the unpleasant realities of life makes a better contribution to the world than one who paints the harsh truth. Benson succumbed to the temptation to please a transient taste of this kind, and so did not fulfill the promise for greatness so evident in *Rainy Day*.

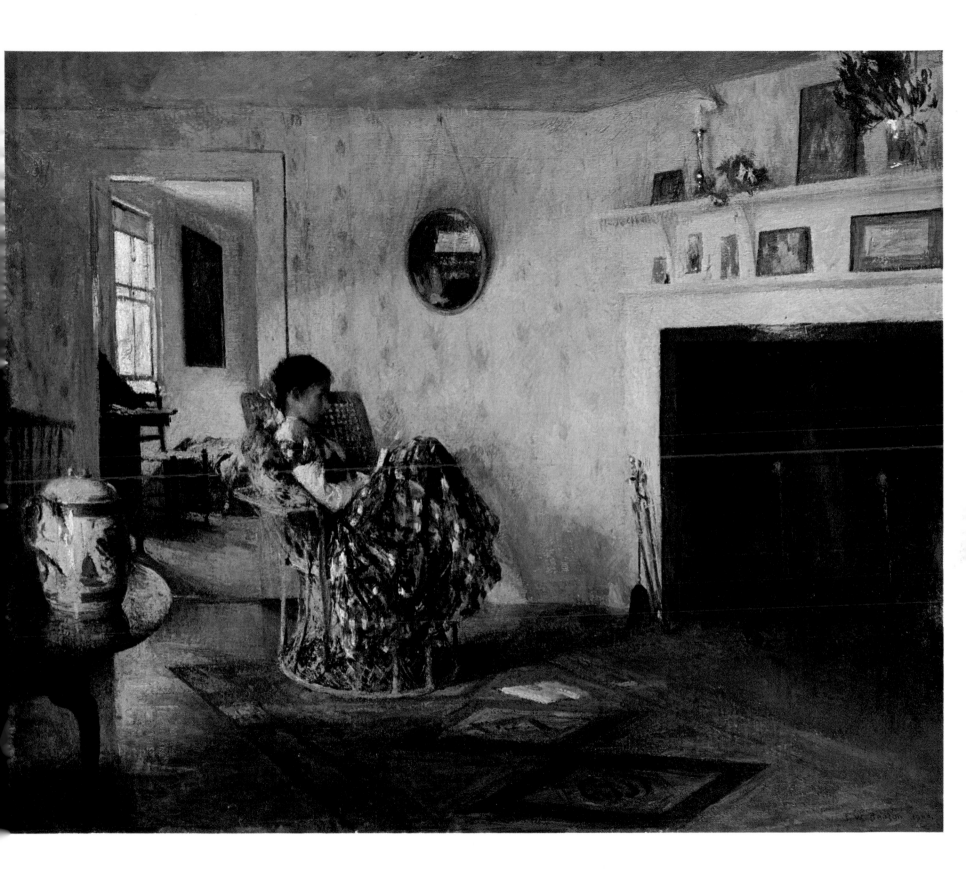

Plate 42
EDMUND CHARLES TARBELL (1862–1938)
In the Orchard, 1891
Oil on canvas, 60¼" x 65" (153.0 cm. x 165.1 cm.)
National Collection of Fine Arts, Smithsonian Institution

James Bryce, the English historian and diplomat, noted in his book *The American Commonwealth*, published in 1888: "In no country are women, and especially young women, so much made of. The world is at their feet. Society seems organized for the purpose of providing enjoyment for them. Parents, uncles, aunts, elderly friends, even brothers, are ready to make their comfort and convenience bend to the girls' wishes." Bryce saw the middle class American woman as the most liberated of her time; and Tarbell, among all of the artists who dwelled on this theme, rendered her image in a glowing and triumphant manner throughout his prolific career. As much as Dewing and De Camp specialized in portraying women enclosed in the moody stillness of dimly lighted interiors, Tarbell's penchant was for the out of doors.

In the Orchard is conceived as a conversation piece, a pictorial device for grouping various figures within a single picture. This device was common in the 18th century. Renoir also used it with great effect, especially in paintings like his *Boating Party at Argenteuil* of 1881; and Tarbell's effort of a decade later is strongly reminiscent of Renoir's decorative use of bright color. Tarbell's effect is more sober, however, and reflects his bias for a genteel tradition, avoiding the robust sensuality of the French artist.

Tarbell was a faithful mirror of his times and tempered his predisposition for impressionism with an authentic realist persuasion. Despite his enchantment with impressionist color, he was ever guided by a principle of reasonableness: "One should try to render the beauty of the thing seen, its color, its drawing, its values, and moreover, it should be a logical whole when finished."

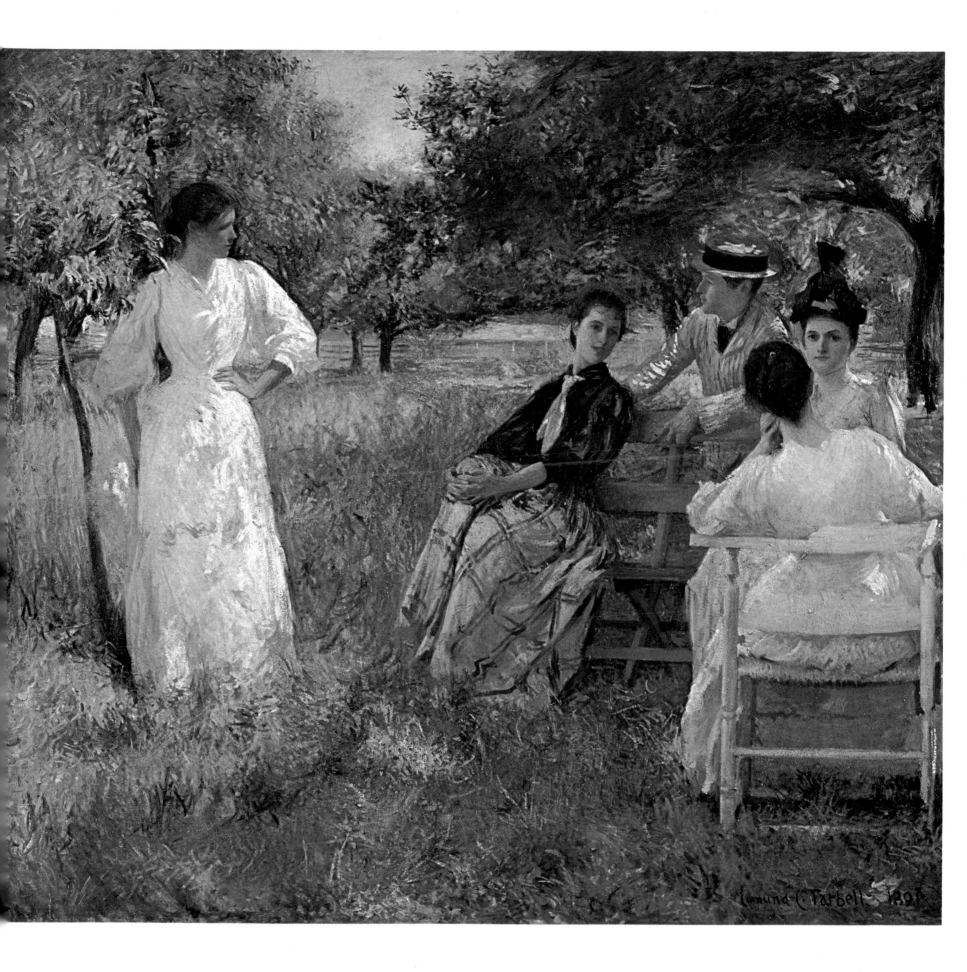

Plate 43
WILLARD LEROY METCALF (1858–1925)
Early Spring Afternoon, Central Park, 1911
Oil on canvas, 36" x 36⅛" (91.4 cm. x 91.7 cm.)
The Brooklyn Museum, Frank L. Babbott Fund

Of the founding members of the "Ten," eight had studied in Paris at the Académie Julian under the conservative guidance of the critics Boulanger and Lefebvre. To some degree, each artist was indoctrinated with an academic dependence upon drawing that permeated even his mature works. At the time of his participation in the exhibition of the "Ten" in 1898, Metcalf was still painting in a manner dependent upon line rather than color. He had largely worked in a traditional, academic method: studies from nature made in the field were brought back to the studio and reassembled into finished compositions.

By the turn of the century, his growing dissatisfaction with his painting changed the course of his career. In 1903, Metcalf moved to Maine for a year during which time he concentrated on painting the northern landscape. He referred to this experience as his "Renaissance," and he returned to New York with twenty-one canvases unlike anything he had painted before.

Metcalf had learned to work directly from nature, but his was an adaptation of impressionist technique more suited to descriptive handling of subject matter than to generalized statements about nature. He adopted the principles of diffused luminosity and broken color, but he maintained a meticulous definition of form. His technique called for a smooth, thin application of color, lacking in the characteristic vibration of plein-air.His painting surface is unobtrusive and recalls the American luminist tradition.

The spirit of impressionism, more than the manner, is seen in *Early Spring Afternoon, Central Park*, with its glowing color and panoramic sweep. The view is from the rooftop of the artist's studio near the corner of Central Park at Columbus Circle. In this painting, impressionist technique becomes a vehicle for the expression of atmospheric perspective: by gradually diminishing the intensity of his brushstroke from foreground to horizon, an illusion of space is created. In its simplicity, the painting has extraordinary visual impact: conceived as three bands of distinct but interrelating colors, the painting carries an impact of nearly abstract formalism.

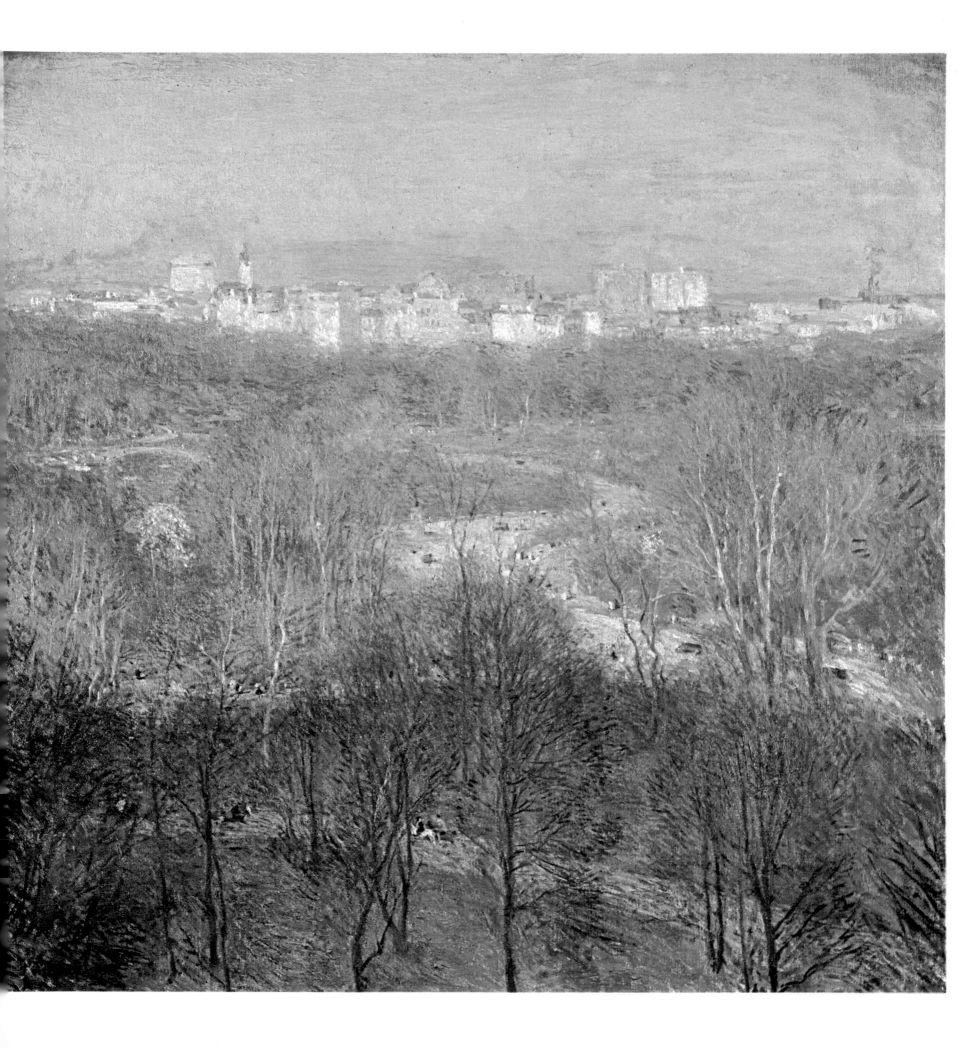

Plate 44
ROBERT REID (1862–1929)
Fleur-de-Lys, ca. 1899
Oil on canvas, 44⅛" x 42¾" (112.0 cm. x 108.5 cm.)
The Metropolitan Museum of Art, George A. Hearn Fund

The career of Robert Reid is difficult to assess today. Like Edward Simmons, a fellow member of the "Ten," Reid was primarily a mural painter and much of the architecture for which these artists provided designs has been demolished under modern urban redevelopment. Only a few of Reid's major examples of mural decoration remain today; his designs for the State House in Boston and the Library of Congress in Washington are insistently neo-Classical figures in the approved beaux-arts manner.

The decade of the 1890's witnessed an unprecedented building boom in the United States, and many young artists who would otherwise have kept to easel painting eagerly responded to the opportunities offered by architects who were looking for suitable decorations to fill the vast new wall spaces. Reid, like most of his contemporaries in mural decoration, created endless processions of idealized girls in Greek costumes. Taken as a whole, the mural decoration of the era presents a monotonous uniformity of theme and style and renders virtually anonymous a whole generation of American muralists. Seen in the context of their easel paintings, however, these same artists assert the individuality of their styles and visions.

In his *Fleur-de-Lys*, Reid enters so zestfully into the spirit of impressionism that one wishes he had spent less time with mural painting. In the high key of its broken-color scheme and in the vigorous but sensitive handling of paint, *Fleur-de-Lys* attains the visual excitement of true impressionism. The compelling boldness of its design renders comparatively harmless the inherent note of cloying sentiment. To compare a girl to a flower is, after all, hardly an original or even an interesting idea. But through the sheer power of its beautiful color, *Fleur-de-Lys* transcends its now-unfashionable literary limitations.

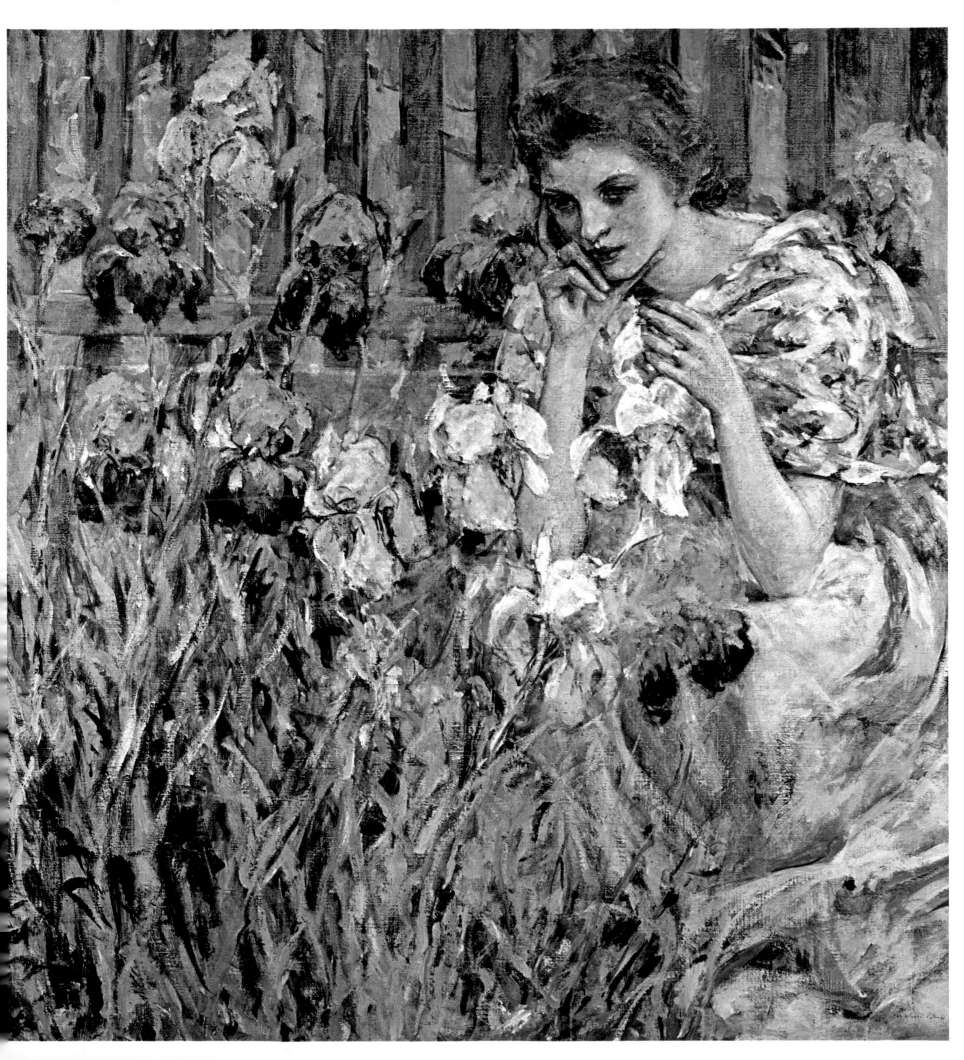

Plate 45
CHARLES HAROLD DAVIS (1815–1933)
North West Wind, 1914
Oil on canvas, 49½" x 39½" (125.7 cm. x 100.3)
The Art Institute of Chicago, The Walter H. Schulze Memorial Collection

Writing in 1905, the historian Samuel Isham complained that Charles Davis and many others of his generation brought "direct vision and workmanship back from the Paris ateliers, but they have usually developed more in accord with a popular taste that knows too little about sound workmanship to enjoy and buy it on its own account." Davis's decade of independent work in France during the 1880's undoubtedly brought him into contact with the strong currents of impressionism then gaining ascendancy. He was a landscape painter exclusively, and like so many others returning to America on the crest of impressionism, he chose to settle in New England. In particular, Southern Connecticut became the home of American impressionsim around the turn of the century: Twachtman and Weir in Greenwich, Hassam and Griffin in Old Lyme, Ranger at Noank, and Davis at Mystic.

Isham's criticism of Davis, that he was pandering to a "public taste" now seems unduly harsh; certainly, the historian preferred less flamboyant artists such as Twachtman and Hassam, but in Davis's hands, the uses of impressionism were taken beyond the realm of calm poetic reflection to a more excited state of mind. This difference is made clearer by comparison between Davis's *North West Wind* and Hassam's treatment of the same theme (Plate 28). Where Hassam's interpretation is more subtle, Davis aims for an immediate dramatic impact through a startling and energetic emphasis on the cloud-filled sky.

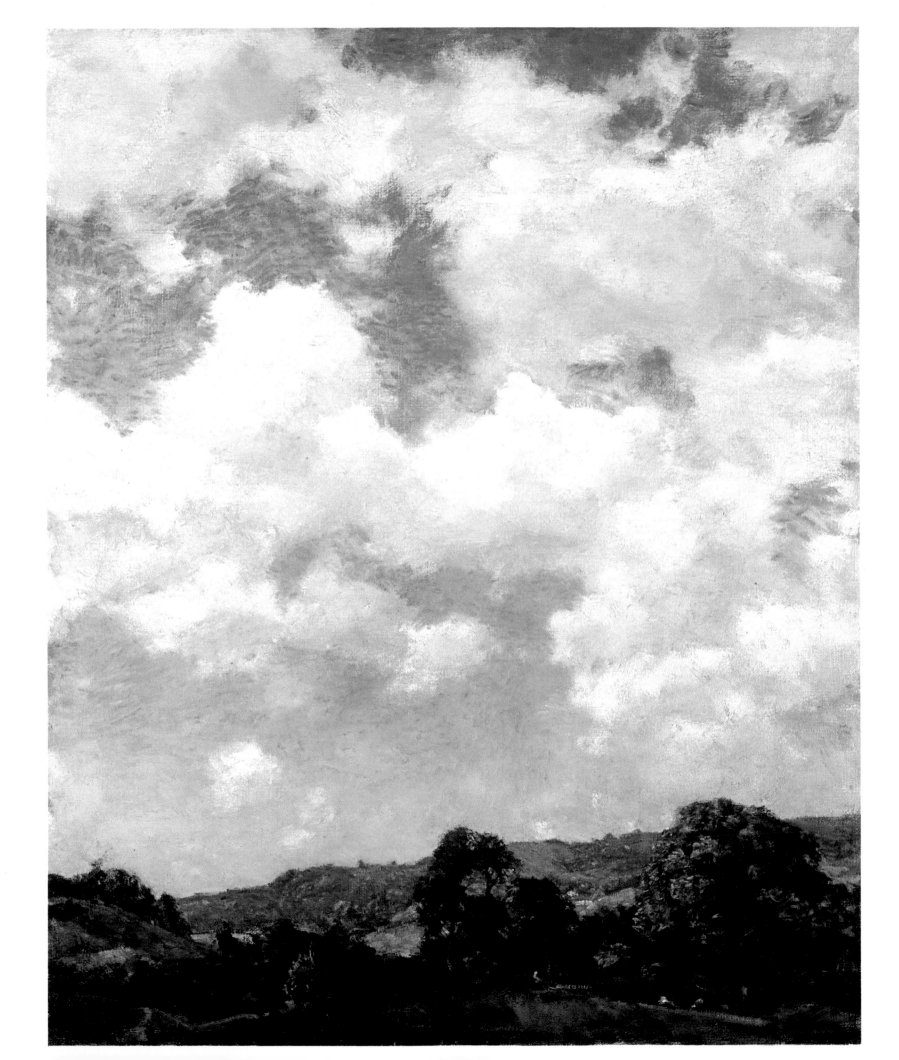

Plate 46
SOREN EMIL CARLSEN (1853–1932)
Connecticut Hillside, 1920
Oil on canvas, 29¼″ x 27⅜″ (74.3 cm. x 69.5 cm.)
The Art Institute of Chicago, The Walter H. Schulze Memorial Collection

Not until he was nearly thirty years old, did Carlsen formally establish himself as an artist. He had struggled with the problems of poverty since his immigration from his native Denmark in 1872, working first as an architectural draftsman in Chicago and then as as engraver in New York. Besides this, he partially supported himself in New York by teaching painting in the private schools of the city and in his studio.

Lacking funds to employ models and lacking the time to travel outside the city, he settled upon still life painting as a means of expression. Gradually he built a reputation in this field so that by 1884 he was retained by a picture dealer to produce an annual quota of still life paintings for the market. Because of the vogue for French art then gripping American collectors, Carlsen was sent to Paris for two years where he might, it was assumed, transform himself into a French artist. The artificiality of this idea was distinctly distasteful to Carlsen, and he apparently turned his interests elsewhere and took a serious interest in landscape painting for the first time.

Immediately upon his return to America in 1886, he collaborated with the Boston animal painter, Alexander Pope, supplying the landscape background for Pope's lifesize figures of a fox-hunting scene. By the turn of the century, Carlsen was formally established as a landscape painter, meriting the attention of Isham who observed of his work that: "It has the quality of his still life studies of game or fish; broad, unbroken masses of color strongly relieved against each other whether sunlit trees against a deep blue sky or white swan against a dead wall, the contrast not being relied on alone for the effect, but the color being made as absolutely true as in less vigorous works."

This sense of fidelity to visual truth, combined with an impressionist orientation to color and light, creates a realism not dependent upon line, and this was present in Carlsen's *Connecticut Hillside.* The composition is highly selective, isolating an apparently random section of nature from which the artist extracts and heightens latent color harmonies. The artist performs the act of the seer: through his eyes the ordinary becomes eloquent.

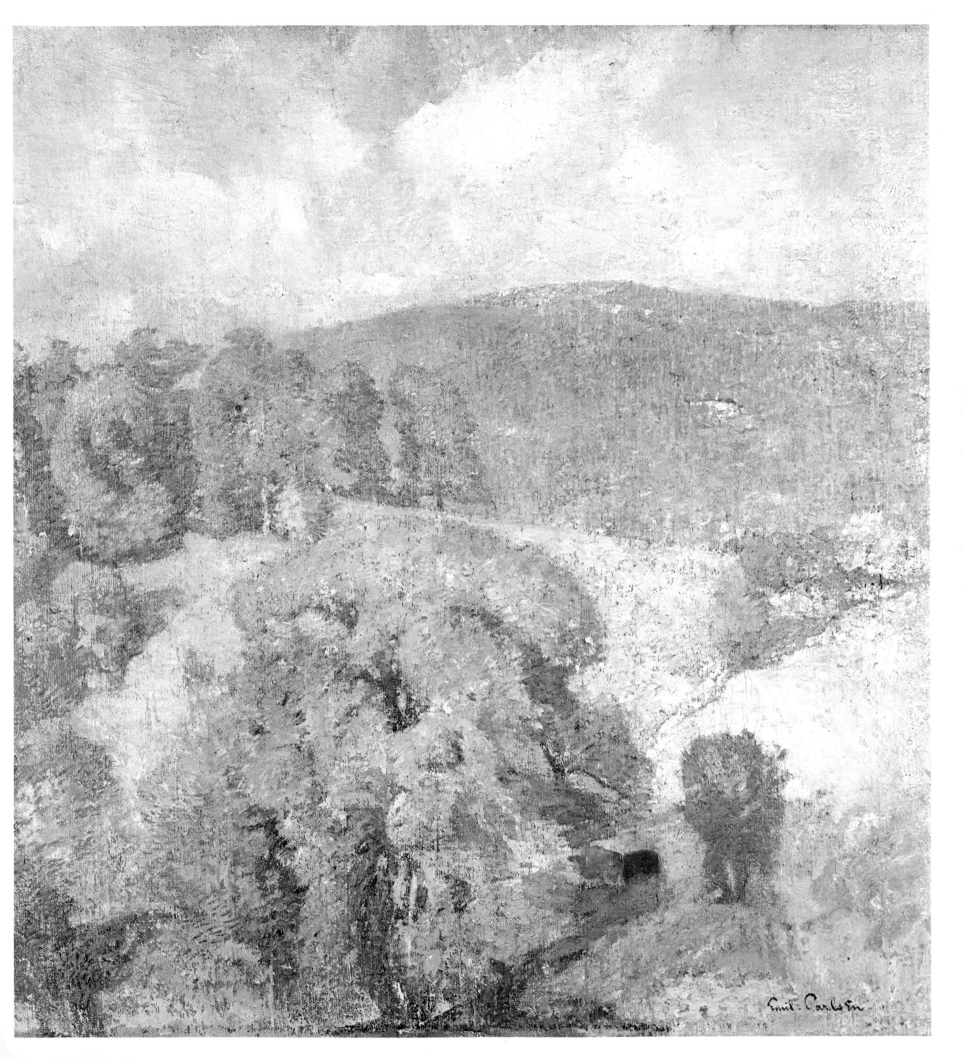

Plate 47
ABBOTT HANDERSON THAYER (1849–1921)
Monadnock, ca. 1911
Oil on canvas, 22" X 24" (55.9 cm. x 61.0 cm.)
The Corcoran Gallery of Art

When Abbott Thayer exhibited his *Virgin Enthroned* at the Columbian Exposition in 1893, it was called "the best work yet produced by an American artist." Among all of the American artists of his generation, Thayer was the acknowledged master of that now curious subject matter—the sentimental, idealized female figure.

There is a quality in Thayer's ethereal maidens that recalls Henry Adams's celebration of the 14th century *Virgin of Chartres.* To both Adams and Thayer, modern life was beset by problems that dissipated man's energies; both of them saw redemption in turning away from the machine age of their own time to the civilizing and humanizing influence of another era, symbolized by the Virgin. Thayer was less sure of himself than Adams; Thayer's struggles to achieve a painted image of maidenly innocence and perfection usually left him exhausted and discouraged. His career is a curious example of a talented artist bent on achieving something which was not really within his grasp.

His summer home at Dublin, New Hampshire, far from being a change from his normal studio work in New York, was an extension of it. For there, his visions of angelic chil-

dren were reinforced by the close association with his neighbors, the painter George de Forest Brush and the sculptor Augustus St. Gaudens, of nearby Cornish.

Through his summers in New England, Thayer developed into an amateur naturalist with a special interest in the protective coloration of animals. While his studies eventually led to the development of the theory of camouflage, Thayer remained a theorist about color, a man who understood the science of color but who could not make the necessary translation of these ideas into art as the impressionists had done.

In spite of his thwarted ambitions, Thayer left tantalizing glimpses of his abilities as a landscape painter. The exquisite tonal poetry of his *Monadnock* is an indication of Thayer's true ability as an artist. The painting depicts a mountain which could be seen from Thayer's property at Dublin and which he painted several times. A work like *Monadnock* conveys an assurance that if Thayer has concentrated in this area and had directed his studies at color in art rather than in science he would have become a brilliant landscape painter.

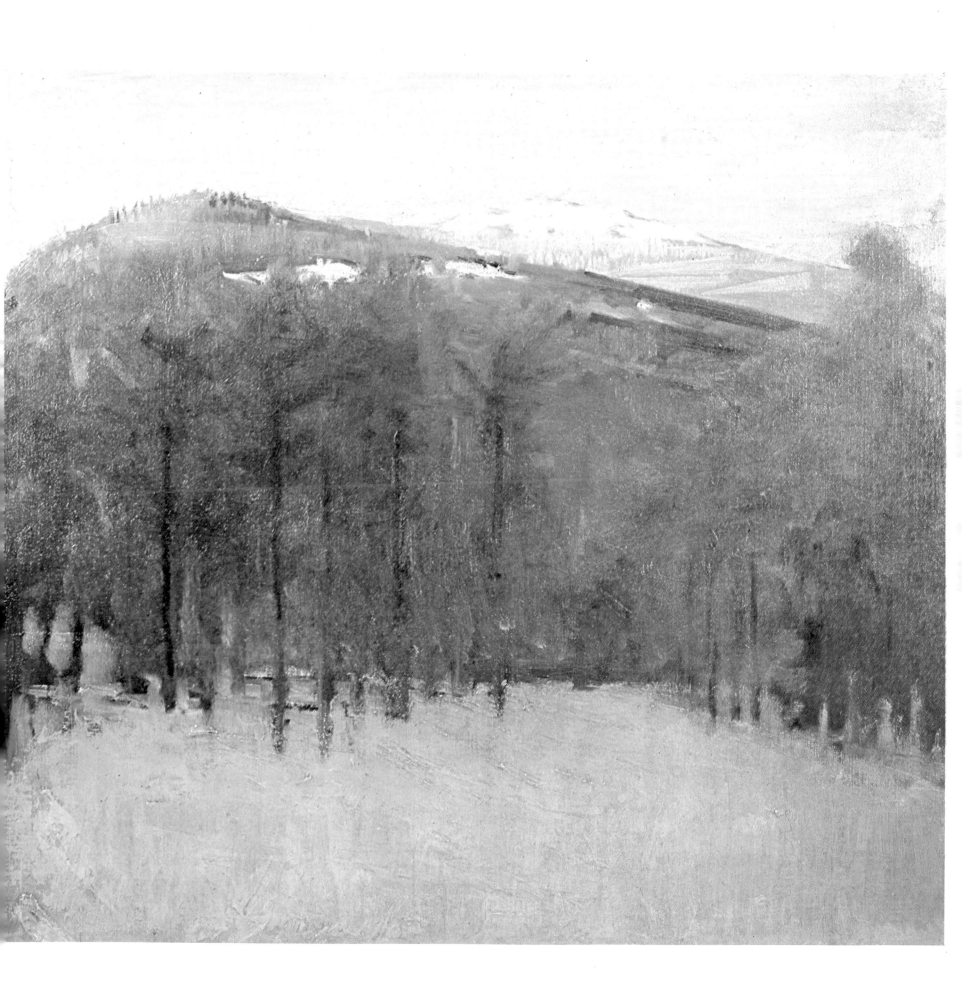

Plate 48
HENRY WARD RANGER (1858-1916)
An East River Idyll, 1896
Oil on canvas, 28″ x 36 ″ (71.1 cm. x 91.4 cm.)
Museum of Art, Carnegie Institute

Through an early interest in the Barbizon School, Ranger was led naturally to the modern Dutch disciples of the school. Ranger was in his thirties at the time of his formal training at the Ecole des Beaux-Arts in Paris, but he was attracted to the work of the genre painters Josef Israels and Anton Mauve, who practiced a style notable for its rather heavy romantic realism. While he was more interested in landscape painting than in genre, Ranger's technique reflected their influence throughout his career. Ranger became well known in America for his dreamy, romanticised, New England woodland scenes. Some critics saw in his work a tendency to paint trees as if they had been observed in other paintings rather than in nature. Ranger composed his landscape paintings in a highly decorative manner and usually presented his subjects as if they were stage settings for a romantic ballet. While he struck a thoroughly agreeable compromise between descriptive realism and poetic vision, Ranger's efforts at idyllic landscape painting are often repetitous.

An East River Idyll avoids easy pictorial clichés; it is one of Ranger's most ambitious and satisfactory efforts. The subject is treated with force, and the broad handling of paint complements the dramatic starkness of this scene of lower East Side New York. The distant, sun-bathed vista of the Williamsburg section of Brooklyn and the honey-hued sky offer a brilliant foil to the darkened foreground, and the whole composition pivots on the pale, blue note of the river. The picture warrants comparison with the work of Sloan and Bellows in its direct observation and rendering of the unexpected visual delights amid the squalor of the city.

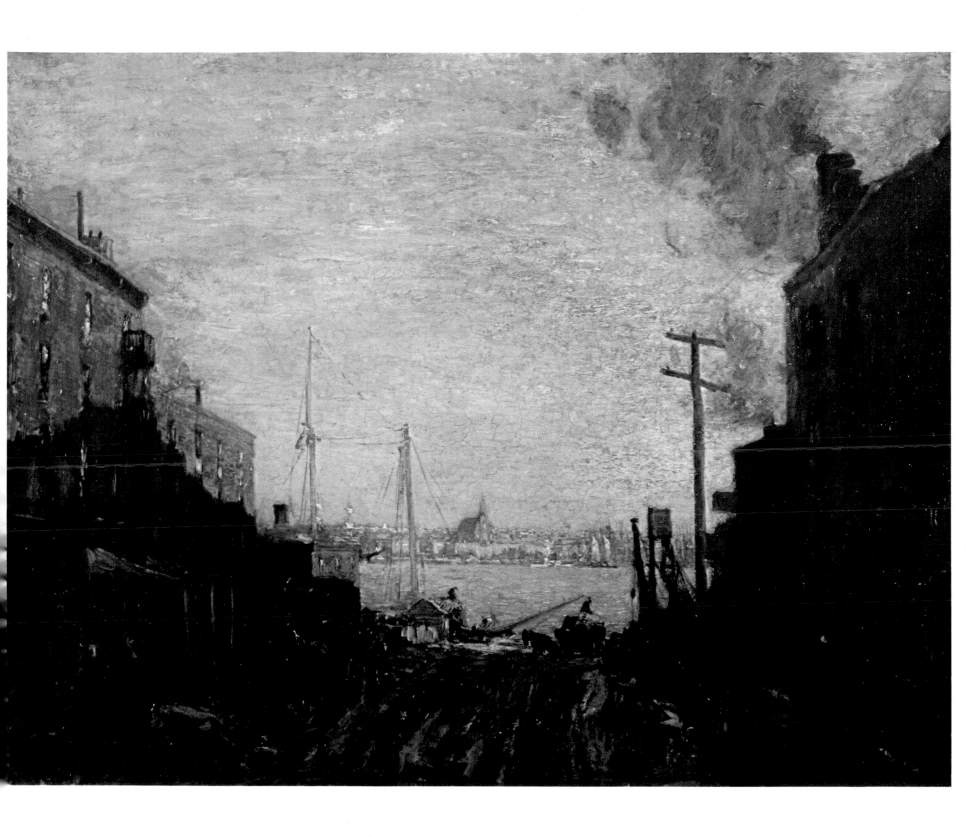

Plate 49
THEODORE EARL BUTLER (1860-1936)
Gisors Train in the Flood, 1910
Oil on canvas, 31¾" x 25¾" (80.6 cm. x 65.4 cm.)
Private Collection

At the turn of the century, Giverny became the center of impressionism as Paris was swept by newer movements in art. Monet settled in Giverny in 1883 at the high tide of impressionism, and through his interest and encouragement to young, visiting students, the town flourished as an artists' colony. Its charm lay in the fact that it did not lose its original character as a rural village. As one observer noted: ". . . there was something in the bland, peaceful, simple Norman atmosphere that kept it from succumbing to Bohemia. In the fields, artists at their easels shared the meadows with farmers who were plowing, and at night . . . they split a comradely bottle of wine together."

In 1888, Butler was introduced to the town and to Monet by Theodore Robinson, who aligned his own style of painting with impressionism that year. The effect on Butler was profound: he became an intimate of Monet's household and eventually married Monet's stepdaughter Suzanne Hochedé. Butler spent his life at Giverny, except for the period of the First World War when he worked in New York. He resumed his life at Giverny in 1921, becoming an accepted permanent resident of his adopted town. A friend described his house there, notable for its ". . . nearly blank wall on the north to protect it from winter rainstorms; the only north light was in Butler's sacrosanct studio. The living room was crowded with pictures, mostly fine Monets."

Butler learned to see nature as if he had been born to impressionism. His close association with Monet was an important factor in his development, yet his work is strongly individual in spite of it. *Gisors Train in the Flood* is a lyrical work and owes much to Monet's broad style; yet its daring harmonies in blue, violet, and gray depart from the master's manner and take on a decorative purpose apart from the impressionist concern for atmospheric color. There is the suggestion of atmosphere, but it is achieved through the symbolic poetry of color, rather than through an approximation of visual phenomena in broken color.

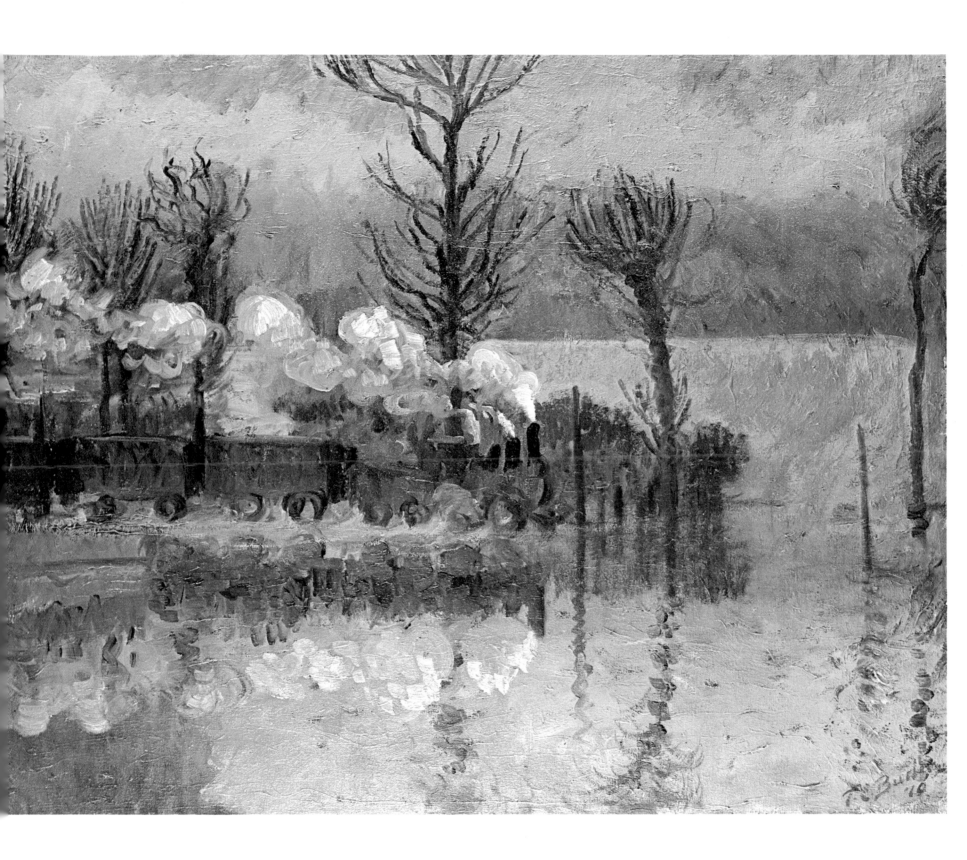

A number of important American artists have emanated from Cincinnati, including Worthington Whittredge, Frank Duveneck, John Twachtman, and Edward Potthast. In the 19th century, the Ohio city had a strong German orientation; a number of immigrants from Germany settled there after having fled the social upheavals in that country during the first half of the 19th century. Twachtman and Potthast came of German stock, and both were first attracted to Munich for their training in art. However, Potthast remained in Cincinnati until he was thirty before going abroad; he had established a career as an illustrator before turning to painting.

Potthast's painting is an amalgam of strong Munich brushwork and the bright palette of impressionism, for his three years of study abroad were spent partially in Paris where he was influenced by the impressionist work of a fellow American student Robert Vonnoh. Potthast established a studio in New York in 1892 and divided his time between painting and illustrating for *Harper's*. Trips to the West gave him an opportunity to paint ambitious pictures of the Grand Canyon, and he also experimented with night scenes in the spirit of the tonalist painters.

But Potthast is best known for his small, sun-drenched beach scenes of people at play on the sand and in the surf. In these pictures, the artist's eye was ever alive to the subtleties of colors found in reflected light as well as colors in direct sunshine. Adjusting his palette to the uppermost register of bright color imposed by these surroundings, he worked spontaneously from nature. His method was direct; there is a great assurance in his work, conveying the sense of life and movement. At the same time he always employed paint in a sensuous, tactile manner, conveyed through a rich, surface impasto. Potthast's prolific variations on this dominant theme, beach scenes, made him a younger, more vigorous counterpart to Eugene Boudin, the French impressionist. Both artists found inexhaustable inspiration in the play of light endlessly reverberating in the elemental confluence of sky, sand, and water.

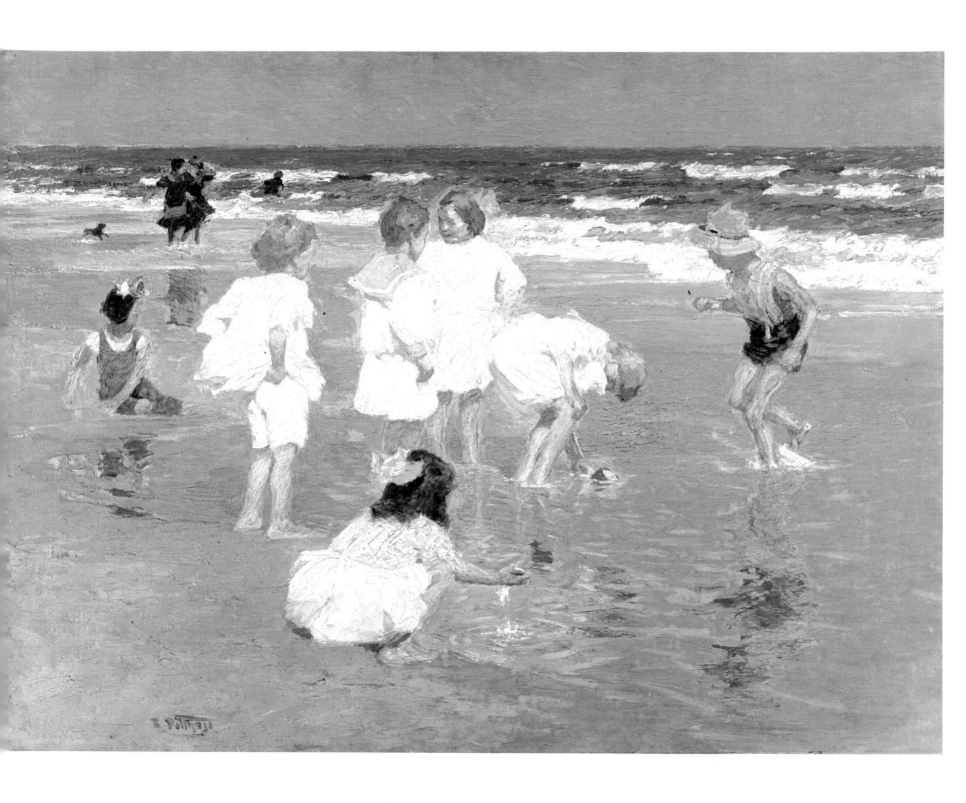

Plate 51
WALTER PARSONS SHAW GRIFFIN (1861-1935)
Springtime, before 1917
Oil on canvas, 23″ x 36″ (58.4 cm. x 91.4 cm.)
Memorial Art Gallery, University of Rochester

Griffin's development as an artist took him through every phase, beginning with a dry, linear manner learned at the National Academy of Design in the early 1880's, through the Barbizon style to plein-air impressionism. His last efforts in the period, just before his death in 1935, suggest an interest in expressionism, where he employed a rugged, palette-knife technique in thick, brilliantly colored impastos.

His long residence in Brittany from 1890 until 1897 and his thorough knowledge of and sympathy for French art gave his painting the quality of an authentic impressionist style. Returning to America at the end of the decade, he settled at Old Lyme, Connecticut in 1905. There he remained for four years; he was a close friend of Childe Hassam and an honored member of the artists' colony of the town. Up to this time Griffin had divided his energies between painting and teaching, but his work at Old Lyme apparently convinced him to become fully committed to painting. Traces of Barbizon sentiment lingered in his work, but Hassam's influence is strong in Griffin's Old Lyme pictures and seems to have been a catalyst for change. Griffin returned to Brittany in 1911 and there firmed his command of impressionist technique.

Springtime was painted during this period. It is one of scores of pictures Griffin painted of the town of Boigneville, his adopted home until 1918 and the place to which he returned many times in the years following. The Boigneville period brought Griffin's art to fruition. In *Springtime* there is an orchestration of pure vibrating color of the utmost richness, but the colors are employed in a way that exactly defines pictorial relationships and forms. Griffin achieved in the Boigneville series a pictorial equivalent of the poet's ambition—the expression of emotion recollected in tranquility.

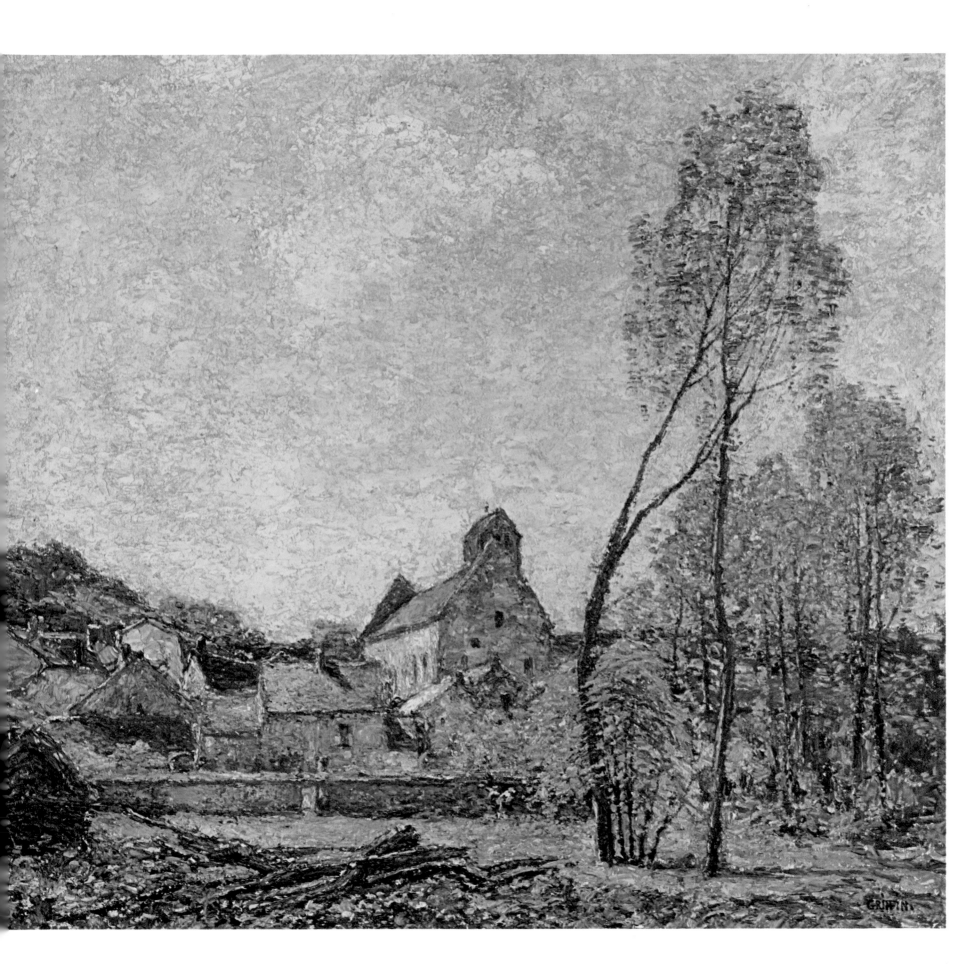

Plate 52
FREDERICK CARL FRIESEKE (1874-1939)
Summer, 1914
Oil on canvas, 45″ x 57¾″ (114.3 cm. x 146.7 cm.)
The Metropolitan Museum of Art

In 1898, at the age of twenty-four, Frieseke went to Europe and remained there for the rest of his life. With only a brief preparation in art gained at the Art Institute of Chicago and at The Art Students League of New York, he entered the Académie Julian. Frieseke preferred to disregard these experiences and say that he was self-taught. Largely that was true; he equipped himself more through the study of the works of other artists than through academic routine. Renoir and Fantin-Latour were his favorites, but Monet proved to be the most formative influence.

In 1906, Frieseke bought a house in Giverny, formerly occupied by Theodore Robinson. His immediate neighbor was Monet, and the proximity to the patron saint of Giverny eventually produced an effect on Frieseke's style. But Monet's example was only part of the richness of French art from which Frieseke drew nourishment. As late as 1910, the strong, flat color and design of the post-impressionists dominated his interior compositions. About that time, he settled down to paint sunlight. As he commented in an interview in 1914, "It is sunshine, flowers in sunshine, girls in sunshine, the nude in sunshine, which I have been principally interested in. . . ."

Frieseke thought of himself as a realist, reproducing nature on canvas exactly as he saw it. His creative process involved immediate transformations of visual phenomena into highly personal statements about color and form, not realistic even by impressionist standards. His color departs from the representation of true sunlight because of its stylistic emphasis upon purely formal harmonies. Chiefly, Frieseke delighted in juxtapositions of pink and white against which he played sharp blues, yellows, and greens. The color relationships of his post-1912 works are decidely more modern in feeling than Monet, yet there lingers about Frieseke's paintings of this period a certain feeling for the handling of paint that links his work with that of the French masters.

Frieseke was concerned for his freedom of expression, citing as his reason for remaining in France as a expatriate, ". . . because I am more free and there are not the Puritanical restrictions which prevail in America. Not only can I paint a nude here out of doors . . . but I can paint a nude in my garden or down by the fish pond and not be run out of town." That freedom is frankly expressed in *Summer*, where Frieseke's sense of color is stated in strongly accented patterns of the foliage which serve to heighten the more delicate passages of whites and pinks of the nude figure and her companion. Here he comes close to the sensuousness of Renoir in his frank admiration of the female nude.

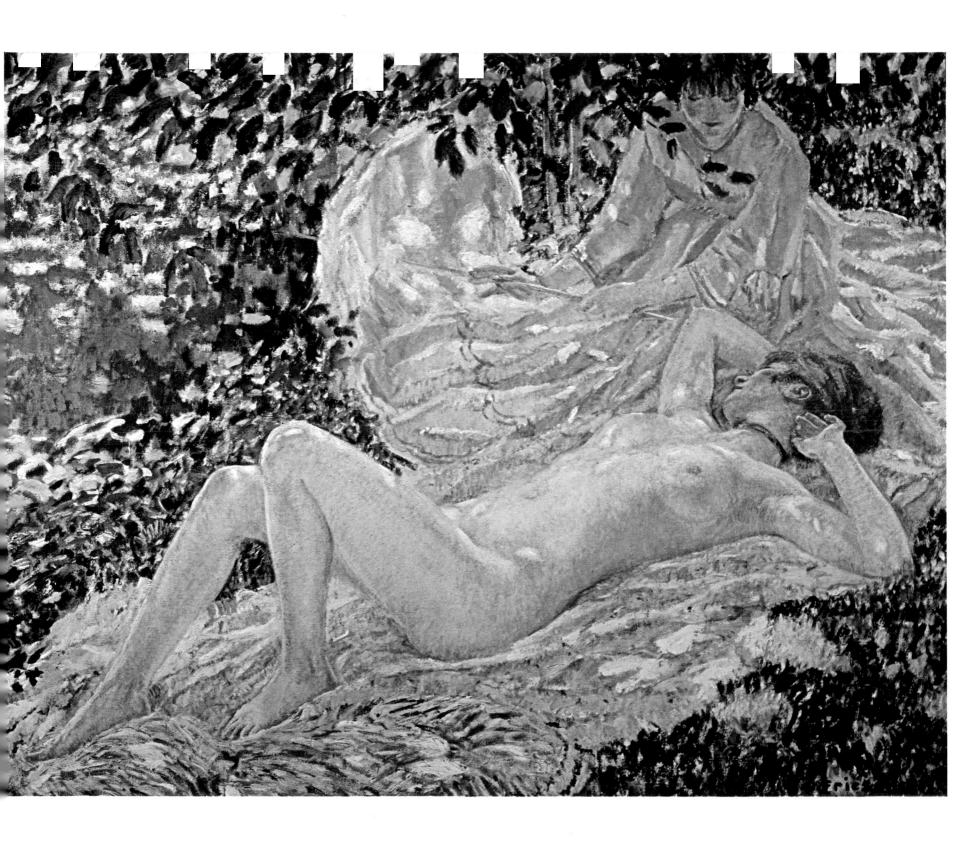

Plate 53
JOHN SLOAN (1871-1951)
Wake of the Ferry, 1907
Oil on canvas, 26" x 32" (66.0 cm. x 81.3 cm.)
The Phillips Collection, Washington, D. C.

As an artist-reporter for the Philadelphia *Inquirer,* Sloan early in his career developed the habit of rapid sketching from scenes of contemporary life. Moreover, he had the advantage of having studied with Thomas Anshutz, a disciple of Thomas Eakins, and with Robert Henri, who had studied in France and admired Courbet and Manet, the leaders of French realism. Sloan commenced to paint seriously around 1900.

In 1904 he moved to New York and supported himself by giving lessons in etching. He found New York a source of constant stimulation: "When I had city life work to do while drawing for the paper, it was just a 'job' . . . I emerged into real interest in the life around me, with paint in hand, *after* I came to New York." Sloan spent several hours each day walking the streets of lower Manhattan in search of that life. Theodore Roosevelt described that part of the city in his *Historical Essays:* "The Bowery is one of the great highways of humanity, a highway of seething life, of varied interest, of fun, of work, of sordid and terrible tragedy, and it is haunted by demons as evil as any that stalk through the pages of the *Inferno."* Sloan's eye was attuned to the rhythms of that life; he was the artist counterpart of the great social writers of the time like Theodore Dreiser and O. Henry.

Sloan's mentor continued to be Robert Henri, who had gone to New York to teach at the Chase School. Henri was a champion of realism in art, and he taught as he painted— with fervor and incisiveness. Sloan never studied in Europe, but Henri's understanding of the modern French schools imparted to the younger man a style of painting that was charged with expressive use of color. The mood of that color was sombre; Manet's influence was closely at the center of Henri's style. Henri and Sloan offered an alternative to the kind of colorful decorative impressionism then ruling American art. Sloan retained the fluidity of impressionist brushwork but chose a muted palette, suiting his color to the temper of urban experience, and frequently, of his state of mind. *Wake of the Ferry* joins these impulses.

During his first years in New York, Sloan often made trips across the Hudson River aboard the Jersey City Ferry. He explained this as a vague impulse to escape: "New York still awed an unacclimated Pennsylvanian." The ferry ride was a symbolic gesture as, ". . . the first lap on the road home." An entry for his diary for March 19, 1907, records, "Back home from the ferry ride, I made a start on a canvas, *The Wake of the Ferry* it might be called if it is ever finished. . . ." In a fit of despair prompted by personal anguish, he destroyed the first picture. In May, 1907, he began the second version, the one represented here. The picture exudes a profound melancholy; the lonely traveller is perhaps a self-portrait of the artist who once observed, "Optimistic people go to the front of the boat, the depressed stand on the stern."

A year later, in 1908, Sloan participated in the exhibition of "The Eight" at William Macbeth's New York Gallery. Joining Henri, William Glackens, George Luks, Everett Shinn, Arthur B. Davies, Maurice Prendergast, and Ernest Lawson, Sloan contributed to an event that shook the American art scene to its foundations. Ridiculed by conservative critics for depicting ordinary life in New York, "The Eight" had acquired the sobriquet "Black Gang." But it was largely on the basis of Sloan's paintings of Greenwich Village backyards that the term "Ashcan School" came into general usage. Once a title given in contempt to this group, it has in time acquired—like the term "impressionist"— honorable connotations.

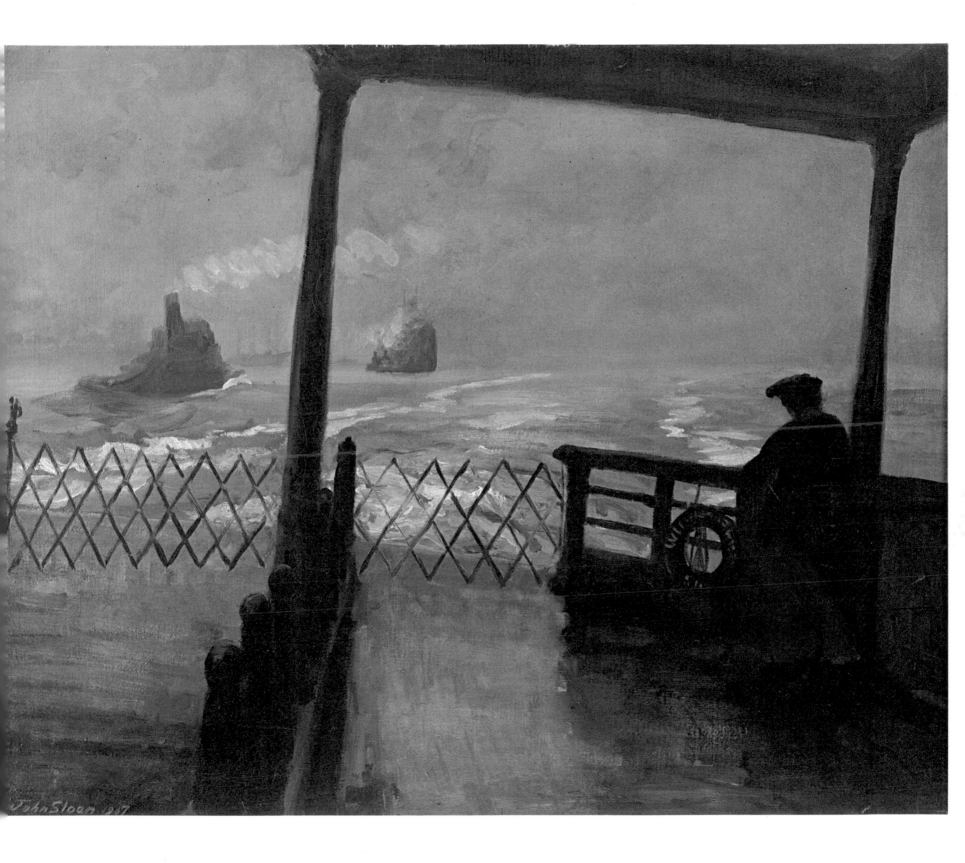

Plate 54
GEORGE WESLEY BELLOWS (1882-1925)
Pennsylvania Station Excavation, ca. 1906
Oil on canvas, 30¼" x 38¼" (79.4 cm. x 97.1 cm.)
The Brooklyn Museum, A. Augustus Healy Fund

The nucleus of "The Eight" was formed by men who had worked together as newspaper artists in Philadelphia. Only Davies, Prendergast, and Lawson came from outside this circle. Bellows might well have joined this group, for his background as an illustrator for a Columbus, Ohio, newspaper gave him a point of view about art similar to that held by "The Eight." And had "The Eight" exhibited as a group again after their Macbeth Gallery debut in 1908, it is conceivable that Bellows might have been invited to join. He was already one of Henri's favorite students in the latter's controversial art school on upper Broadway. And Bellows had caused a sensation in 1908 with his energetic prizefight scene *Stag at Sharkey's,* a picture as fully charged with creative energy and forthright realism as anything conceived by the Ashcan painters. However, Sloan was an adamant and formidable enemy who remained opposed to Bellows, calling him "a sentimental illustrator" with "no selective impulses."

Bellows had been an amateur prize fighter. He reserved a special place in his affections for the glamor and excitment of the ring, and he created a formidable body of pictures on the subject. However, away from the sporting world, Bellows tended to paint New York's more smiling aspects, such as pleasant snow scenes of the Hudson River or children at play in Central Park.

The point at which he truly merged with the spirit of the Ashcan painters occurred around 1906 when he made a group of paintings all based on the ongoing excavation for the new Pennsylvania Station building designed by McKim, Meade, and White. The work for the building had opened up a gigantic hole in midtown Manhattan that covered an entire city block. Bellows was inspired to make a series of six pictures on the subject. In each he chose dusk or night as the setting for the excavation under way. Some of these pictures seem illuminated by hellish fires and Bellows's comment on the Herculean project leaves no doubt that he viewed it with mixed reactions of awe and apprehension. In the Brooklyn version, he charges the scene with a spectacular, nearly garish sunset, against which stark buildings loom dramatically. Down in the vast pit, human ants labor at their steam shovels and rock drills, while scattered fires burn in the growing winter dusk. In this, Bellows caught the spirit of modern New York bent on becoming the most important city in America and sweeping aside the past and its outmoded architecture in its rush to create immense new symbols of power.

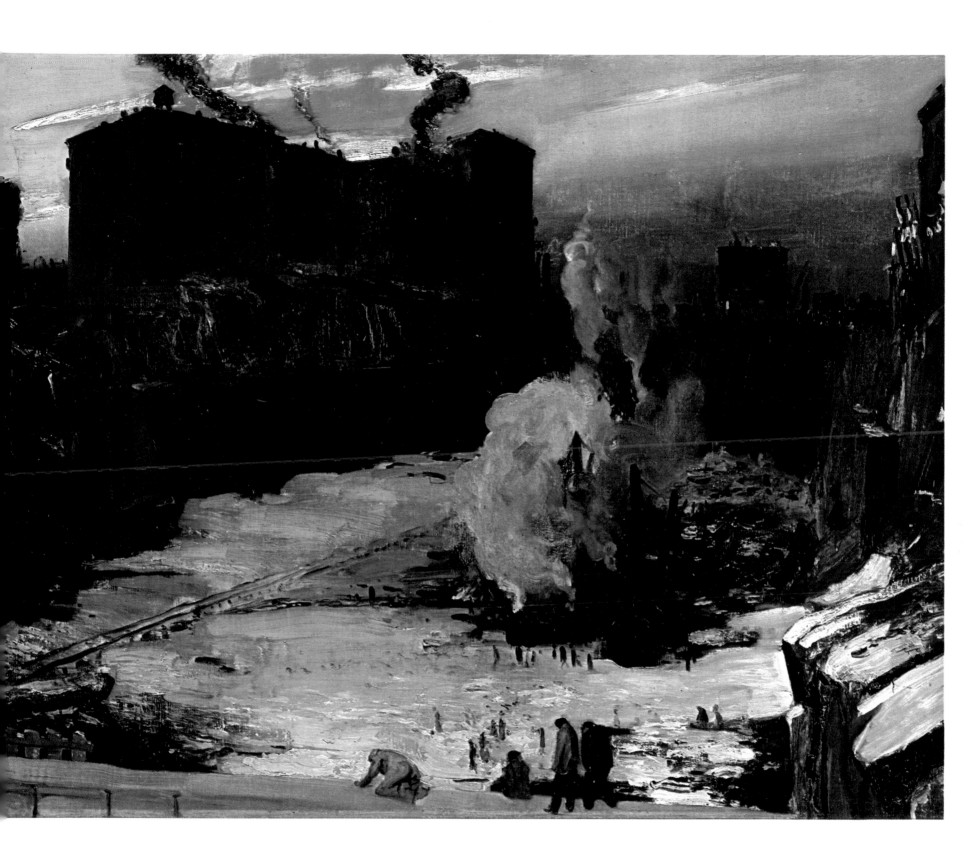

Plate 55
WILLIAM JAMES GLACKENS (1870-1938)
Chez Mouquin, 1905
Oil on canvas, 48⅜" x 36¼" (122.3 cm. x 92.1 cm.)
The Art Institute of Chicago, Friends of American Art Collection

In 1895, Glackens gave up his job as an artist-reporter for the Philadelphia *Ledger* and went to France for a year of study. Robert Henri, his mentor in Philadelphia, had studied painting in Paris in the late 1880's and accompanied Glackens, acting as his guide in matters of art. Glackens returned to New York in 1896 and began to exhibit his paintings while he continued his old profession, this time for *McClure's Magazine*. That year, he sent three pictures to the Pennsylvania Academy's annual exhibition; from their titles, they were scenes of New York: Central Park, the Battery, and his first version of *Chez Mouquin*. Mouquin's restaurant, at Twenty-eighth Street and Sixth Avenue, was the favorite gathering place for artists, writers, adventurers, and ladies of easy virtue. Everett Shinn, another member of Henri's Philadelphia coterie, recently come to New York himself, observed, "It was at Mouquin's that the crowd really became intimate."

By 1905, Glackens had become well acquainted with this place, and with the raffish personalities who made it interesting. One of these, James B. Moore, a lawyer by profession and a dilettante *restaurateur* who ran his own Café Francis on West Thirty-fifth Street, was one of its most colorful figures. Moore exchanged meals at his restaurant for paintings from young artists like Ernest Lawson and allowed the impoverished poet Edward Arlington Robinson to live rent free in the attic of his house. Moore had a large following of pretty young women, whom he referred to as his "daughters," and was fond of being seen with them at Mouquin's. He appears with one of these "daughters" in the 1905 *Chez Mouquin*, a picture that indicates Glackens's appreciation for French impressionism. The painting is full of homage to Manet and bears a striking similarity to the *Bar aux Folies-Bergere* in subject matter and execution.

Glackens immediately submitted his picture to the Carnegie Institute exhibition where it won an honorable mention at the hands of a jury which included Thomas Eakins and J. Alden Weir. How curious, then, was its reception at the Macbeth Gallery three years later. The exhibition of "The Eight" should not have aroused the storm of critical abuse that ensued; most of the artists of the group had been showing the same kind of realism in their work for several years prior to 1908 and had drawn generally favorable notices. Unaccountably, the Macbeth show drew the critics' fire, as one of them wrote: "Vulgarity smites one in the face at this exhibition, and I defy you to find anyone in a healthy frame of mind who for instance wants to hang Luks' posteriors of pigs or Glackens's *At Mouquin's* or John Sloan's *Hairdresser's Window* in his living room or gallery and not get disgusted two days later. Is it fine art to exhibit our sores?"

The reason for the critics' concerted attack probably lies in the politics of the New York art world. Henri had defied the National Academy of Design just a year before the Macbeth Gallery exhibition by withdrawing his pictures from the Academy's show in protest to the arbitrary decisions, as he saw it, of the jury of selection, who had refused to accept works by two of his proteges, Sloan and Glackens. Thus Glackens came in for special scorn with his confreres of the "Revolutionary Black Gang," as the critics described them in 1908.

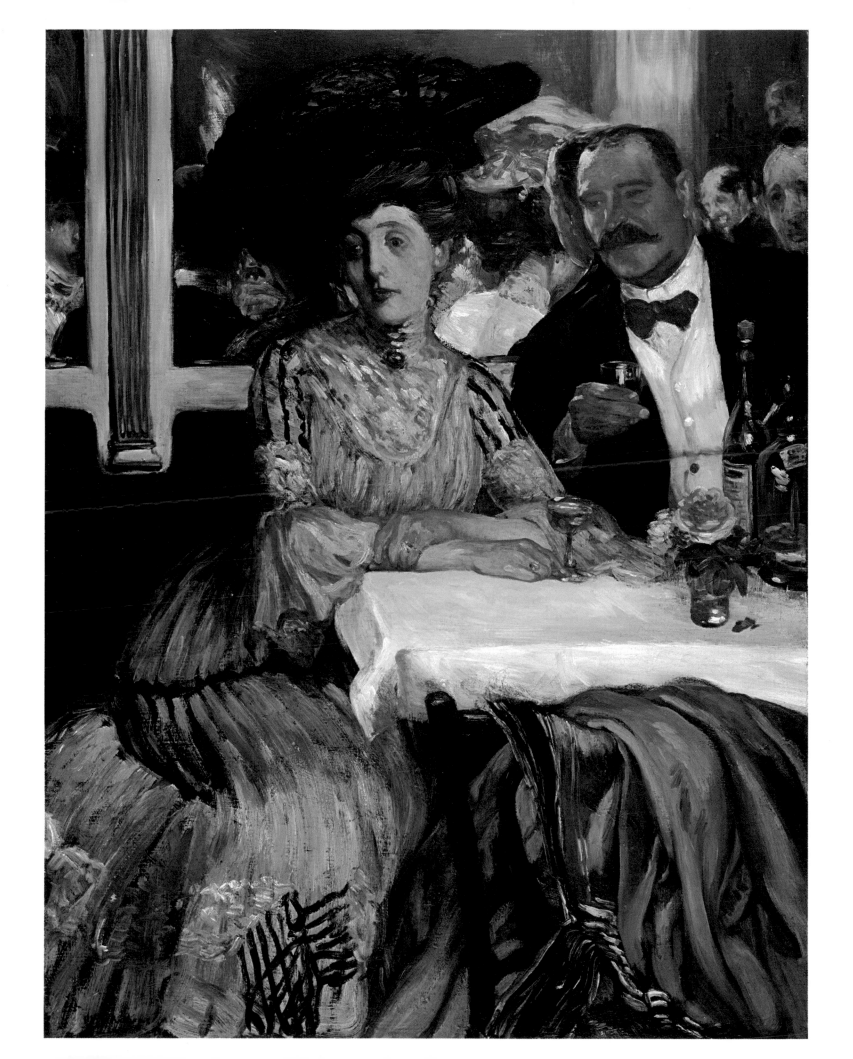

Plate 56
WILLIAM JAMES GLACKENS (1870-1938)
Nude with Apple, 1910
Oil on canvas, 40" x 57" (101.6 cm. x 144.8 cm.)
The Brooklyn Museum, Dick S. Ramsay Fund

As early as 1906, Glackens's landscape paintings began to show the influence of bright, impressionist color. (This tendency may have been inspired by a trip to France in that year.) Glackens gradually eliminated the deeper, more sonorous colors from his palette in favor of brighter color schemes. By 1910, the use of impressionist color was apparent in his figure painting as well, and Glackens was obviously becoming enchanted with the work of Auguste Renoir. In *Nude with Apple,* Glackens's sense of organization of his subject and the high and colorful key of his color reveals that he knew of Renoir's nude subjects from the 1880's.

Renoir became something of an obsession with Glackens who, in his later years, gave himself over quite completely to painting in the manner of Renoir. That portion of his career becomes important primarily in relation to the part he played as advisor to his friend Albert Barnes. It was through Glackens that Barnes developed a taste for French painting, a taste which yielded one of the most important collections of French impressionist and postimpressionist painting in America.

Nude with Apple was one of Glackens's works shown at the exhibition of Independent Artists in April, 1910. The exhibition was organized by Robert Henri and John Sloan in an effort to consolidate the position won by "The Eight"

two years earlier. Having once successfully defied the National Academy of Design, they wished to create a viable alternative for other painters who shared their disenchantment with the Academy's rule over American art. "The Independents," as they became known, managed to completely overshadow the Academy's spring exhibition. Sloan and Henri welcomed all artists with the proviso that the show would have "no jury—no prizes." Two thousand persons attended the exhibition which required the assistance of the police riot squad to control the tumult.

"The Independents" received critical notices in the press similar to those which greeted "The Eight." Once more their accusers pointed at the vulgarity of subject matter: "When it is not an ugly, poorly drawn nude sitting on her bed washing her feet, or a strumpet in a nightgown, cigarette in mouth . . . it is a coarse, wooden nude, like Glackens's *Girl with Apple.*" Another critic lamented that the show was ". . . enough to make the most hardened Academician burst into tears."

Looking at *Nude with Apple* today, it is impossible to understand why the critics found it so offensive, except that Glackens and the others had repudiated the genteel tradition in American art. That they did so in a way that was eminently painterly was of no concern to the critics.

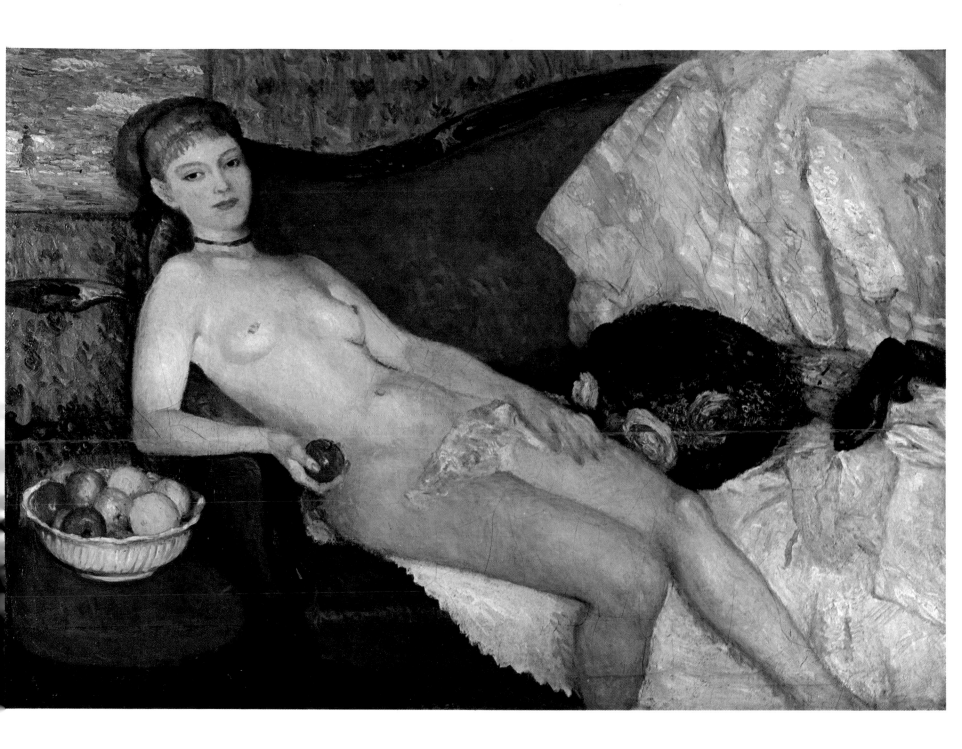

Plate 57
ERNEST LAWSON (1873-1939)
Spring Night, Harlem River, 1913
Oil on canvas, 25" x 30" (63.5 cm. x 76.2 cm.)
The Phillips Collection, Washington, D.C.

Ernest Lawson's membership in "The Eight," like that of Prendergast, is an indication of the diversity to be found in the group whose primary aim in the eyes of the critics was the painting of "pig's posteriors" and ash cans. Lawson had been a student of Weir and Twachtman, those pillars of conservative impressionism, and had studied independently in France under Alfred Sisley, one of the leaders of the impressionist movement there. Thus, by the time Lawson had fallen in with Henri and the other artists who frequented New York's convivial watering places like Mouquin's, he had already firmly established the impressionist idiom as his style of painting. He was a prolific artist who supported himself entirely by painting, often trading his pictures for meals at the well-known Café Francis in New York. Lawson developed a highly personal color sense— one critic described him as painting from a "palette of crushed jewels."

Like Monet, who often selected a single subject to be painted under various conditions of weather and light, Lawson chose the Harlem river at the point where it is crossed by the High Bridge. He painted this scene at all seasons of the year and even at night, as in the example illustrated here. *Spring Night, Harlem River* shows Lawson's exquisite use of glowing, transparent color and his special way of applying paint that enhances his flat, decorative surface. The turning point in Lawson's fortunes coincided with his participation in the Armory show in 1913, the same year this painting was made. This show secured him national recognition.

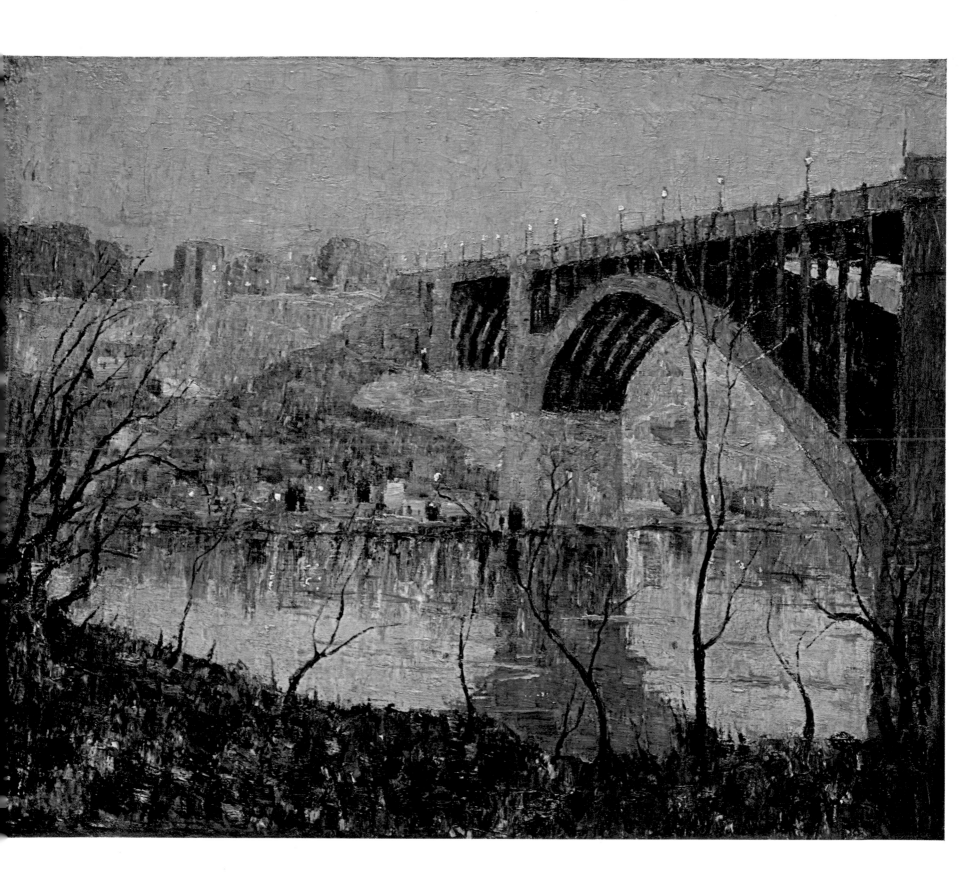

Plate 58
MAURICE BRAZIL PRENDERGAST (1859-1924)
The East River, 1901
Watercolor on paper, 13½″ x 19½″ (34.3 cm. x 49.5 cm.)
The Museum of Modern Art, gift of Abby Aldrich Rockefeller

During the decade of the 1890's, Prendergast was painting in Boston while supporting himself by operating a picture-frame shop in collaboration with his brother Charles. Even at this time his style was marked by a highly decorative sense of pattern and color. He worked largely in water-colors, defying the difficulties inherent in the medium by making his pictures out of highly complicated clusters of colors which remained independent of one another and which were always controlled by precise, underlying draw-ings.

In 1897, his work came to the attention of prominent Bos-ton collectors who financed a trip to Europe where Prender-gast painted in Venice, Siena, and Capri. His recognition in America came in 1900 when he was given an exhibition at the Art Institute of Chicago. By this time also, Prender-gast was becoming acquainted with the group surrounding Henri's school on upper Broadway, and in 1904, he exhib-ited at the National Arts Club in New York with Henri, Luks, Sloan, and Arthur B. Davies. At the time Prendergast was still working largely in watercolor; *The East River* of 1901 indicates the direction his art was taking.

His European trip precipitated Prendergast's thinking toward greater pictorial unity. Prior to that time, his compo-sitions often disassociate the subjects from their back-grounds. However, *The East River* and other watercolors from this period in his life show his emerging concern with relating all of the elements in a close-knit design. Also present in this picture is the tendency for his paintings to become more and more a flat pattern complemented by an equally flat application of color. In this respect, Prendergast was giving free rein to a decorative impulse. He is not a commentator on the quality of life around him; rather he chose to avoid relating his art to the humanistic impulse that guided Henri and Sloan.

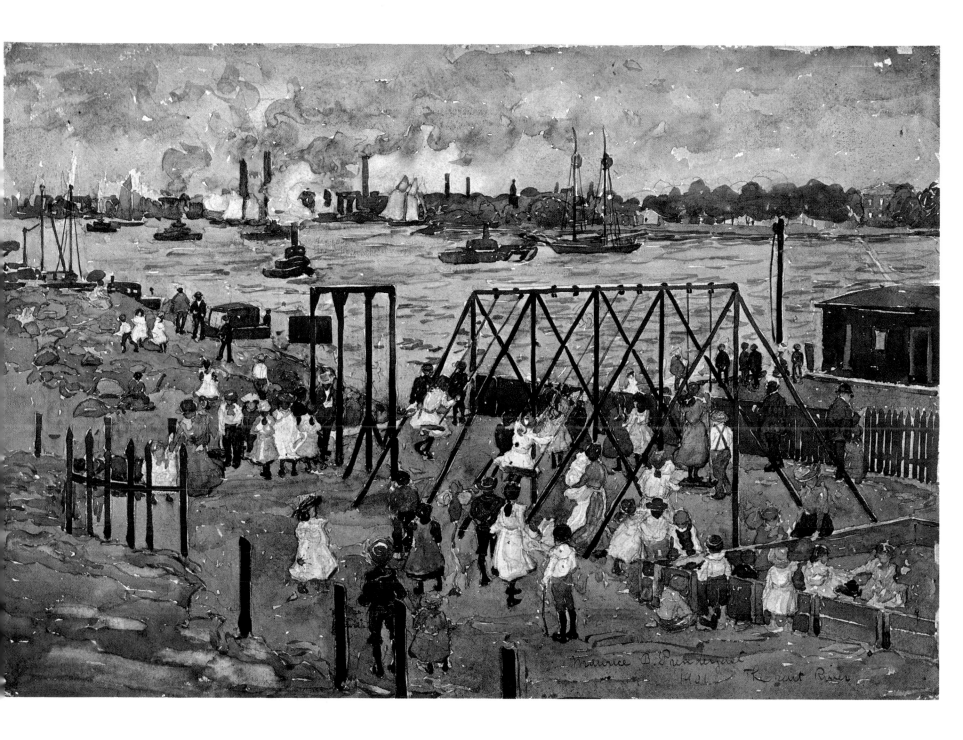

Plate 59
MAURICE BRAZIL PRENDERGAST (1859-1924)
Eight Bathers, ca. 1916-18
Oil on canvas, 28¼" x 24" (71.7 cm. x 61.0 cm.)
Museum of Fine Arts, Boston, Abraham Shuman Fund

In 1914 Prendergast moved from Boston to New York and occupied a studio on Washington Square. His studio was in the top floor of a house also used by William Glackens. In the biography of his father, Ira Glackens described the manner in which Prendergast and his brother Charles lived. Charles continued to make picture frames and elaborate decorative panels and chests covered with intricate, curiously primitive figures of people and animals. The Prendergast studio was filled with objects whose single unifying quality was flat decoration: Persian jars, scraps of brocade, ancient mosaics. All of these accumulations reflected Prendergast's growing preoccupation with flat pattern in his paintings.

The interest he had shown in flat pattern at the turn of the century had by 1914 turned into full-blown abstraction. Color and form are fully integrated into an overall concept unified by the deliberate application of texture paint so that the work begins to appear as a tapestry, or as a mosaic. *Eight Bathers* is an example of Prendergast's mature style in which he allows the oil paint to be built up on the canvas to create tactile values; he is not concerned about the old-fashioned idea of "finish." Parts of the painting reveal remnants of an earlier composition, and these remnants enrich the succeeding layers of paint.

In his experiments with painting, Prendergast advanced art far beyond the limits of his own time and into the realm of abstract expressionism of the mid-20th century. His art endures in a way consistent with what he said about the act of painting: "The love you liberate in your work is the only love you keep."

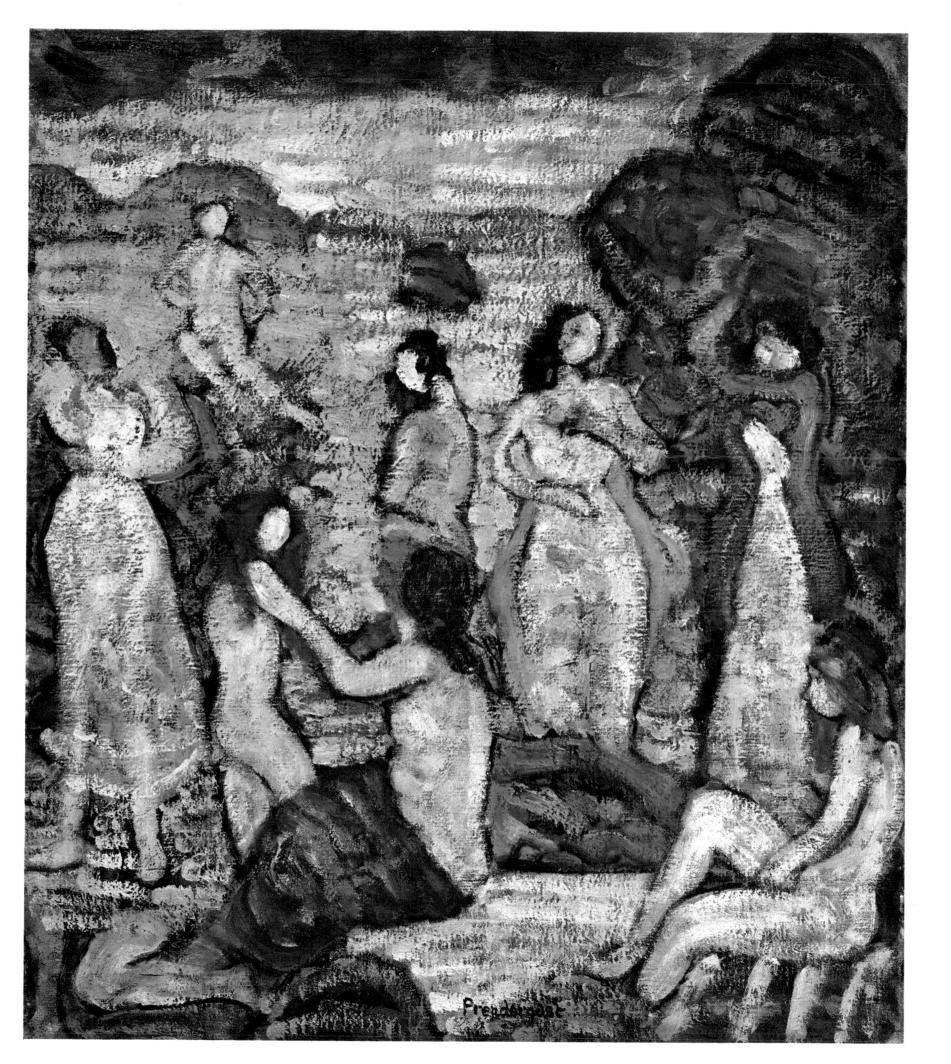

Plate 60
WALTER ELMER SCHOFIELD (1867-1944)
Building the Coffer Dam, 1914
Oil on canvas, 50" x 60" (127.0 cm. x 152.4 cm.)
The Art Institute of Chicago, Friends of American Art

As a student at the Pennsylvania Academy, Schofield became associated with Henri and Glackens and was a member of the social group of artists who gathered regularly at Henri's studio. His association with Henri's group ended around the turn of the century when Schofield took up residence in Europe. For about ten years he worked independently in Brittany and Normandy and on the South Coast of England, where he eventually established a permanent residence.

Like Henri, Schofield was influenced by French painting, but he remained true to landscape throughout his career and was never concerned with scenes of urban life. Nor is the bulk of his work taken from the American landscape. Early in his career Schofield established the broad incisive style that made his pictures stand out forcefully on exhibition walls. It is a style deriving from the school of Manet in its technique and from plein-air impressionism in color.

He returned to the United States around the turn of the century and re-established himself in Philadelphia, where a new, strong school of landscape painting was evolving. There he continued to exhibit paintings at the Pennsylvania Academy along with Daniel Garber and Robert Spencer, even after his return to Europe around 1902. From that year

until the outbreak of the First World War in 1914, Schofield was painting steadily and sending his pictures of Brittany, Normandy, Devon, and Cornwall home to exhibitions in Philadelphia. His landscape paintings of European places became as familiar to visitors to the Academy exhibitions as Garber's and Redfield's pictures of the Delaware Valley.

Schofield was a true expatriate, however, and never returned to America. His identification with European culture was deep and sincere; he served in the British Army during the war, and afterwards married into an English family. From his studio in Cornwall, where he spent his last years, Schofield continued to paint landscapes that seem touched with the easy, suave elegance of the manner associated with painters like Sir Alfred Munnings.

Building the Coffer Dam is a picture that relates to the strong painterly realism of the Delaware Valley artists, however; and it is for such manifestations of his art that Schofield is best remembered. The critics of his day admired him as a "painter of places," an artist who conceived of his landscape painting as a portrait of nature. In this picture there is an energetic handling of paint and a bold conception of design that renders the mood and character of the scene as if it were a portrait of an individual.

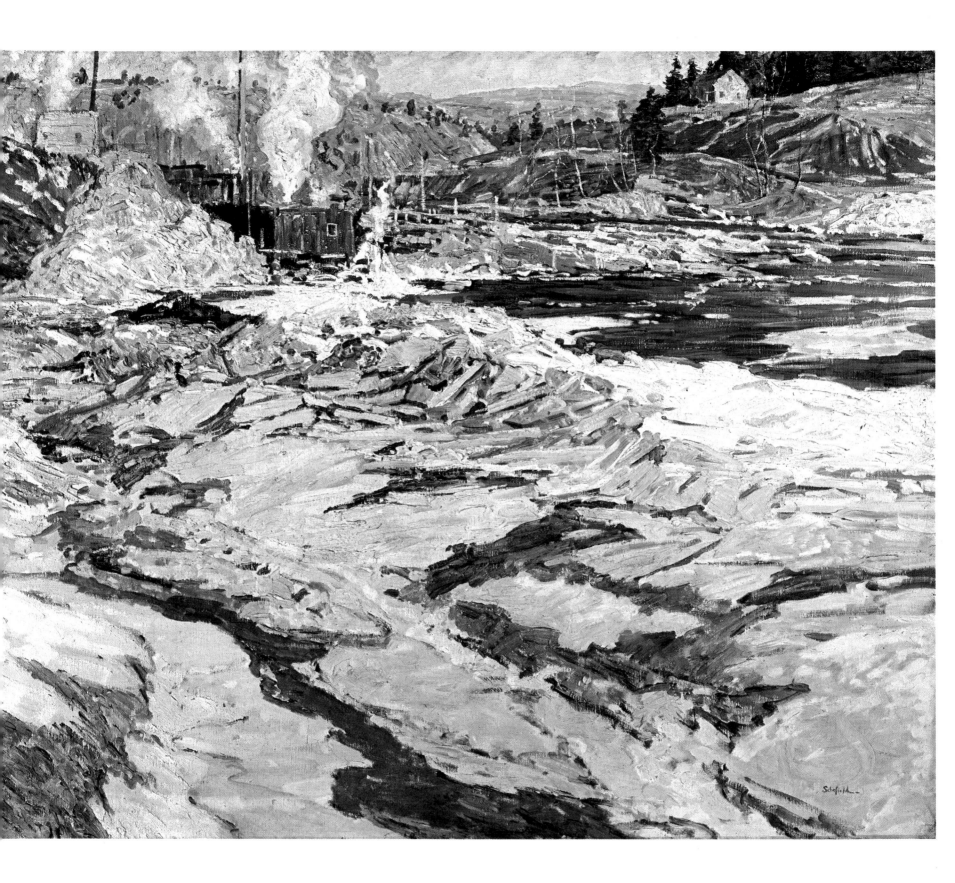

Plate 61
GUY CARLETON WIGGINS (1883-1962)
Lightly Falling Snow, before 1917
Oil on canvas, 34" x 40" (86.3 cm. x 101.6 cm.)
The Art Institute of Chicago, The Walter H. Schulze Memorial Collection

Wiggins had acquired his impressionist vocabulary from American artists, rather than from Frenchmen. He never studied in France, but found his models in the works of Childe Hassam and John Twachtman. By the time Wiggins had completed his studies at the National Academy of Design in New York, impressionism was the official mode of academic expression. He was oriented to the life of the serious, hard-working professional; his father had been an established figure of the National Academy in the preimpressionist days when a heavy, colorless realism held sway.

It is all the more remarkable, therefore, that the younger Wiggins established for himself a style of painting that is at once so French and so free of academic routine.

Wiggins represents the final flourish of the impressionist style in American painting. The school which he established in Essex, Connecticut, in 1937 was dedicated to the principles of impressionism as Wiggins had learned them from observing the works of Childe Hassam and the other American impressionists of "The Ten." While American art moved steadily away from impressionism toward realism, Wiggins firmly maintained the integrity of his style. Many artists had used impressionist color as a point of departure for moving into a conservative realism which crowded the exhibitions of the established academies.

Lightly Falling Snow successfully reiterates a kind of impressionism that flourished in France during the 1880's. It achieves an atmospheric colorism that recalls the work of Pissarro and Sisley. It is a brilliant demonstration of the use of impressionist color and technique, and its highly successful poetic observation of nature is an achievement which justifies the appreciation of a style which had gone out of fashion.

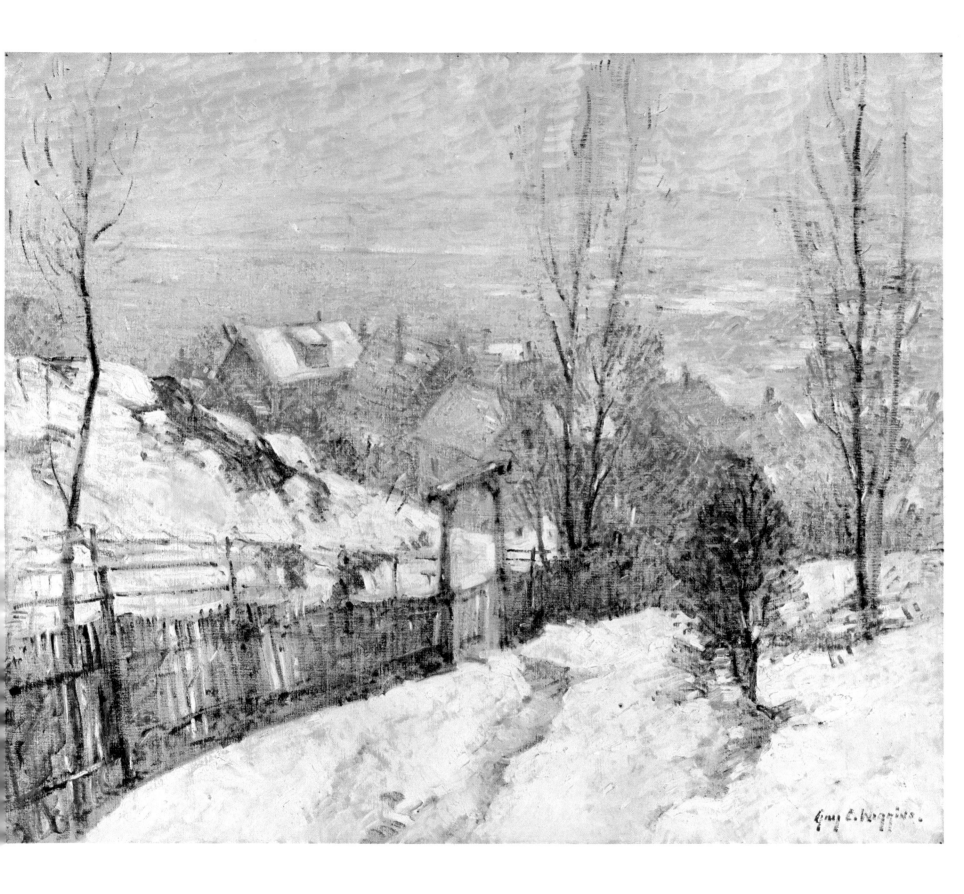

Plate 62
EDWARD WILLIS REDFIELD (1869-1965)
The Mountain Stream, 1912
Oil on canvas, 26" x 32" (66.0 cm. x 81.3 cm.)
Museum of Fine Arts, Boston, The John Pickering Lyman Collection

Edward Redfield's work bears striking similarities to that of Elmer Schofield, although the two artists worked on separate sides of the Atlantic Ocean. Redfield settled in a town on the Delaware River near Philadelphia around 1900 and remained there for the rest of his life. He was a landscape painter, and during the more than sixty years in which he remained in his Delaware River studio, he created a series of paintings that must surely constitute the most definitive representation of a limited portion of nature that has been accomplished by any single artist. Redfield was always very careful to identify the exact location of all the scenes in his paintings; *The Mountain Stream* depicts Johnson's Creek near New Hope, Pennsylvania.

Redfield's style is a synthetic impressionism; during his student days at the Pennsylvania Academy, he was a close friend of Robert Henri and shared much of Henri's enthusiasm for a direct, trenchant realism in art. The two went abroad in 1887, and it was in France that Redfield decided to concentrate on landscape painting while Henri went on to genre and portraiture.

Redfield became convinced that his paintings should be spontaneously created and should be done out of doors with no alterations made later in the studio; done "at one go" as he put it. He allowed himself ten years to succeed at painting in this manner, convinced that he should abandon painting if he failed. His determination led him to essay a single theme in order to achieve an integration of mind and manual skill; he became known as the "painter of winter-locked nature." The writer Newlin Price observed, ". . . a strange hostility in Redfield. He will fight the winter's hardest weather, and struggle through the deepest snows to paint when the fever is on him. He will say to his friends, 'Sure, come up to the place, but you know the snow is on the ground and I am painting.' "

His association as a teacher with the Pennsylvania Academy during these years produced a succession of students, all of whom found inspiration under his powerful influence. Redfield's style was direct and brilliant in its succinct rendering of the mood and character of his landscape subjects. Redfield brought academic impressionism to its final development, and as its leading practitioner, he created an art expression which was at once comprehensible to the layman and admired by his colleagues.

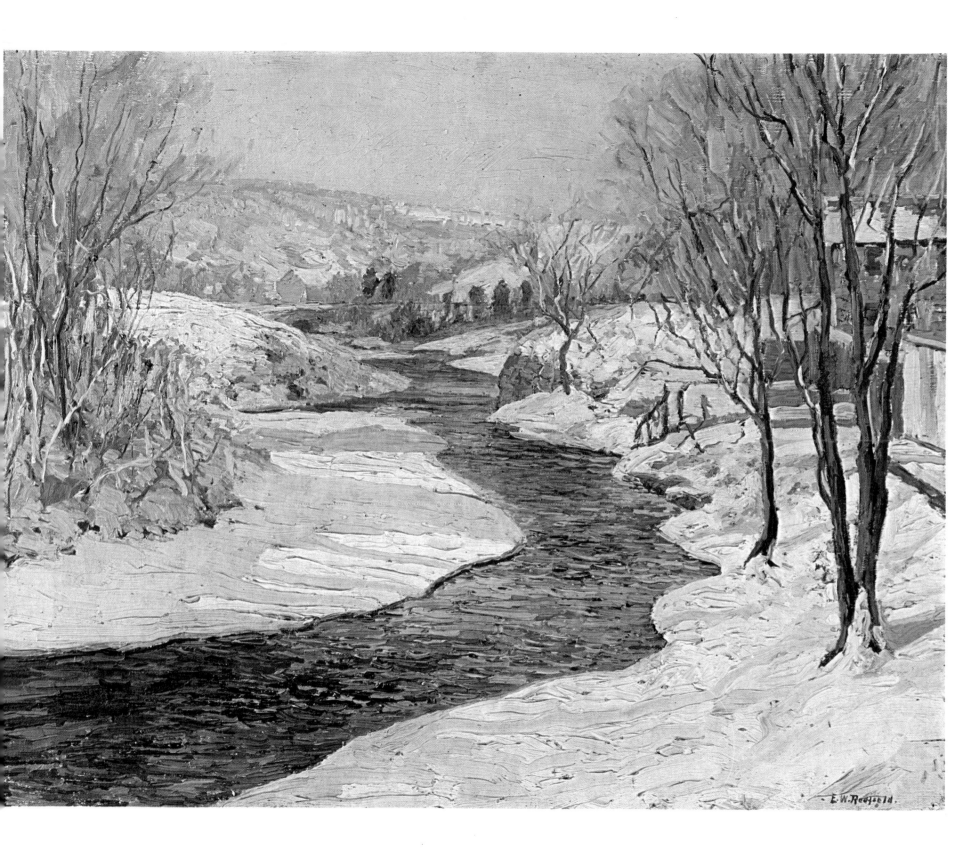

Plate 63
DANIEL GARBER (1880-1958)
The Quarry, 1917
Oil on canvas, 50½" x 60½" (128.2 cm. x 153.2 cm.)
Pennsylvania Academy of the Fine Arts

Redfield's principal disciple was Daniel Garber. Together they formed the strongest school of academic impressionism in the United States. But Garber diverged from the older man by relying upon a more traditional application of impressionist ideas in his painting. Garber was influenced by the work of Alden Weir and remainded faithful to the qualities of Weir's style, which favored a gentle, lyrical colorism over the broad handling of paint that characterizes Redfield's work.

Contemporary assessments of Garber's work lay heavy emphasis upon the decorative qualities of his pictures. Comparisons between his feathery brushstroke and French tapestry are frequently encountered in the published criticism. Too often his landscapes seem overly influenced by the decorative impressionism of Henry Ward Ranger. However, in his best work, like *The Quarry*, Garber achieves a balance between his poetic theme and his soft, lyrical color. This subject returned frequently in his pictures, as if the elusive vision were always eluding his ability to fully comprehend it.

Garber worked slowly, and there is always the suggestion of enormous deliberation about his work; yet he held the poetic delicacy of his visions above the struggle that attended his completion of a painting. Homer St. Gaudens, whose criticism reflects the taste of the early 20th century, wrote, "Garber . . . does not paint a sugary picture, but a picture that is fortunate to contemplate. Other audiences may favor depressants as a sort of hair of the dog that is now biting this miserable world . . . the Garber type of spirit bears itself with graciousness that keeps tactfully within the forms that are distinguished by the enrichment of the gentler, less argumentative type of imagination."

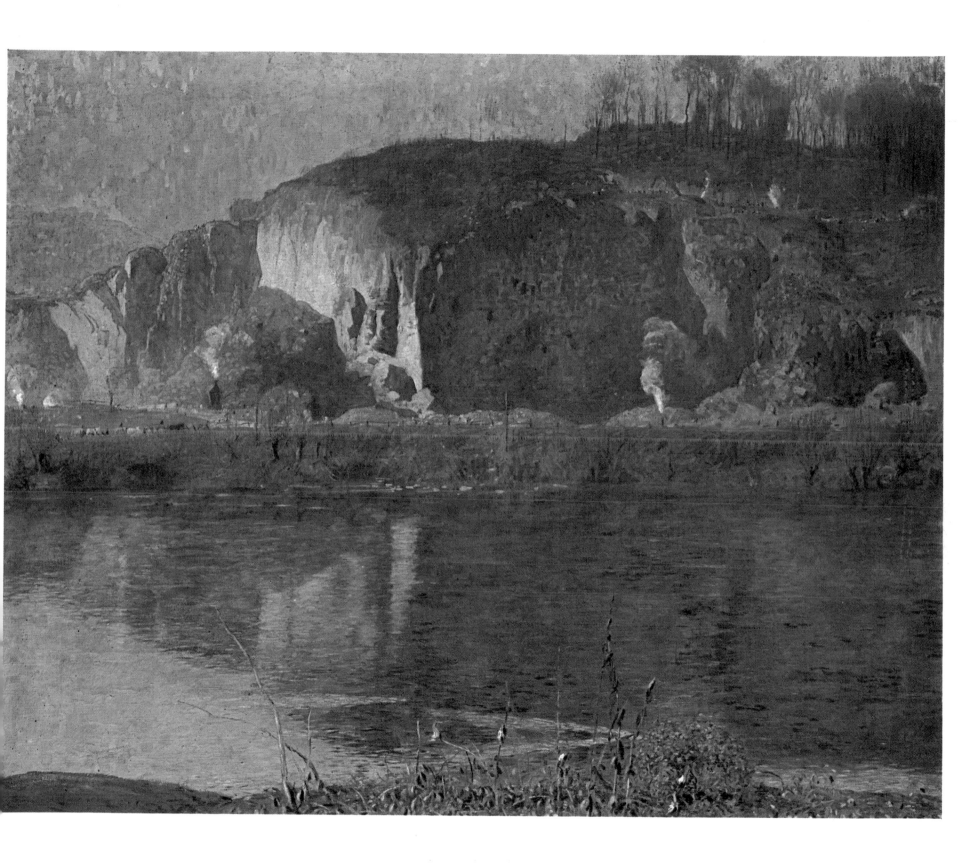

Plate 64
ROBERT SPENCER (1879-1931)
White Tenements, 1913
Oil on canvas, 30″ x 36¼″ (76.2 cm. x 92.1 cm.)
The Brooklyn Museum, J.B. Woodward Fund

Under the impetus of the strong school of landscape painting that developed at the Pennsylvania Academy after the turn of the century, Robert Spencer was determined to create a place for himself as a landscape painter. As a student of Daniel Garber, he was inclined toward a style of painting more heavily influenced by traditional impressionist technique than by the broader academic variant of Redfield's and Schofield's style. Spencer's subject matter is frequently taken from architecture within the landscape, rather than from broad views of nature.

White Tenements won for Spencer the Gold Medal of the National Academy of Design in 1914, the same year in which he was elected an Associate of the Academy. His work was viewed as "the immobile portrait of a place" and Spencer lavished more than just a sensitive eye for color upon his works. For, woven into the fabric of his designs is the observation of a social realist painter whose innate sympathy with the struggles and aspirations of working people is made an important part of the artist's statements. The critic Royal Cortissoz noted about this time, "His river scenes, vivaciously painted and mildly luminous are almost in Mr. Hassam's key . . . Spencer has elected to specialize in the painting of prosaic walls of lofty warehouses and tenements, often introducing a medley of figures at their base, but plainly trying hardest to get a certain effect of tone. . . ."

His compositions stress the flat sides of buildings, as in *White Tenements*, and he deliberately emphasizes this further by his flat handling of paint. In Spencer's work the surface paint texture is very important, much as in Prendergast's paintings. Spencer might have pursued his career beyond this point and into a more synthetic impressionism had not his career been cut short by his death in 1931.

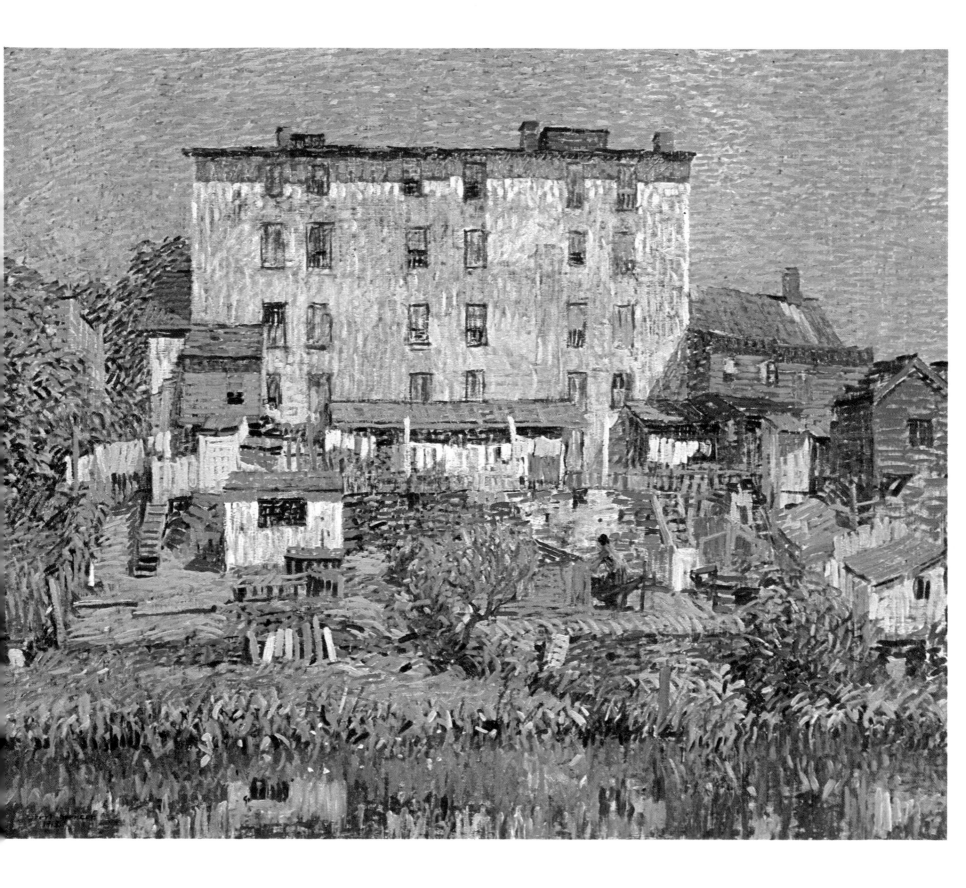

BELLOWS, George Wesley. Born Columbus, Ohio, 1882; died New York City, 1925. Attended Ohio State University; graduated 1903. Worked briefly as a newspaper cartoonist in Columbus. Studied at New York School of Art and under Robert Henri and Kenneth H. Miller, 1904-05. Elected Associate, National Academy of Design, 1909; Academician, 1918. Taught at Art Students League, New York, 1910-11 and 1918-19. Exhibited six paintings in the Armory Show of 1913. Original member of the Society of Independent Artists, founded by John Sloan, 1917. Began working in lithography, 1916; illustrated for *Century Magazine*, 1921-22; *Hearst's International Magazine*, 1922-23.

BENSON, Frank Weston. Born Salem, Massachusetts, 1862; died Salem, Massachusetts, 1951. Studied at Boston Museum School of Art, 1880-83; Académie Julian, Paris, under G. Boulanger and J. Lefebvre, 1883-85. Returned to the United States, 1885; taught at Portland (Maine) Society of Art, 1886-87. Opened portrait studio in Boston, 1889; appointed instructor in drawing, Boston Museum School of Art. Began teaching painting in life classes at Museum School, 1892. Awarded medal Columbian Exposition, Chicago, 1893; medal, Paris Exposition, 1900; Lippincott Prize, Pennsylvania Academy of the Fine Arts, 1904. Elected Associate, National Academy of Design, 1897; Academician, 1905. Member "Ten American Painters," organized 1898. Painted seven mural decorations for Library of Congress, Washington, D. C.

BUTLER, Theodore Earl. Born Columbus, Ohio, 1860; died Giverny, France, 1936. Attended Marietta College, Ohio; graduated about 1880. Studied at Art Students League, New York, early 1880s. Studied at Académie Julian, Paris, beginning in 1885. Represented in Paris Salon of 1888; won Honorable Mention. Painting trip to Giverny with Theodore Robinson; met Claude Monet, summer, 1888. Returned to United States; second trip to France, painted at Giverny, 1892. Married daughter of Monet's second wife. Returned to United States, 1899. Third visit to Giverny, 1900. Remained in France until 1913; worked on mural decorations for United States Pavilion, International Exposition, Turin, 1910. Helped found Independent Artists, New York, 1917; served as vice president under John Sloan. Returned to Giverny, 1921. Made life member, Salon d'Automne, Paris; exhibited regularly at Salon des Independants.

CARLSEN, Sören Emil. Born Copenhagen, Denmark, 1853; died New York City, 1932. Studied architecture at the Danish Royal Academy before emigrating to the United States in 1872. Worked in Chicago as architectural draughtsman; began to paint, 1872-75. Trip to Denmark and France, 1875. Returned to Chicago 1876. Began living in New York about 1880; worked as engraver and teacher of painting. Commissioned by art dealer to paint still life subjects in Paris, 1884-86. Returned to United States and taught painting in San Francisco, 1887-91. Taught irregularly at Pennsylvania Academy of the Fine Arts until 1918. Established studio in New York City and first became known as a painter of still life subjects. Elected to membership in the National Academy of Design, Society of American Artists, Salmagundi Club of New York, and St. Botolph Club of Boston. Honors for painting included Gold Medal, St. Louis Exposition, 1904; Inness Medal, National Academy of Design, 1907; Temple Medal, Pennsylvania Academy of the Fine Arts, 1912; Saltus Medal, National Academy of Design, 1916; Carnegie Prize, 1919.

CASSATT, Mary Stevenson. Born Allegheny City, Pennsylvania, 1844; died Château Beaufresne, France, 1926. Studied at Pennsylvania Academy of the Fine Arts, 1864-65. Studied in Paris under Benjamin Constant and independently, 1866-69; at the Royal Academy, Parma, Italy 1872. Exhibited in the Paris Salon, 1872-76. Invited by Edgar Degas to join the impressionists, 1877; continued to exhibit with them until 1886. First one-man show at Durand-Ruel, Paris, 1891. Commissioned to paint mural decoration for Columbian Exposition, 1892. Made Chevalier of the Légion d'Honneur, 1904. Elected Associate, National Academy of Design, but declined to accept, 1909. Awarded Gold Medal of Honor, Pennsylvania Academy of the Fine Arts, 1914.

CHASE, William Merritt. Born Franklin, Indiana, 1849; died New York City, 1916. Studied portrait painting under Benjamin Hayes in Indianapolis, 1867-69. Studied at National Academy of Design under L. E. Wilmarth, 1869-70. Enrolled in Royal Academy, Munich, Germany 1872; studied under Alexander Wagner and Karl von Piloty. Came under the influence of Wilhelm Leibl and his group of realist painters; shared studio with Frank Duveneck, 1875. Awarded medal for painting, Centennial Exposition, Philadelphia, 1876. Returned to New York; began teaching at Art Students League, 1878. Trips to Spain and Holland, 1881-85. Elected Associate, National Academy of Design, 1889. Began teaching at Brooklyn Museum School of Art, 1890; summer art school at Shinnecock, Long Island, 1891. Founded "The Chase School," New York, 1896; continued teaching there until 1908. Joined "Ten American Painters" group, 1902. First one-man exhibition at M. Knoedler and Co., New York, 1903. Awarded Gold Medal for painting, St. Louis Exposition, 1904; Grand Prize, International Fine Arts Exposition, Buenos Aires, 1910.

DAVIS, Charles Harold. Born Amesbury, Massachusetts, 1856; died Mystic, Connecticut, 1933. Studied privately with O. Grundeman in Boston, 1876-79. Attended Académie Julian, Paris 1880-81. Spent years 1881-91 painting independently in France; represented in Salon of 1883. Awarded Honorable Mention, Salon of 1887. Returned to United States; settled at Mystic, Connecticut, 1891-96. Elected to National Academy of Design, 1906. Awards for painting include Gold Medal, American Art Association, New York, 1886; Silver Medal, Exposition Universelle, Paris, 1889; Palmer Prize, Art Institute of Chicago, 1890; Lippincott Prize, Pennsylvania Academy of the Fine Arts, Philadelphia, 1901; Medals from Pan-American Exposition, Buffalo, 1901; St. Louis Exposition, 1904; Pan-Pacific Exposition, San Francisco, 1915; Corcoran Gallery of Art, Washington, D. C., 1920; National Academy of Design, New York, 1921.

DE CAMP, Joseph Rodefer. Born Cincinnati, Ohio, 1858; died Boca Grande, Florida, 1923. Studied with Frank Duveneck in Cincinnati; accompanied Duveneck to Munich, 1875. Member of group of students under Duveneck, including John W. Alexander, John H. Twachtman, and William M. Chase; group trip to Florence and Venice, 1878. Returned to Boston, 1880; established studio as portrait painter and became instructor at Massachusetts Normal Art School. Member, "Ten American Painters," 1898, and exhibited annually with them. Awards for painting include Temple Medal, Pennsylvania Academy of the Fine Arts, 1899; Honorable Mention Paris Exposition 1900; Gold Medal, St. Louis Exposition, 1904.

DEWING, Thomas Wilmer. Born Boston, Massachusetts, 1851; died New York City, 1938. Studied at Académie Julian, Paris under G. Boulanger and J. Lefébvre, 1876-79. Returned to Boston, then established a studio in New York; taught at Art Students League, 1881-88. Elected Associate, National Academy of Design 1887; Academician, 1888. Exhibited in Paris Exposition, 1889. Resigned membership in Society of American Artists, 1897; joined "Ten American Painters" group, 1898. Represented in collection given to the nation by Charles L. Freer, 1906. Awards for painting include Clarke Prize, National Academy of Design, 1887; Gold Medal, St. Louis Exposition, 1904; First Medal, Carnegie International Exhibition, Pittsburgh, 1908.

FRIESEKE, Frederick Carl. Born Owosso, Michigan, 1874; died Mesnil-sur-Blagny, France, 1939. Studied at Art Institute of Chicago, Art Students League of New York, early 1890's. Studied with B. Constant and J. P. Laurens, Paris; briefly with J. M. Whistler, 1898. Early influence by Monet.

Began painting at Giverny, 1900. First exhibitions in United States: National Academy of Design and Pennsylvania Academy of the Fine Arts, 1903. First one-man show at Macbeth Galleries, New York; elected Associate, National Academy of Design, 1912. Summer trip to Corsica, 1913. Elected Academician, National Academy of Design, 1914. Moved summer studio from Giverny to Mesnil-sur-Blagny in Normandy, 1920. Given one-man exhibition, Corcoran Gallery of Art Washington, D. C., 1924. Exhibited at Venice International Exposition, 1930. Spent winter in Samedan, Switzerland, 1931. Awards include Clark Prize, Corcoran Gallery of Art; Gold Medal, St. Louis Exposition, 1904; Temple Medal, Pennsylvania Academy of the Fine Arts, 1914; Grand Prize, Panama-Pacific Exposition 1915.

GARBER, Daniel. Born North Manchester, Indiana, 1880; died Lumberville, Pennsylvania, 1958. Studied at the Cincinnati Art Academy under Frank Duveneck, 1897. Moved to Philadelphia and studied at the Pennsylvania Academy of the Fine Arts, principally under Thomas Anshutz, 1899-1905. Influenced by J. Alden Weir, then visiting instructor in painting at the Academy. Appointed to faculty of the Academy, 1909. Elected to National Academy of Design, 1913. Awards for painting include Hallgarten Prize, National Academy of Design, 1901; Clark Prizes, Corcoran Gallery of Art, 1910, 1912, 1921; Palmer Prize, Art Institute of Chicago, 1911; Gold Medal, San Francisco Exposition, 1915; Medal, Pennsylvania Academy of the Fine Arts, 1937.

GLACKENS, William James. Born Philadelphia, Pennsylvania, 1870; died Westport, Connecticut, 1938. Artist-reporter for Philadelphia press, 1891; colleagues included John Sloan, George B. Luks, and Everett Shinn. Attended night classes, Pennsylvania Academy of the Fine Arts; studied under Thomas Anshutz, 1892. Trip to Holland and France, with Robert Henri, 1895. Returned to New York; began exhibiting paintings, 1896. Exhibited in "The Eight," New York, 1908. Helped organize exhibition of the "Independents," 1910. Chairman for committee of selection, American section, Armory Show, New York, 1913. Elected first president, Society of Independent Artists, 1917. Awarded Temple Gold Medal, Pennsylvania Academy of the Fine Arts, 1924. Made annual painting trips to France, 1925-32. Awarded *Grand Prix* for painting, Paris Exposition, 1937.

GRIFFIN, Walter Parsons Shaw. Born Portland, Maine, 1861; died Stroudwater, Maine, 1935. Studied at School of Art, Museum of Fine Arts, Boston, 1880; Art Students League, New York, 1882. Studied at Académie Clarossi under R. Collin and J. P. Laurens, Paris, 1886. Painted in Barbi-

zon, 1888; and settled in Brittany, 1890. Returned New York; began directorship of art school of Wadsworth Athenaeum, Hartford, Connecticut, 1897. Founded art school in Quebec, 1898. Moved to Old Lyme, Connecticut, 1905; close friends included Childe Hassam. Painting trips to Norway, 1909-10; Venice, 1913. Lived in Boigneville, France, 1911-18. Elected Associate, National Academy of Design, 1912; Academician, 1922. Awards for painting include Medal of Honor, Panama-Pacific Exposition 1915; Gold Medal, Pennsylvania Academy of the Fine Arts, 1924.

HASSAM, Frederick Childe. Born Dorchester, Massachusetts, 1859; died Easthampton, New York, 1935. Employed in Boston as illustrator, 1878. Trip to Britain, Netherlands, Spain, and Italy, 1883. Second European trip, 1886-89; settled in Paris and came under influence of impressionism. Exhibited in Salon of 1888; awarded Bronze Medal, Paris Exposition of 1889. Returned to New York, 1889; began summer painting trips to New England. Trip to Havana, Cuba, 1895. Trip to France and Italy, 1897. Joined "Ten American Painters" group, 1898. Taught at Art Students League, New York, 1898-99. Painting trips to Oregon, 1908; Paris, 1910. Established summer studio at Easthampton, Long Island, 1920. Elected National Academy of Design, 1906. Awards for painting include Gold Medal, Pennsylvania Academy of the Fine Arts, 1910; Clark Prize, Corcoran Gallery of Art, 1912; Altman Prizes, National Academy of Design, 1918 and 1925.

INNESS, George. Born Newburg, New York, 1825; died Bridge of Allan, Scotland, 1894. Studied briefly under Régis Ginoux in Brooklyn, 1846. Largely self-taught. Exhibited in first exhibition, American Society of Painters in Watercolors, New York, 1866. Sent to Europe for study by patron; settled in Italy and was influenced by Claude and Poussin, 1850. Stayed briefly in Paris, 1854; elected the same year as Associate, National Academy of Design. Settled in Medfield, Massachusetts, 1859. Moved to Perth Amboy, New Jersey, 1864. Represented in American Art section at Paris Exposition of 1867. Elected Academician National Academy of Design, 1868. Trip to Europe, 1870-74; painted in Rome, Paris, and Barbizon. Worked in Boston and New York, 1875-78. Settled permanently in Montclair, New Jersey, 1878. Painting trips to Virginia, 1884; Yosemite, California, 1891.

LAWSON, Ernest. Born San Francisco, California, 1873; died Miami Beach, Florida, 1939. Studied at Kansas City Art League School, 1888; San Carlos Academy, Mexico City, 1889; Art Students League, New York under J. Alden Weir and J. H. Twachtman, 1890-91. Went to France, stud-

ied independently, with lessons from A. Sisley, 1893. Elected Associate, National Academy of Design; exhibited with "The Eight," Macbeth Gallery, New York, 1908. Exhibited in the Armory Show, 1913. Joint exhibition with Bryson Burroughs in Paris, 1914. Trip to Segovia, Spain, 1916. Elected Academician, National Academy of Design, 1917. Trip to Halifax, Nova Scotia, 1924. Awards for painting include Silver Medal, St. Louis Exposition, 1904; Medal of the Society of American Artists, 1907; Altman Prize, National Academy of Design, 1916; Inness Gold Medal, National Academy of Design, 1917; Gold Medal, Panama-Pacific Exposition, San Francisco, 1915; Gold Medal, Carnegie International Exhibition, Pittsburgh, 1921.

MARTIN, Homer Dodge. Born Albany, New York, 1836; died St. Paul, Minnesota, 1897. Studied landscape painting under James M. Hart, National Academy of Design, New York, 1862. Moved to 10th Street Studio Building, New York; associates included Sanford R. Gifford, Eastman Johnson, and John La Farge. Summer painting trips to Adirondacks, 1864-69. Elected Associate, National Academy of Design, 1868; Academician, 1875. Trip to France and England, 1876; influenced by James Whistler. Founder, Society of American Artists, 1878. Trip to England and Normandy, France, 1881-82. Commissioned by *Century Magazine* to illustrate views of England, 1885. Returned to New York, 1887; eyesight progressively deteriorating. Last years spent in St. Paul, 1892-97.

METCALF, Willard Leroy. Born Lowell, Massachusetts, 1858; died New York City, 1925. Studied under George L. Brown and apprenticed as wood engraver in Boston, 1875-77. Attended life classes, Lowell Institute, Boston, 1876-77. Trip to New Mexico and Arizona, 1880-82. Studied at Académie Julian, Paris; trips to North Africa, 1883-88. Received Honorable Mention, Paris Salon of 1888. Returned to Boston 1889; established studio in New York City about 1890. Taught at Cooper Union, Art Students League of New York and Rhode Island School of Design during the 1890's. Member "Ten American Painters" group, 1898. Established summer studio at Chester, Vermont, about 1900. Awards for painting include Medal, Columbian Exposition, Chicago, 1893; Silver Medal, Pan American Exposition, Buffalo, 1901; Medal, Pennsylvania Academy of the Fine Arts, 1907; Medal of Honor, 1911, and Gold Medal, Pennsylvania Academy of the Fine Arts, 1912; Gold Medal of Honor, Panama-Pacific Exposition, San Francisco, 1915.

PRENDERGAST, Maurice Brazil. Born St. John's, Newfoundland, 1859; died New York City, 1924. Designed commercial posters, Boston, 1873. First trip to Europe, 1886.

Sketching tours of New England, 1887-89. Studied at Académie Julian and Colarossi under G. Courtois and J. L. Gérôme, Paris; summer painting trips to Normandy and Brittany, 1892-94. Returned to Boston to paint and open frame shop, 1894-97. Trip to Italy; painted in Venice, Siena, and Capri, 1898-99. Exhibited at Chase Gallery, Boston; Art Institute of Chicago, 1900; Macbeth Gallery, New York, 1905. Exhibited in "The Eight" group show, New York, 1908. Returned to France; beginning of post-impressionist influence, 1909-10. Represented in the Armory Show, New York, 1913. Moved to New York, 1914; summer painting trips to New England, 1914-22. Awarded Clark Prize, Corcoran Gallery of Art, 1923. Memorial Exhibition held at Cleveland Museum of Art, 1926.

POTTHAST, Edward Henry. Born Cincinnati, Ohio, 1857; died New York City, 1927. Worked in Cincinnati as lithographer's apprentice, 1874-79. Lithographic illustrator and student at Cincinnati Museum art school, 1879-87. To Europe for study at Antwerp Academy, in Paris and Munich, 1887-90. Returned to Cincinnati; resumed employment as illustrator, 1891. Moved to New York City; worked as illustrator for *Harper's* about 1892. Established studio in New York. Elected to National Academy of Design, 1906. Awards for painting include Clark Prize, National Academy of Design, 1899; Evans Prize, American Watercolor Society, 1901; Silver Medal, St. Louis Exposition, 1904; Silver Medal, Panama-Pacific Exposition, San Francisco, 1915.

RANGER, Henry Ward. Born Syracuse, New York, 1858; died New York City, 1916. Studied photography with father, Ward V. Ranger, Syracuse; attended Syracuse University, 1873-75. Established studio in New York City, 1878; first works were watercolors, influenced by Barbizon school. Trip to Europe, early 1890's; studied at Académie Julian under J. P. Laurens and J. E. Blanc. Came under influence of Josef Israels and Anton Mauve. Returned to New York, 1888. Moved to Connecticut, 1900; painted on Fisher's Island. Established permanent summer studio at Noank, Connecticut, after 1900; autumn and winter in New York City, teaching at National Academy of Design. Elected Associate, National Academy of Design, 1901; Academician, 1906, Bequeathed Ranger Fund to National Academy, for purchase of works of art, 1916. Awarded Bronze Medal, Paris Exposition, 1900; Medal Pan American Exposition, Buffalo, 1901; Gold Medal, American Art Society, Philadelphia, 1907.

REDFIELD, Edward Willis. Born Bridgeville, Delaware, 1869; died Center Bridge, Pennsylvania, 1965. Studied at Pennsylvania Academy of the Fine Arts about 1886. Trip to

Europe with Robert Henri, Charles Grafly, and Stirling Calder; painted near Fontainebleau, and with W. Bougueareau and Robert-Fleury, Paris, 1887-92. Bought studio-house on Delaware River at Center Bridge; given first one-man show at Pennsylvania Academy, 1898. Second trip to Europe, 1898-1900. One-man show at Philadelphia Art Club, 1900. Except for one winter in Pittsburgh, 1919, lived at Center Bridge until his death. Awarded Bronze Medal, Paris Exposition, 1896; Temple Medal, Pennsylvania Academy of the Fine Arts, 1903; Gold Medal, Art Institute of Chicago, 1913; Carnegie Prize, National Academy of Design, 1918.

REID, Robert. Born Stockbridge, Massachusetts, 1862; died Clifton Springs, New York, 1929. Studied at School of Art, Museum of Fine Arts, Boston, 1880; worked there as assistant instructor. Studied at Art Students League, New York, 1885. Studied at Académie Julian, Paris, 1886-89. Exhibited in Paris Salon of 1886. Returned to New York, 1889; opened portrait studio, and taught at Art Students League and Cooper Union. Painted frescos for Liberal Arts Building, Columbian Exposition, Chicago, 1893. Exhibited with "Ten American Painters" group, 1898. Painted mural decorations for State House, Boston, 1901. Elected to National Academy of Design, 1906. Painted mural decorations for Palace of Fine Arts, Panama-Pacific Exposition, San Francisco, 1915. Taught at Broadmoor Art Academy, Colorado Springs during early 1920's. Retrospective exhibition, National Academy of Design, 1928.

ROBINSON, Theodore. Born Irasburg, Vermont, 1852; died New York City, 1896. Studied at Art Students League, 1874. Studied independently in Paris with C. Carolus-Duran and J. L. Gérôme, 1876-77. Exhibited at the Salon of 1877. Travelled in France and Italy, 1878. Returned to New York, 1879; established studio, gave private classes, and worked for John LaFarge. Elected to Society of American Artists, 1881. Trip to France; painted in Paris, Barbizon, and Giverny, 1884-88. Became exponent of impressionism under Monet's influence. Annual trips to Europe, 1889-92. Received award from Society of American Painters, 1892. Worked winters in New York studio; summer painting trips to New England, New York, and New Jersey, 1893-95. Taught at Pennsylvania Academy of the Fine Arts; gave first one-man show, Macbeth Gallery, New York, 1895.

SARGENT, John Singer. Born Florence, Italy, 1856; died London, England, 1925. Studied under C. Carolus-Duran, Paris, 1874-79; class included J. C. Beckwith, J. A. Weir, and Paul Helleu. Met Monet and began interest in impressionism; first trip to United States, 1876. Began exhibiting at Paris Salon; won Honorable Mention, 1878. Painting trips

to Morocco, Spain, Holland, and Italy, 1880; Venice, 1882. Exhibited *Madame X*, Paris Salon of 1884. Moved to London, 1885; began painting impressionist pictures during summers in Worcestershire, 1885-89. Painted portraits in United States, 1887-88 and 1890. Commissioned to paint mural decorations for Boston Public Library, 1890. Elected Associate, Royal Academy, London, 1894; Academician, National Academy of Design, New York, and Royal Academecian, London, 1896. Decade of prolific portrait painting, England and United States, 1894-1904. Worked on murals for Museum of Fine Arts, Boston, 1916-1925.

SCHOFIELD, Walter Elmer. Born Philadelphia, Pennsylvania, 1867; died Cornwall, England, 1944. Attended Swarthmore College, Pennsylvania, about 1885. Trip to Texas, 1886-87. Studied under T. Anshutz at Pennsylvania Academy of the Fine Arts, 1887-90. Studied at Académie des Beaux Arts and Academie Julian with A. W. Bouguereau and H. L. Doucet, Paris, 1890 until about 1895. Returned to United States, about 1900. Painting trips to Brittany and Normandy, France and Devon and Cornwall, England, 1902-14. Served in British Army, 1914-18. Established studio in Cornwall, England, about 1920. Awards for painting include Honorable Mention, Paris Exposition; Gold Medal, Carnegie Institute; Sesnan Gold Medal, Pennsylvania Academy of the Fine Arts, 1900; Inness Gold Medal, National Academy of Design, 1911; Spaulding Prize, Art Institute of Chicago, 1921.

SLOAN, John. Born Lock Haven, Pennsylvania, 1871; died Hanover, New Hampshire, 1951. Studied at Pennsylvania Academy of the Fine Arts under Thomas Anshutz, 1892. Member of "Charcoal Club," Philadelphia with Robert Henri and William Glackens, 1893. Worked as artist-reporter for Philadelphia *Inquirer*, 1892-1900. Began exhibiting paintings: Chicago Art Institute and Carnegie Institute, Pittsburgh, 1900. Moved to New York City, 1904. Exhibited with "The Eight," 1908. Represented in the Armory Show, 1913. Summer painting trips to Gloucester, Massachusetts, 1914-18. Taught at Art Students League, New York, 1916-24. Founding member of Society of Independent Artists, 1917; president of the Society, 1919-51. Began regular annual painting trips to Santa Fe, New Mexico, 1919-50. Began to concentrate on figure painting, 1928. Worked in etching, 1930-31; illustrated Maugham's *Of Human Bondage*, 1931. Retrospective exhibition at Addison Gallery of American Art, 1935. Awarded Gold Medal, National Academy of Arts and Letters.

SPENCER, Robert. Born Harvard, Nebraska, 1879; died New Hope, Pennsylvania, 1931. Studied at National Acad-emy of Design, 1899-1901; studied under Robert Henri and William M. Chase in New York about 1900. Studied at New York School of Art, 1903-05. Moved to Philadelphia about 1905; studied at the Pennsylvania Academy of the Fine Arts, and under Daniel Garber, 1909. Moved to New Hope, Pennsylvania, 1909; painted and wrote novels under the name "John St. John." Elected Associate, National Academy of Design, 1914; Academician, 1920. Frequent painting trips to Europe during the 1920's. Awarded Gold Medal Pennsylvania Academy of the Fine Arts, 1914; Inness Gold Medal (1914), Altman prizes (1920 and 1921), Gold Medal (1929), all from the National Academy of Design.

TARBELL, Edmund Charles. Born West Groton, Massachusetts, 1862; died New Castle, New Hampshire, 1938. Studied at the Boston Museum School of Art about 1880; studied in Paris at Académie Julian under G. Boulanger and J. Lefébvre. Returned to Boston about 1885; began teaching at the Museum School. Became a member of the Society of American Artists; resigned to join "Ten American Artists" group, 1898. Elected Associate, National Academy of Design, 1902; Academician, 1906. Awards from National Academy of Design include Clark Prize (1890), Hallgarten Prize (1894); from the Pennsylvania Academy of the Fine Arts, Temple Gold Medal (1895), Elkins Prize (1896), Medal of Honor (1908). Awarded Bronze Medal, Paris Exposition, 1900; Clark Prize, Corcoran Gallery of Art, 1910.

THAYER, Abbott Handerson. Born Boston, Massachusetts 1849; died Monadnock, New Hampshire 1921. Studied under H. D. Morse, Boston, about 1867; under J. B. Whittaker and L. E. Wilmarth in New York, 1869-75. Went to Paris; studied under J. L. Gérôme at École des Beaux Arts, 1875. Returned to New York, 1879. Began summer painting trips to New England. Elected president, Society of American Artists, 1880; Academician, National Academy of Design, 1901; member, American Academy of Arts and Letters, 1909. Painted mural for Bowdoin College, Brunswick, Maine, 1894. Became interested in color theory in nature; published article on natural camouflage, 1909. Awarded Bronze Medal, Paris Exposition, 1900; Elkins Prize, Pennsylvania Academy of the Fine Arts, 1895; Clark Prize (1898) and Salyus Medal (1915), National Academy of Design.

TRYON, Dwight William. Born Hartford, Connecticut, 1849; died South Dartmouth, Massachusetts, 1925. Studied independently at first; influenced by works of Thomas Cole, Frederick Church, and William Turner. Worked as bookseller while painting; first picture bought from exhibition, National Academy of Design, 1872. Established studio in Hartford, 1873. Exhibited at the Centennial Exposition,

Philadelphia, 1876. Trip to Paris, studied under J. de la Chevreuse, 1876. Worked at Fontainebleau, influenced by C. F. Daubigny and H. J. Harpignes. Exhibited at the Paris Salon of 1881; returned to New York City the same year. Appointed visiting professor of art, Smith College, 1885. Met Charles L. Freer, 1889; forty paintings eventually bought for Freer Collection. Elected Associate, National Academy of Design, 1890; Academician, 1891. Endowed Tryon Gallery at Smith College, 1923. Awarded Gold Medal, Society of American Artists, 1886; Gold Medal, National Academy of Design, 1891.

TWACHTMAN, John Henry. Born Cincinnati, Ohio, 1853; died Gloucester, Massachusetts, 1902. Studied at McMicken School of Design, Cincinnati, 1871. Came under influence of Frank Duveneck, 1874; followed him to Munich and enrolled at Royal Academy of Fine Arts, 1875. Travelled with Duveneck and W. M. Chase to Venice, 1877. Returned to Cincinnati 1878. Second European trip; worked with Duveneck in Florence, 1880; to Holland with J. A. Weir, 1881. Studied at Académie Julian, under G. Boulanger and J. Lefébvre, 1883. Settled in Greenwich, Connecticut, 1888. Began teaching at Art Students League, New York City, 1889 . Exhibited with Monet, J. A. Weir, and P. Besnard, New York, 1893. Associated with "Ten American Painters" group, New York, 1897. Given two-man show with his son at Cincinnati Art Museum; began to paint at Gloucester, Massachusetts in summer, 1900. Exhibited in New York City and Cincinnati; last exhibition with "Ten American Painters," 1901.

WEIR, Julian Alden. Born West Point, New York, 1852; died New York City, 1919. Studied with his father R. W. Weir; then at National Academy of Design about 1870. Studied under J. L. Gérôme, Paris, 1873; trip to Belgium to study Flemish painting. Painting trips to Holland, 1874; Spain, 1876. Influenced by Velasquez. Returned to New York, established studio, 1877. Trip to Holland and Belgium with brother J. F. Weir and J. H. Twachtman 1880-81. Returned to New York, moved studio to Tenth Street Building; Neighbors included Twachtman, T. Robinson, and W. M. Chase, 1883. Elected Associate, National Academy of Design, 1855; Academician, 1886. Taught at Art Students League, New York, 1885-87 and 1890-98. Exhibited with "Ten American Painters" group, 1898. One-man show at American Art Galleries, New York City, 1893. Exhibited twelve paintings, Armory Show, New York City, 1913. Elected President, National Academy of Design, 1915-17. Memorial Exhibition, Metropolitan Museum of Art, 1924.

WHISTLER, James McNeill. Born Lowell, Massachusetts, 1834; died London, England, 1903. Attended United States Military Academy; excelled in drawing, 1851-54. Moved to Paris; attended Ecole Impériale de Dessin, 1855. Attended Académie Gleyre, Paris, 1856. Moved to London; began suite of "Thames" etchings, 1859. Painting trip to Trouville, France; worked in company of Courbet, Monet, and Daubigny, 1865. First one-man exhibition, London, 1874. Trip to Venice; worked in etching and pastel, 1880. Annual painting trips: St. Ives, 1883; Dordrecht, 1884; Dieppe, 1885. Exhibited fifty works at International Exhibition, Paris, 1886. Retrospective exhibitions in London, 1889 and 1892. *Portrait of the Artist's Mother* acquired by Musée du Luxembourg, Paris, 1891. Worked in London and Paris alternately between 1892 and 1903. Elected President, International Society of Sculptors, Painters, and Gravers; opened art school in Paris, 1898. Painting trips to Holland, Ireland, and Mediterranean, 1899-1901. Awards include Gold Medal, International Exhibition, Amsterdam, 1889; Prize, Venice International Exhibition, 1895; Gold Medal, Antwerp Exhibition, 1895; *Grand Prix* Paris International Exhibition, 1900.

WIGGINS, Guy Carleton. Born Brooklyn, New York, 1883; died Essex, Connecticut, 1962. Studied under his father, Carleton Wiggins, painter of animal subjects. Studied drawing at Polytechnic Institute, Brooklyn, about 1900. Studied painting at National Academy of Design; elected Associate, 1916. Moved to Old Lyme, Connecticut, about 1920; influenced by works of Childe Hassam. Joined Connecticut Academy of Fine Arts; won Athenaeum Prize, 1933. Moved to Essex, Connecticut, 1937; established Guy Wiggins Art School. Formed Essex Painters Society; exhibited with group in New York City, 1941. Elected Academician, National Academy of Design, 1935. Awards for painting include Harris Bronze Medal, Art Institute of Chicago, 1917; Honorable Mention, Philadelphia Art Club, 1917; J. Francis Murphy Prize, Rhode Island School of Design, 1922.

General

Caffin, Charles H. *The Story of American Painting.* New York, 1907.

Goodrich, Lloyd. "The Impressionists Fifty Years Ago," *Arts,* vol. 11 (January, 1927), pp. 5-22.

Isham, Samuel. *American Painting.* New York and London, 1905.

Rewald, John. *The History of Impressionism.* New York, 1946.

Richardson, E. P. *Painting in America.* New York, 1956.

St. Gaudens, Homer. *The American Artist and His Times.* New York, 1941.

The Brooklyn Institute of Arts and Sciences. *Leaders of American Impressionism.* Exhibition catalogue, introduction by J. I. H. Baur. Brooklyn, 1937.

Wright, Willard H. *Modern Painting: Its Tendency and Meaning.* New York, 1915.

Bellows

Bellows, Emma Louise (Story). *The Paintings of George Bellows.* New York, 1929.

Boswell, Peyton. *George Bellows.* New York, 1942.

Morgan, Charles H. *George Bellows, Painter of America.* New York, 1965.

Benson

Downes, W. M. "Frank W. Benson and His Work," *Brush and Pencil,* vol. 6 (1900), pp. 145-157.

Seaton-Schmidt, Anna. "Frank W. Benson," *American Magazine of Art,* vol. 12 (1921), pp. 365-372.

Smith, Minna. "The Work of Frank W. Benson," *International Studio,* vol. 35 (1908), pp. 99-106.

Carlsen

Clark, Eliot. "Emil Carlsen," *Scribner's Magazine,* vol. 6 (1919), pp. 767-770.

Price, F. Newlin. "Emil Carlsen-Painter and Teacher," *International Studio,* vol. 75 (1922), pp. 300-308.

Steele, John. "The Lyricism of Emil Carlsen," *International Studio,* vol. 88 (1927), pp. 53-60.

Cassatt

Breeskin, Adelyn D. *Mary Cassatt: A Catalogue Raisonné of the Oils, Pastels, Watercolors and Drawings.* Washington, D.C., 1970.

Bruening, Margaret. *Mary Cassatt.* New York, 1944.

Carson, Julia M. *Mary Cassatt.* New York, 1966.

Sweet, Frederick A. *Miss Mary Cassatt, Impressionist from Pennsylvania.* Norman, Oklahoma, 1966.

Chase

Lauderbach, Frances. "Notes from Talks by William M. Chase at Carmel, California," *American Magazine of Art,* vol. 8 (1917), pp. 432-438.

Phillips, Duncan. "William Merritt Chase," *American Magazine of Art,* vol. 8 (1916), pp. 45-50.

Roof, Katherine M. *The Life and Art of William Merritt Chase.* New York, 1917.

University of California, Santa Barbara. *William Merritt Chase.* Exhibition catalogue, introduction by Ala Story. Santa Barbara, 1964.

Davis

Worcester Art Museum. *Exhibition of Paintings by Charles H. Davis.* Worcester, 1910.

De Camp

Downes, W. H. "Joseph De Camp and His Work," *Art and Progress,* vol. 4 (1913), pp. 919-925.

Berry, Rose V. S. "Joseph De Camp, Painter and Man," *American Magazine of Art,* vol. 14 (1923), pp. 182-189.

Dewing

Ely, Catherine B. "Thomas W. Dewing," *Art in America,* vol. 10 (1922), pp. 225-229.

Tharp, Ezra. "Thomas W. Dewing," *Art and Progress,* vol. 5 (1914), pp. 155-161.

White, Nelson C. "The Art of Thomas W. Dewing," *Art and Archaeology,* vol. 27 (1929), pp. 253-261.

Frieseke

Gallatin, Albert E. "The Paintings of Frederick C. Frieseke," *American Magazine of Art,* vol. 3 (1912), pp. 747-749.

Hirschl and Adler Galleries. *Frederick Frieseke.* Exhibition catalogue, introduction by A. S. Weller. New York, 1966.

Taylor, E. A. "The Paintings of Frederick C. Frieseke," *International Studio,* vol. 53 (1914), pp. 259-268.

Walton, William. "Two Schools of Art: Frank Duveneck and Frederick C. Frieseke," *Scribner's Magazine,* vol. 58 (1915), pp. 643-646.

Garber

Breck, Bayard. "Daniel Garber, A Modern American Master," *Art and Life,* vol. 11 (1919-20), pp. 493-497.

Pennsylvania Academy of the Fine Arts. *Daniel Garber Retrospective Exhibition: Paintings, Drawings and Etchings.* Philadelphia, 1945.

Glackens

City Art Museum of St. Louis. *William Glackens in Retrospect*, Exhibition catalogue, introduction by L. Katz. St. Louis, Missouri, 1966.

Glackens, Ira. *William Glackens and the Ash Can Group*. New York, 1957.

Whitney Museum of American Art. *William J. Glackens*. Exhibition catalogue, introduction by G. Pene Du Bois. New York, 1931.

Griffin

Cortissoz, Royal and Price, F. Newlin. *Walter Griffin*. New York, 1935.

Merrick, L. "Walter Griffin, Artist," *International Studio*, vol. 62 (1917), pp. 45-48.

Hassam

Adams, Adeline. *Childe Hassam*. New York, 1938.

Corcoran Gallery of Art. *Childe Hassam*. Exhibition catalogue, introduction by C. E. Buckley. Washington, D. C., 1965.

Hassam, Childe. *Three Cities*. New York, 1899.

Morton, Frederick W. "Childe Hassam, Impressionist," *Brush and Pencil*, vol. 8 (1901), pp. 141-150.

Inness

Inness, George, Jr. *Life, Art and Letters of George Inness*. New York, 1917.

Ireland, LeRoy. *The Works of George Inness*. Austin, Texas, 1965.

McCausland, Elizabeth. *George Inness, An American Landscape Painter*. New York, 1946.

Lawson

Berry-Hill, Harry and Sidney. *Ernest Lawson, American Impressionist*. Leigh-on-Sea, England, 1968.

Martin

Martin, Elizabeth G. (Davis). *Homer Martin, A Reminiscence*. New York, 1904.

Mather, Frank J. *Homer Martin, Poet in Landscape*. New York, 1912.

Sherman, Frederick F. "The Later Canvases of Homer Martin," *Art in America*, vol. 7 (1919), pp. 255-260.

Metcalf

Cortissoz, Royal. "Willard L. Metcalf," *American Academy of Arts and Letters*, No. 60 (1927), pp. 1-8.

___"Willard L. Metcalf, An American Landscape Painter," *Appleton's Magazine*, vol. 6 (1905), pp. 509-511.

Ely, Catherine B. "Willard L. Metcalf," *Art in America*, vol. 13 (1925), pp. 332-336.

Prendergast

Bruening, Margaret. *Maurice Prendergast*. New York, 1931.

Knoedler Galleries. *Maurice Prendergast*. Exhibition catalogue, introduction by C. H. Sawyer. New York, 1966.

Phillips Academy, Addison Gallery of American Art. *The Prendergasts: Retrospective Exhibition of the Work of Maurice and Charles Prendergast*. Andover, Massachusetts, 1938.

Robinson

Clark, Eliot. "Theodore Robinson, American Impressionist," *Scribner's Magazine*, vol. 70 (1921), pp. 763-768.

Brooklyn Institute of Arts and Sciences. *Theodore Robinson*. Exhibition catalogue, introduction by J. I. H. Baur. Brooklyn, 1946.

Ranger

Bell, R. H. *Art Talks with Ranger*. New York, 1914.

Bromhead, Harold W. "Henry Ward Ranger," *International Studio*, vol. 29 (1906), pp. 34-44.

Smithsonian Institution, National Collection of Fine Arts. *Henry Ward Ranger Centennial Exhibition*. Washington, D.C., 1958.

Redfield

Laurvik, J. Nilsen. "Edward W. Redfield, Landscape Painter," *International Studio*, vol. 41 (1910), pp. 29-34.

Price, F. Newlin. "Redfield, Painter of Days," *International Studio*, vol. 75 (1922), pp. 402-410.

Reid

Cortissoz, Royal. "The Work of Robert Reid," *Appleton's Magazine*, vol. 6 (1905), pp. 738-742.

Goodrich, Henry W. "Robert Reid and His Work," *International Studio*, vol. 36 (1909), pp. 112-122.

Stoner, Stanley. *Some Recollections of Robert Reid*, Colorado Springs, 1934.

Sargent

Corcoran Gallery of Art. *The Private World of John Singer Sargent*. Exhibition catalogue, introduction by D. F. Hoopes. Washington, D. C., 1964.

Charteris, Evan E. *John Sargent*. New York, 1927.

Hoopes, Donelson F. *Sargent Watercolors*. New York, 1970.

Mount, Charles M. *John Singer Sargent, A Biography*. New York, 1955.

Schofield

Hoeber, Arthur. "Walter Elmer Schofield, A Painter in the Open," *Arts and Decoration*, (October 1911), p.473 ff.

Sloan

Brooks, Van Wyck. *John Sloan, A Painter's Life*. New York, 1955.

Goodrich, Lloyd. *John Sloan*. New York, 1952.

John Sloan's New York Scene. Diaries, Notes and Correspondence, ed. by B. St. John. New York, 1965.

Spencer

Price, F. Newlin. "Spencer and Romance," *International Studio*, vol. 76 (1923), pp. 485-491.

Tarbell

Coburn, Frederick W. "Edmund C. Tarbell," *International Studio*, vol. 32 (1907), pp. 75-88.

Hale, Philip L. "Edmund C. Tarbell, Painter," *Arts and Decoration*, vol. 2 (1912), pp. 129-131.

Trask, John E. D. "About Tarbell," *American Magazine of Art*, vol. 9 (1918), pp. 217-228.

Thayer

White, Nelson C. *Abbott H. Thayer, Painter and Naturalist*. Hartford, 1951.

Metropolitan Museum of Art. *Memorial Exhibition of the Works of Abbott Handerson Thayer*. New York, 1922.

Tryon

Caffin, Charles H. *The Art of Dwight W. Tryon*. New York, 1909.

Sherman, Frederick F. "The Landscapes of Dwight W. Tryon," *Art in America*, vol. 7 (1918), pp. 31-38.

White, Henry C. *The Life and Art of Dwight W. Tryon*. Boston, 1930.

Twachtman

Clark, Eliot. *John Twachtman*. New York, 1924.

Cincinnati Art Museum. *John H. Twachtman Retrospective Exhibition*. Introduction by R. J. Boyle. Cincinnati, 1966.

Tucker, Allen. *John H. Twachtman*. New York, 1931.

Weir

Metropolitan Museum of Art. *Memorial Exhibition of the Works of J. Alden Weir*. New York, 1924.

Phillips Memorial Art Gallery. *J. Alden Weir: An Appreciation of His Life and Works*. Washington, D. C., 1922.

Young, Dorothy (Weir). *The Life and Letters of J. Alden Weir*. New Haven, 1960.

Whistler

Holden, Donald. *Whistler Landscapes and Seascapes*. New York, 1969.

Arts Council of Great Britain. *James McNeill Whistler*. Exhibition catalogue, introduction by A. McL. Young. London, 1960.

Pennell, E. R. and J. Pennell *The Life of James McNeill Whistler*. Philadelphia, 1920.

Whistler, James McN. *The Gentle Art of Making Enemies*. New York, 1967.

Abbey, Edwin Austin, 58
Abstraction, 136
Académie des Beaux-Arts, 11, 12, 82; compared to National Academy of Design, 13
Académie Julian, 66, 86, 100, 104, 122
Academy of Fine Arts. See Académie des Beaux-Arts.
Adams, Henry, 78, 112
American Academy of Art, 8
American Art Association, 15, 72
American Society of Painters in Pastel, 46
Anshutz, Thomas, 124
Armory Show, 17, 132
Arques-la-Bataille, 87
Art Institute of Chicago, 134
Art Students League, 13, 14, 16, 38, 82, 122
Ashcan School, 124, 126

Barbizon School, 9, 11, 44, 48, 52, 56, 66, 82, 86, 114, 120; first American exhibit, 14; influence on Inness, 20
Barnes, Albert, 130
Barocci, Federigo, 46
Bassano, Jacopo, 46
Bastien-Lepage, Jules, 52, 86
Bath, The, 37
Bellows, George Wesley, 17, 114, 126; illus. by. 127; interest in prize fighting, 126
Benson, Frank Weston, 16, 18, 96, 100; illus. by, 101; use of plein air style, 100; women as subject matter, 100
Bird's Eye View: Giverny, France, 51
Bingham, George Caleb, 9
Black, in impressionism, 9
Blakelock, Ralph Albert, 94
Blond palette, 14
Blum, Robert, 38
Bonheur, Rosa, 12
Bonnard, Pierre, 68
Boudin, Eugene, 118
Boulanger, Gustav Rodolphe Clarence, 86, 100, 104
Bracquemond, Felix, 12, 36
Brush, George de Forest, 16, 78, 112
Bryce, James, 102
Building the Coffer Dam, 139
Butler, Theodore Earl, 16, 116; illus. by, 117

Caffin, Charles, 28, 100
Caillebotte, Gustave, 34
Camouflage, (Thayer's) theory of, 112
Carlsen, Sören Emil, 110; illus. by, 111
Carnegie, Andrew, 17
Carnegie Institute, 128
Carlyle, Thomas, 24
Carolus-Duran, 12, 13, 48, 60
Cassatt, Lydia, 32
Cassatt, Mary Stevenson, 12-13, 14, 15, 32, 34, 46, 48, 56; friendship with Degas, 30; illus. by, 31, 33, 35, 37; influence of 18th century

French art, 30; influence of Japanese art, 34, 36; influence of Persian miniature paintings, 36; influence of Spanish painters, 30; mother and child subject matter, 36
Cassatt, Mrs. Robert, 32, 34
Centennial Exposition, Philadelphia, 14
Cézanne, Paul, 10, 17, 22
Chardin, Jean Baptiste Siméon 46
Chase, William Merritt, 13, 14, 16, 46, 82; and art school at Shinnecock, Long Island, 44; as teacher, 42; early training, 38; financial difficulty, 42; illus. by, 39, 41, 43, 45, 47; influence of Japanese art, 46; influence of Whistler, 40; pastel work, 46; trip to Spain, 38
Chez Mouquin, 129
Church, Frederic Edwin, 8
Claude Monet Sketching at the Edge of a Wood, 61
Classicism, 8, 9, 10
Cole, Thomas, 8, 9
Color, in impressionism, 9, 10, 14
Columbian Exposition, Chicago. See World's Columbian Exposition.
Connecticut Hillside, 111
Constant, Benjamin, 30
Corot, Jean Baptiste Camille, 9
Cortissoz, Royal, 17, 76, 146
Courbet, Gustave, 9, 11, 24, 26, 124
Couture, Thomas, 11

Daguerre, Louis, 10
Dannat, William T., 100
Davies, Arthur Bowen, 17, 124, 126, 134
Davis, Charles Harold, 16, 108; illus. by, 109
Debussy, Claude, 12
De Camp, Joseph Rodefer, 16, 96, 98, 100, 102; as portrait painter, 96; illus. by, 97, 99; influence of Munich School, 96; landscape work, 98; portrait work, 98
Degas, Edgar, 10, 13, 15, 32, 34, 36, 46; friendship with Cassatt, 30
De Hoogh, Pieter, 40, 96
Delacroix, Eugene, 8, 9, 46
Delaware Valley artists, 138, 142
Dewing, Thomas Wilmer, 14, 16, 78, 80, 96, 100, 102; illus by, 79, 81; influence of Japanese art, 80; use of symbolism, 80; use of tonalism, 80; women as subject matter, 78
Dreiser, Theodore, 124
Duffee, Mrs., 31, 32
Durand, Asher, 9
Durand-Ruel, Paul 14, 15, 17, 72, 76
Duret, Theodore, 12
Duveneck, Frank, 38, 86, 96, 118

Eakins, Thomas, 8, 15, 124, 128
Early Morning, September, 57
Early Spring Afternoon, Central Park, 105
East River, The, 135
East River Idyll, An, 115

Ecole des Beaux-Arts, 36, 114. See also Académie des Beaux-Arts.
"The Eight", 14, 17, 124, 126, 128, 130, 132
Eight Bathers, 137
Elder, Louisine. See Mrs. H. O. Havemeyer.
Exhibition of Independent Artists, 17

Fantin-Latour, Ignace Henri Joseph Theodore, 12, 22, 24, 46, 122
Fauves, 76
Fleur-de-Lys, 107
Flower Garden, The, 69
Fontainebleau, 9, 48
Fragonard, Jean Honoré, 30
Freer, Charles, 14
Friendly Call, A, 43
Frieseke, Frederick Carl, 17, 122; illus. by, 123

Garber, Daniel, 18, 138, 144, 146; illus. by, 145
Gauguin, Eugene Henri Paul, 15, 34
Gellatly, John, 14
Gérôme, Jean Léon, 48, 82
Gibson, Charles Dana, 78
Gifford, Sanford Robinson, 9
Gisors Train in the Flood, 117
Giverny, 9, 98; as center of impressionism, 116
Glackens, Ira, 136
Glackens, William James, 17, 124, 128, 130, 136, 138; illus by, 129, 131; influence of Renoir on, 130
Gleyre, Charles Gabriel, 12
Goodrich, Lloyd, 17
Gosse, Edmund, 58
Grand Prix Day, 67
Gray Day, Goochland, 21
Greenaway, Kate, 36
Griffin, Walter Parsons Shaw, 16, 108, 120; illus. by, 121
Guèrin, Alice, 62
Guitar Player, The, 97

Hals, Frans, 30
Harp of the Winds: View of the Seine, 29
Hassam, Frederick Childe, 8, 14, 16, 17, 46, 56, 66, 68, 72, 74, 76, 82, 94, 108, 120, 140, 146; flags as subject matter, 76; illus. by, 67, 69, 73, 75, 77; use of realism, 74; use of tonalism, 72
Havemeyer, Mrs. H. O., 13, 30, 34
Haystack series, 58
Heffernan, Joanna, 20
Helleu, Paul, 62
Henri, Robert, 17, 124, 126, 128, 130, 132, 134, 138, 142
Hide and Seek, 41
Hochedé, Suzanne, 116
Hokusai, Katsushika, 36
Holiday, A, 119
Home Fields, 59

Homer, Winslow, 8, 50, 66
Howells, William Dean, 17
Hudson River School, 8, 12, 20
Hunt, William Morris, 9, 11

Impressionism: acceptance in America, 15; blond palette, 14; colors, 9, 10; definition of style, 9; domination of post-World War I art in America, 18; first American exhibit, 14; first book on, 12; influence of collapsible metal paint tube, 10; influence of new colors, 10; influence of photography, 10; in Southern Connecticut, 108; official mode of academic expression, 140; origin of term, 10; spontaneous approach to painting, 10; subject matter, 9; technique, 9
In the Orchard, 103
Independent Artists, 130
Ingres, Jean Auguste Dominique, 8, 9
Inness, George, 11, 20; and impressionism, 20; illus. by, 21; Hudson River School, 20
Interior: Young Woman at a Table, 47
Isham, Samuel, 14, 56, 72, 108
Israels, Josef, 114

James, Henry, 14, 58, 78
Japanese art, 86; influence on Cassatt, 36; influence on Chase, 46; influence on Dewing, 80; influence on Whistler, 12
Jarves, James Jackson, 11
Johnson, Eastman, 50

La Farge, John, 48
Latour, Quentin, 46
Lady at a Tea Table, 35
Lady in Gold, 79
Late Afternoon, Winter, New York, 73
Lawson, Ernest, 17, 124, 126, 128, 132; illus. by, 133
Lefebvre, Jules Joseph, 86, 100, 104
Leroy, Louis, 10
Lightly Falling Snow, 141
Little Hotel, The, 99
Lorraine, Claude, 11
Luks, George, 17, 124, 128, 134
Luminism, 56, 104
Lydia Working at a Tapestry Frame, 33

Manet, Edouard, 9, 12, 22, 28, 30, 36, 38, 44, 48, 82, 124, 128, 138
Martin, Homer Dodge, 12, 56; illus. by, 29
Mauve, Anton, 86, 114
McKim, Meade, and White, 16
Metcalf, Willard Leroy, 104; American luminist tradition, 104; illus. by, 105; plein air style, 104
Metropolitan Museum of Art, The, 34
Miller, Joaquin, 40
Millet, Jean François, 11, 46
Monadnock, 113
Monet, Claude, 8, 9, 10, 11, 13, 16, 17, 20, 48, 50,

52, 54, 58, 60, 68, 86, 94, 98, 116, 122, 132; Haystack series, 58
Moore, Albert, 24
Moore, George, 9, 10
Moore, James B., 128
Morisot, Berthe, 10, 12, 15
Mount, William Sidney, 9
Mountain Stream, The, 143
Munich School, 14, 38, 86, 96, 118
Munkácsy, Mihály, 100
Munnings, Sir Alfred, 138
Mural painting, 16, 106
Murger, Henri, 11
Murphy, J. Francis, 56

Napoleon III, Emperor of France, 11
National Academy of Design, 8, 14, 15, 16, 17, 18, 42, 72, 82, 120, 128, 130, 140, 146; compared to Academy of Fine Arts, 13
National Arts Club, 134
Naturalism, 15
Near the Beach, Shinnecock, 45
Neoclassicism, 106
New English Art Club, 60
Nieuwerkerke, Count, 11
Nocturne in Black and Gold: The Falling Rocket, 25
North West Wind, 109
Norton, Charles Eliot, 14
Note in Blue and Opal: The Sun Cloud, 27
Nude with Apple, 131

O. Henry, 124

Palette, blond, 14
Paris Salon, 30, 34, 58; exhibition of Cassatt's work, 13; rejection of Cassatt's work, 30; rejection of Whistler's "Thames Set", 12
Pastel, 46
Paul Helleu Sketching, and His Wife, 63
Pennsylvania Academy of Fine Arts, 18, 30, 128, 138, 142, 146
Pennsylvania Station Excavation, 127
Persian miniature painting, influence on Cassatt, 36
Phillips, Duncan, 84
Photography, 52; in development of impressionism, 10
Picasso, Pablo, 17
Pissarro, Camille, 9, 10, 15, 22, 140
Plein air style, 98, 100, 104, 120
Pointillism, 15
Pope, Alexander, 110
Portrait painting, 98, 96; Sargent's work in 60, 64
Postimpressionism, 76, 130
Potthast, Edward Henry, 118; illus. by, 119
Poussin, Nicholas, 11, 20
Pre-Raphaelite Brotherhood, 12, 22
Prendergast, Charles, 134, 136
Prendergast, Maurice Brazil, 17, 124, 126, 132,

134, 146; illus. by, 135, 137; use of abstraction, 136; use of flat design, 136; use of watercolor, 134
Price, Newlin, 142
Prize fighting, 126

Quarry, The, 145

Raffaelli, Jean François, 34
Rainy Day, 101
Rand, John G., 10
Ranger, Henry Ward, 108, 114, 144; illus. by, 115
Realism, 8, 9, 26, 50, 74, 86, 114, 124, 128, 138, 142; and Barbizon painters, 11; and Velàsquez, 10; repudiated by Whistler, 24
Red Bridge, The, 85
Redfield, Edward Willis, 18, 138, 142, 144, 146; illus. by, 143; working methods, 142
Refelctions, 93
Reid, Robert, 16; illus. by, 107; mural painting, 106
Rembrandt (Harmenzoon van Rijn), 9
Renoir, Pierre Auguste, 10, 46, 84, 102, 130
"Revolutionary Black Gang", 128
Rewald, John, 12
Richardson, E. P., 12
Riddle, Mrs. Robert, 34
Ribera, José, 30
Robinson, Edward Arlington, 128
Robinson, Theodore, 14, 16, 52, 54, 56, 88, 116, 122; and native American realism, 50; illus. by 49, 51, 53, 55; training in impressionism, 48; use of photography, 52
Romanticism, 9
Roosevelt, Theodore, 124
Rossetti, Dante Gabriel, 22
Rousseau, Theodore, 9
Royal Academy of Arts, The, 22, 38, 60
Rubens, Peter Paul, 30
Ruskin, John, 24
Ryder, Albert Pinkham, 84, 94

Sailing in the Mist, 95
St. Gaudens, Augustus, 112
St. Gaudens, Homer, 144
Salon des Refusées, 22
Sargent, John Singer, 13, 16, 48, 58, 60, 62, 64, 78, 96, 98; illus. by, 59, 61, 63, 65; portrait work, 60; termination of portrait work, 64
Schofield, Walter Elmer, 138, 142; illus. by, 139
Seurat, Georges, 15
Shinn, Everett, 17, 124, 128
Simmons, Edward, 16, 106
Sisley, Alfred, 10, 132, 140
Sloan, John, 17, 114, 124, 126, 128, 130, 134; illus. by, 125; and "Ashcan School", 124
Snowbound, 89
Society of American Artists, 13, 15, 16, 42, 50
Society of Independent Artists, The, 15

INDEX

Southwest Wind, 75
Spencer, Robert, 138, 146; illus. by, 147
Spinet, The, 81
Spring Night, Harlem River, 133
Springtime, 121
Stream in the Val d'Aosta, 65
Summer, (Twachtman) 91
Summer (Frieseke), 123
Sunlight and Shadow, 39
Symbolism, 80

Tarbell, Edmund Charles, 16, 100, 102; illus. by, 103
"Ten American Painters", 8, 17, 16, 74, 82, 94, 96, 98, 104, 106, 140
"Thames Set," 12
Thayer, Abbott Handerson, 14, 16, 78, 112; illus. by, 113; theory of camouflage, 112
Thoreau, Henry David, 92
Tocqueville, Alexis de, 12
Tonalism, 72, 80
Toulgouat, Pierre, 98

Toulouse-Lautrec, Henri-Marie Raymond de, 46
Tryon, Dwight Williams, 12, 14, 56; illus. by, 57; influence of luminism, 56
Twachtman, John Henry, 14, 16, 74, 82, 86, 88, 90, 92, 94, 96, 108, 118, 132, 140; illus. by, 87, 89, 91, 93, 95; influence of Japanese art, 86; influence of Munich School, 86

Union Jack, New York, April Morn, 77
Upland Pasture, 83

Vale of Arconville, The, 49
Van Gogh, Vincent, 17
Velásquez, Diego Rodriguez di Silva y, 9, 10, 30, 38, 42
Vermeer, Johannes, 40, 96
Vigée-Lebrun, Marie, 12
Vonnoh, Robert, 118
Vuillard, Jean Edouard, 46

Wake of the Ferry, 125
Watering Pots, The, 53

Weir, John Ferguson, 14
Weir, Julian Alden, 14, 16, 44, 48, 74, 82, 84, 86, 88, 90, 108, 128, 132, 144; illus. by, 83, 85
Weir, Robert Walter, 82
Whistler, James McNeill, 8, 11, 12, 13, 14, 28, 36, 46, 60, 80, 86, 92; abstract work, 24; illus. by, 23, 25, 27; influence of Japanese prints, 12; influence on Chase, 40; landscape work, 26; libel suit against John Ruskin, 24
White Girl, Symphony in White Number 1, The, 23
White Tenements, 147
Whittredge, Worthington, 9, 118
Wiggins, Guy Carleton, 16, 140; illus. by, 141
Willows (En Picardie), 55
World War I, 76, 116, 138
World's Columbian Exposition, 16, 82, 112
World's Fair Exhibition, 11
Wyant, Alexander Helwig, 56

Yale School of Fine Arts, 82
Young Girl Reading, 31

Zola, Emile, 36

Edited by Adelia Rabine
Designed by James Craig and Robert Fillie
Composed in 11 point Elegante by Publishers Graphics, Inc.
Printed and bound in Japan by Toppan Printing Company Ltd.